November 22, 2012 Zoo

A gift from Susan

my Parents caregiver.

Zoo

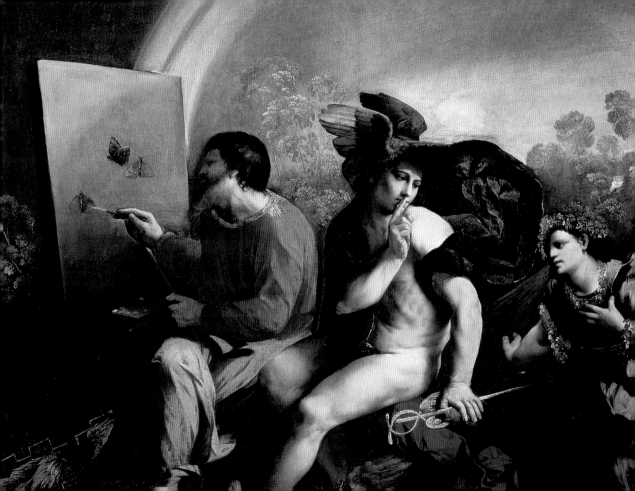

ANIMALS IN ART

Zoo

Edward Lucie~Smith

WATSON-GUPTILL
PUBLICATIONS
─────
New York

Design copyright © 1998 by The Ivy Press Limited
Text copyright © 1998 by Edward Lucie-Smith

First published in the United States in 1998
by Watson-Guptill Publications,
a division of BPI Communications, Inc.,
1515 Broadway, New York, NY 10036

Art Director: PETER BRIDGEWATER
Editorial Director: SOPHIE COLLINS
Designer: CLARE BARBER
Project Editor: NICOLA YOUNG
Editor: CAROLINE BEATTIE
Page make-up: CHRIS LANAWAY
Picture research: LIZ EDDISON
Calligrapher: TREVOR MARCHANT

Library of Congress Catalog Card Number: 98-85579

ISBN 0-8230-5981-2

This book was conceived, designed, produced, and
first published in the United Kingdom in 1998
by THE IVY PRESS LIMITED
2/3 St Andrews Place
Lewes, East Sussex BN7 1UP

Printed and bound in Hong Kong
First printing, 1998

1 2 3 4 5 6 7 8 9 10/06 05 04 03 02 01 00 99 98

Illustration on page 2: Dosso Dossi. *Jupiter, Mercury and Virgo* (c. 1529)
Illustration on page 3: J. Le Moyne de Morgues. *Serpentaria* (c. 1568) (detail)

Contents

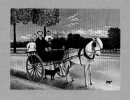

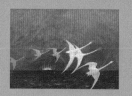

THIS BOOK IS ABOUT *the oldest of all subjects in art—the animal kingdom.*

The earliest human beings were fully confident about making images of the animals who surrounded them, as we can see from the Paleolithic paintings at Lascaux in France and Altamira in

LEONARD KOSCIANSKI
Modern Living *1989*

ASHMOLE BESTIARY
Early 13th Century

Spain. Regardless of the taboos a culture may have placed on other forms of representation, artists almost invariably continued to make images of animals. The purpose of these images varied widely from age to age and from place to place. Paleolithic cave paintings, it is supposed, were a form of hunting magic. The artist made an accurate representation of a particular beast in order to take possession of its spirit and make it easier to kill.

Later, the picture broadened. Because humans were so dependent on animals in early times, various species acquired totemic significance. That is, an individual from the "bear tribe" thought of himself (or herself) as being at least partly a bear. Animals became symbols of the gods, or might even be gods themselves. The vast ancient Egyptian pantheon was filled with animal or part-animal deities—cows, crocodiles, hippopotamuses, even dung beetles.

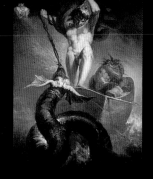

HENRY FUSELI Thor Fighting the Midgard Serpent *1788*

EGYPTIAN A Scarab Beetle *c. 1300 B.C.*

The Egyptians represented animals for other reasons as well. Since they believed that the afterlife was essentially a continuation of the one enjoyed here on earth, they painted the walls of their tombs with scenes from daily life in which animals often played major roles—particularly farming and hunting.

7

The art of the Greek and Roman worlds, though focused on humans as the supreme test of the artist's skill, also made room for representations of animals, which were depicted because they were in some way symbolic, and also purely for their own sake.

The triumph of Christianity and the transition to the Middle Ages affected the way in which animals were depicted in art much less than it affected the representation of the human figure.

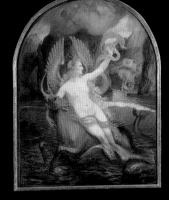

ARMAND POINT
The Siren *1897*

Animals were seen more directly and represented with fewer preconceptions.

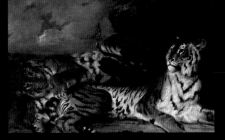

EUGÈNE DELACROIX
Tigress Playing with her Cub *19th Century*

The great age of exploration that followed Columbus' first voyage across the Atlantic in 1492 opened European eyes to the existence of a vast number of hitherto unknown species. Many animals, such as the dodo, were willfully slaughtered

almost as soon as they were discovered. *Physical exploration of the world, however, went hand in hand with the growth of scientific curiosity, and artists were called on to make accurate records of these previously unknown species.*

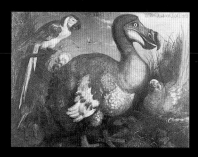

GEORGE EDWARDS Dodo *1759*

Finally, with the birth of the Romantic Movement, the emphasis shifted yet again, and artists started to empathize, as their remotest ancestors had, with the inhabitants of a realm so like and yet so unlike the one in which

ROBIN PALANKER Two Pigs *1988*

human beings live. This tendency continued after the birth of the Modern Movement. Expressionist artists such as Franz Marc (1880–1916) and Auguste Macke (1887–1914), for instance, saw animals as the living representatives of vital forces that moved the whole natural realm. Artists today continue to make inventive and vital use of animal imagery.

IN THE JUNGLE

SUSANA JACOBSON
Siskia
1992

THE WAY IN WHICH *we traditionally see the animal kingdom and its zoological reality are often at variance. The lion, for example, has long been* called the "king of the jungle," *although in fact he is a creature of the savanna, since he needs space in order to run his prey down. More disillusioning still, the king of the beasts leaves most of the work to the lionesses, taking his ease while letting the females do the hunting for the pride. The noble image of the lion— and his symbolic importance—is so strong, however, that it is impossible to think of him in this purely practical fashion. An astrological sign, the emblem of St. Mark (one of the gospel writers), the proud quarry of a royal hunt—the lion has been portrayed by many artists, a large number of whom had clearly never seen a lion in the flesh.*

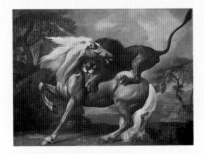

GEORGE STUBBS Horse
Attacked by a Lion *c.1768–72*

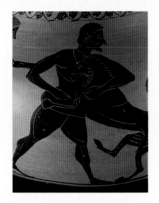

GREEK VASE Hercules Kills
the Nemean Lion *c.500 BC*

The same is true of a number of the other greater cats, among them the tiger and the leopard. The tiger plays an important part in the mythology of Asia, as the third sign in the Chinese zodiac. As with many emblematic beasts, its significance is ambiguous. In one aspect, it signifies violence and destruction; in another, it is protective. In China, small boys used to be given "tiger caps" as magically protective devices. The leopard appears in the Neolithic art of Anatolia (now in Turkey), as the totem-creature of the supreme goddess, and its close cousin the jaguar plays an even more important role in the pre-Columbian mythology of the Americas.

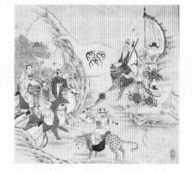

CHINESE
Meeting of the Soldiers *18th Century*

13

The jungle is also home, this time in both imagination and fact, to the apes and their cousins, the monkeys—the difference between the two being that apes are tailless. As the closest creatures to humankind, apes exercise an undoubted fascination, though the comparison is not usually seen as flattering. "To lead apes in Hell," for example, is a proverbial phrase for being perpetually overcome with lust. Monkeys are thought of as not only lustful and sexually shameless, but as

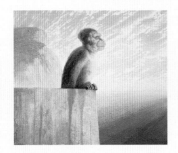

PETER ZOKOSKY
Barbary Ape *1990*

mischievous troublemakers. When they exercise their cleverness, like the monkey in the fable who uses a cat to pull hot chestnuts out of the fire, monkeys are perceived as unscrupulous and slightly cruel.

Since Charles Darwin (1809–82) put forward his evolutionary theories in the mid-nineteenth century, human attitudes towards all apelike and monkeylike

creatures have been imbued with a degree of wariness, since we now have cause to wonder if there really is a firm line of division between these species and ourselves.

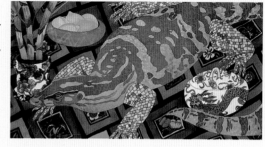

KENDAHL JAN JUBB Golden Monitor *1992*

No such self-identification occurs in the case of the so-called cold-blooded species. Lizards, which can endure extremes of heat and cold and of aridity and moisture, are among the forest's smaller denizens. One of these, the chameleon, fascinates chiefly by its ability to change color—though scientists tell us that these changes are governed by factors such as heat and cold, and emotional states, and have nothing to do with a wish to disguise itself by matching its surroundings.

GERMAN Chameleon *1792*

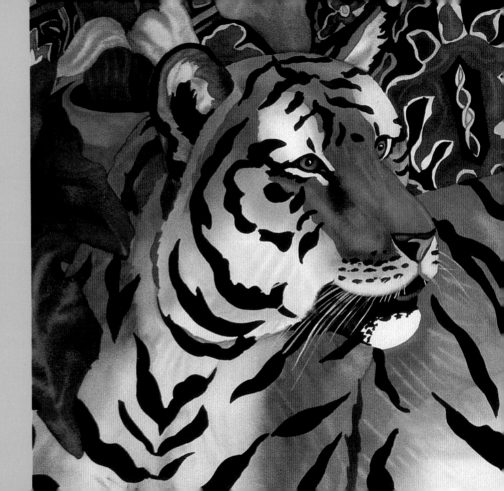

> **TIGER, TIGER,**
> *burning bright,*
> *In the forests*
> *of the night;*
> *What immortal*
> *hand or eye,*
> *Could frame thy*
> *fearful symmetry?*

William Blake
(1757–1827)

JUBB

Still Life with Tiger
1997

● This unlikely conjunction of creature
and setting makes the point that one of
the fiercest of all beasts is now seen
chiefly in terms of its decorative qualities.
If real tiger skin rugs, for example, are
frowned upon by people who are aware
that this beast is now almost extinct in
many regions of the world, tiger
patterns are an almost standard
element in luxurious modern decor.

Kendahl Jan Jubb (b. 1957)

FERNÁNDEZ SAUS

The Tiger
1996

● A "decorative" tiger painting from a contemporary artist influenced by Henri Rousseau (1844–1910) and the Nabis group (1891–1900), who were themselves influenced by the Symbolist Movement and by Paul Gauguin's (1848–1903) use of flat patterning. The curving forms of the body and the over-long, exaggeratedly sinuous tail make the point that this is a kind of dream tiger, rather than a literal representation.

Ramiro Fernández Saus (20th Century)

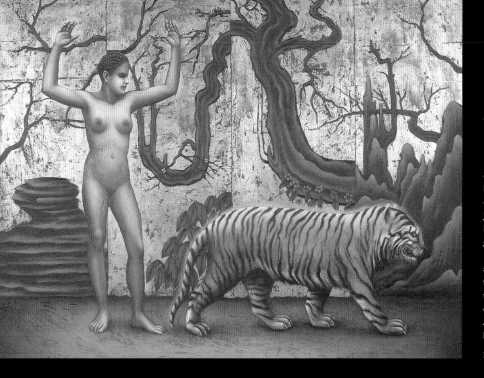

MARQUEZ

The Lost Dream of Shoëi, Tiger Painter 1992

● The Mexican painter of this work has borrowed from the conventions of the Japanese screen, placing isolated forms against a gold-leaf background. The gnarled trees are an almost literal quotation from Japanese art. The two figures, however, come from the Latin American tradition of Magical Realism.

Roberto Marquez (b. 1959)

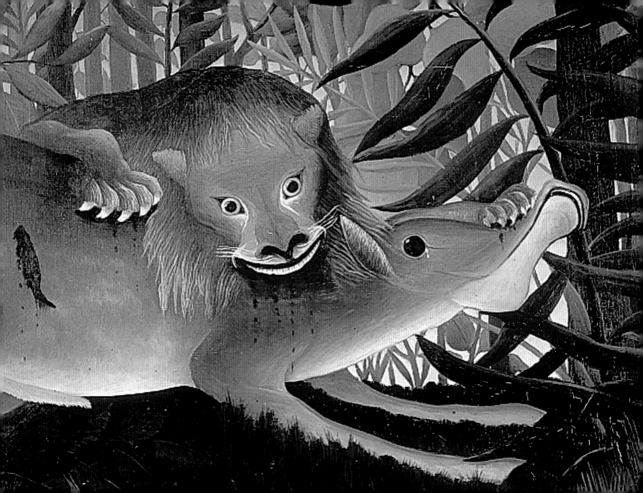

ROUSSEAU

The Hungry Lion
1905

● This is one of Rousseau's simpler jungle scenes, with a lion attacking a slightly indeterminate creature. Rousseau liked to pretend that he had been part of a French expedition to Mexico, but in fact never left France. The main source for his exotic plants and animals seems to have been visits to the Jardin des Plantes in Paris.

Henri Rousseau ("Le Douanier") (1844–1910)

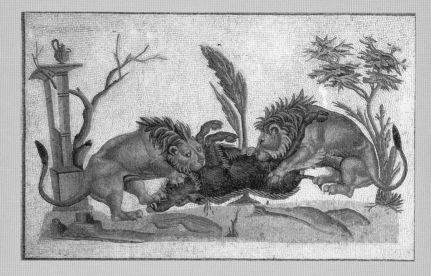

ROMAN

Two Lions Attacking a Boar
3rd Century A.D.

● This floor mosaic, which portrays lions with relative accuracy, suggests that the designer may have seen live specimens. The mosaic itself is made up of tesserae, small stones of various colors that are put together to form the design.

POOR

What the Jaguar Saw
1997

● Jaguars play a major
role in the mythology
of the Amazonian Indians.
The Brazilian artist Kim
Poor, working with a
demanding technique in
which tiny specks of pure
pigment are fused onto
a metal surface, here
gives the beast a
godlike presence.

Kim Poor (20th Century)

> **❝**
>
> *Blot out my spots!"*
> *the leopard said.*
>
> *"I want some peace*
> *and quiet.*
>
> *I've changed my ways.*
> *No meat—instead,*
> *A vegetable diet.*
>
> **❞**
>
> Edward Lucie-Smith

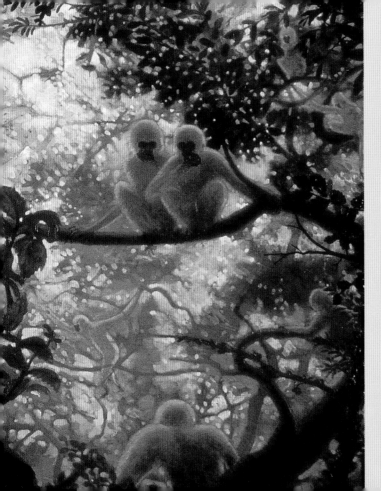

MONKEY

ZOKOSKY

Gibbons in the Trees
1989

● A true-to-life representation
of a small group of gibbons in their
natural forest setting of East India.
The inspiration for the work came
from the artist's trip to the jungle,
where he met and shared peanuts
with such a group of gibbons.

Peter Zokosky (b. 1957)

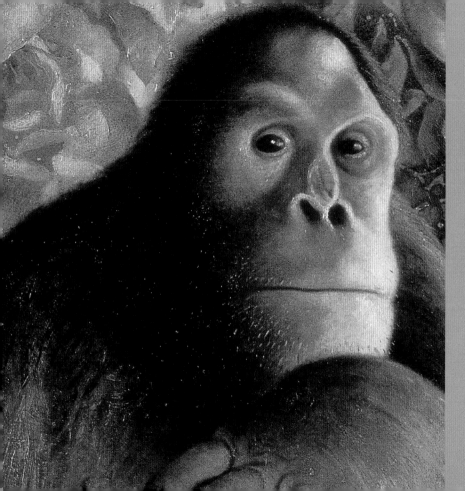

ZOKOSKY

Man of the Forest
1990

● In this picture, the emphasis
is not so much on truth to
nature as on the resemblance
between human beings and
apes—something that has
fascinated human beings since
the beginning of time, and that
has seemed especially relevant
since Darwin. "Man of the
Forest" is the translation of the
Malay word "orang-utan."

Peter Zokosky (b. 1957)

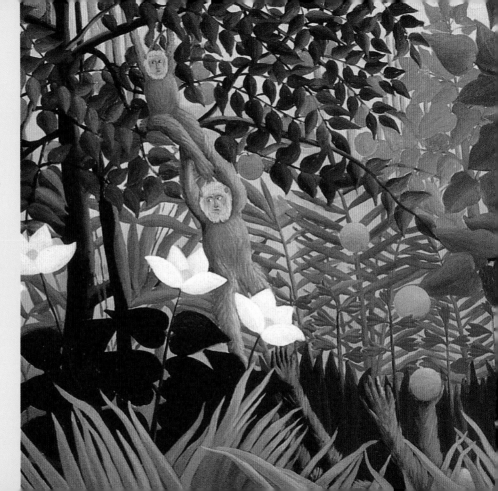

> "
>
> **BEAUTY FOR SOME**
> *provides escape,*
> *Who gain a happiness*
> *in eyeing*
> *The gorgeous buttocks*
> *of the ape*
> *Or Autumn sunsets*
> *exquisitely dying.*
>
> "
>
> Aldous Huxley
> (1894–1963)

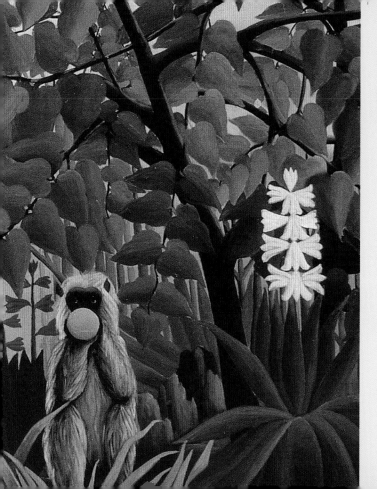

ROUSSEAU

Exotic Landscape
1910

● One of Rousseau's most ambitious compositions, showing the artist's usual blithe disregard for any kind of verisimilitude. The ape shown here, probably intended to be a baboon, is about to devour a large orange—a fruit he would be very unlikely to discover in his native habitat.

Henri Rousseau ("Le Douanier")
(1844–1910)

WILEY

Monkey See
1995

● This contemporary American artist is a sardonic humorist, much influenced by the West Coast "underground" strip cartoonists of the late 1960s and early 1970s, such as Robert Crumb. This uncharacteristically simple composition refers to the old proverb "Monkey see, monkey do."

William T. Wiley (b.1937)

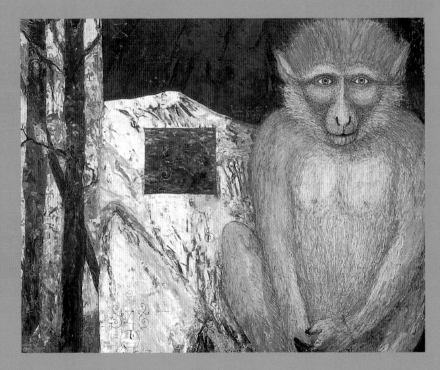

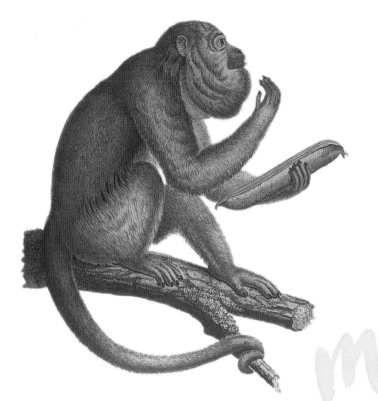

TURPIN

Ape

c. 1805

● This is an illustration made for the great German naturalist Alexander von Humboldt's account of his travels in Venezuela and the Orinoco River basin. Made by another artist from von Humboldt's original sketch, it shows a care for natural appearances combined with slight elements of stylization.

Pierre Jean François Turpin (1775–1840)
after Alexander von Humboldt (1769–1859)

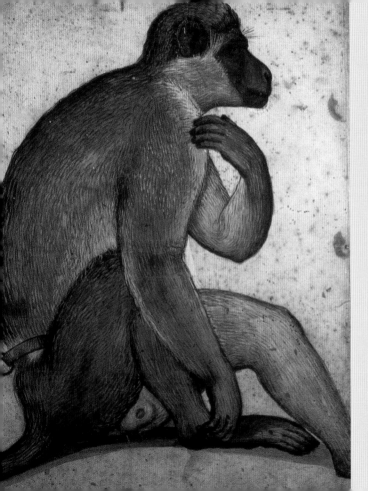

ITALIAN

Seated Monkey
15th Century

● This drawing, unusual for its period
because it is colored, probably comes
from a pattern book made by an artist
who was a humble follower of Antonio
Pisanello (1395–1455). The monkey wears
a chain around its waist, which tells us
that it was a domestic pet. The drawing
would have been used as a model for
some form of fresco decoration.

monkey

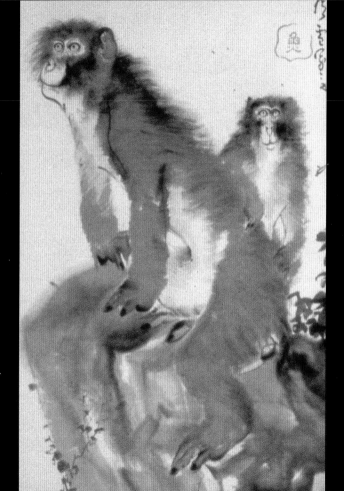

ROSETSU
Mountain Monkey
18th Century

● Rosetsu was a prominent member of the Maruyama School of painters in Japan, who worked for the merchant class in Kyoto and Osaka. They avoided the stylizations of other Japanese schools and painted naturalistically, within the limits of Japanese ink-and-brush technique (which demands a certain degree of boldness and simplification). Rosetsu was particularly famous for his paintings of monkeys.

Nagasawa Rosetsu
(1754–99)

> "
> THERE IS NO reason *to attack the monkey when the organ grinder is present.*
> "

Aneurin Bevan
(1897–1960)

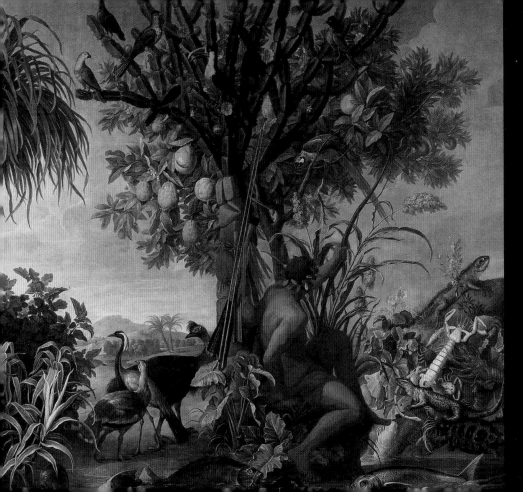

BOUTTATS

Orpheus and the Animals
17th Century

● Here the animals
that Orpheus charms
with his music are
largely peaceable and
domestic, although
there are fiercer
species also present,
but omitted from
this detail. The basic
idea is that musical
harmony, by analogy,
evokes social
harmony, even among
beings who are by
instinct incompatible.

Jacob Bouttats
(fl. c. 1675)

lizard

DITZ

Umbrian Chair
1987

● A lizard suns itself on a kitchen chair in a lush Italian garden. It is emblematic of the vitality and essential wildness of nature, even when nature has been tamed for humankind's pleasure and domestic use.

Ditz (20th Century)

CHAMELEONS FEED
on light and air
Poets' food is love
and air.

Percy Bysshe Shelley
(1792–1822)

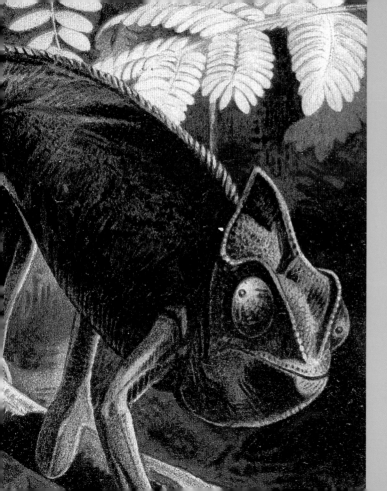

GERMAN

Chameleon
1892

● This fine color lithograph is taken from Brehm's *Lives of the Animals*. It comes from the very end of the great nineteenth-century tradition of natural history drawing, just before it was replaced by photography. Brehm was a celebrated naturalist, and the main building in the East Berlin zoo was named after him by the Communist government.

IN THE FARMYARD

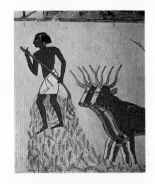

ANCIENT EGYPTIAN
Wall Painting of Oxen Threshing
Corn *14th Century B.C.*

F ARMYARD ANIMALS USED TO *be part of everyday life for most people, so it is not surprising to find more representations of them in art than any other animals. They also have profound symbolic significance. In Christianity, sheep are both Christ's flock and the Savior Himself, transformed into the Lamb of God who is sacrificed to save humankind. In other religions, the idea of a lamb, the first-born of the flock, slain as a propitiation to ward off evil is common.*

The cow, as a milk producer, is symbolic of Mother Earth; the ox (as opposed to the bull) is emblematic of peaceful strength—the Chinese sage Lao Tzu (c. 600 B.C.), the founder of Taoism, is often shown riding upon an ox.

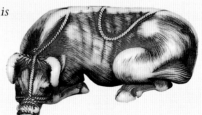

JAPANESE Ox *18th Century*

Horses, the last of the European domestic animals to be tamed, were often associated with the world of darkness, but also with that of the warrior and the liberating forces of youth. For example, in the legends of the Russian steppes—where horses were first tamed—it is the hero's horse that knows the way to the Underworld and can see in darkness. At the same time it is the horse that conquers distance, makes adventures possible, and gives the advantage of surprise in war. Even tranquil farmyard scenes often seem to present horses as being inherently nobler than the other animals.

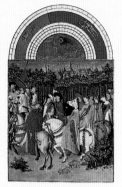

FRENCH
Book Illustration of
The Noblemen *c. 1416*

The donkey, generally regarded as stupid, obstinate, and humble, twice plays a conspicuous role in the Gospel story—at the Nativity, where it is often depicted facing the ox, as an emblem of maleficent powers kept in check by beneficent ones; and when Christ rides a she-ass into Jerusalem on Palm Sunday.

Hogs or pigs were seen as exemplars of dirt, depravity, and wickedness, and only recently as intelligent objects of affection. They are rejected by both Jews and Muslims as unclean. In China, on the other hand, the pig is sometimes regarded as an emblem of prosperity.

Rats enjoyed an even worse reputation, and their smaller cousins, mice, were scarcely better liked, although one of the many

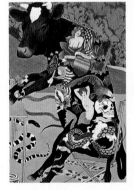

incarnations of the Greek sun god, Apollo, was a god of mice. In this role Apollo had the power to dissuade

RANDALL LAVENDER
The Ram and the Kiss
1992

mice from devouring the harvest (and was also able to control the spreading of plague and disease).

The role of rats and mice as carriers of disease seems to have been recognized in many cultures; rats were plague deities in both ancient Egypt and China.

MARIAN WINSRYG Game Room *1973*

RUPRECHT VON KAUFMANN
Wednesday I'm in Love *1997*

Farmyard birds were also endowed with symbolic significance. In many cultures for example, a rooster heralding the coming of day was seen as a protector against the evil powers of darkness. The Chinese also regard roosters as birds of good omen; in fact their word for rooster, ki, sounds very similar to the word for "favorable" or "fortunate." Geese also have symbolic meaning and are regarded as messengers between heaven and earth, or between earth and the underworld.

A newcomer to the farmyard population is the turkey, which was originally domesticated in Mexico and then imported into Europe in the early sixteenth century. It was re-exported to the northeastern United States in the seventeenth century.

INDIAN Basketry Turkey *1864*

41

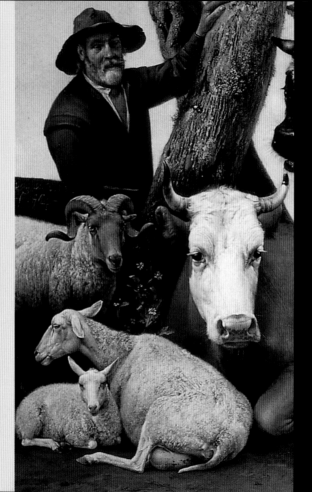

POTTER
The Young Bull
1647

● This life-sized canvas
is the most celebrated
of all Potter's works.
Spectators in the past
particularly admired
it for its naturalism.
To them the animals
seemed to be present
in the room where
the picture was hung.

Paulus Potter (1625–54)

ZURBARÁN
Agnus Dei
17th Century

● The sacrificial lamb is
a frequent metaphor, in
theological writing, for
the crucified Christ.
Zurbarán here seizes
on the metaphor
with extreme clarity,
depicting a bound and
helpless creature that
gives the image its
hallucinatory force.

Francisco de Zurbarán
(1598–1664)

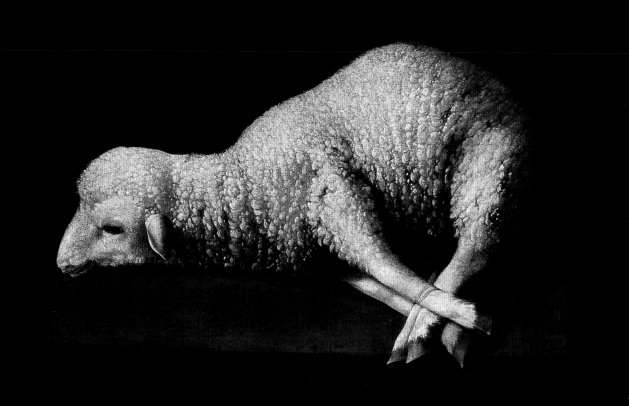

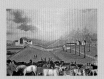

HICKS

The Connell Farm
1848

● Hicks, an American Quaker
preacher turned artist, here
takes over the conventions used
by English journeyman painters
of the late eighteenth century.
Their concern was to depict
prize animals in forms that
would satisfy proud breeders
and owners. Hicks elaborates on
this to create a utopian vision of
rural life in which humans and
beasts live in total harmony with
one another.

Edward Hicks (1780–1849)

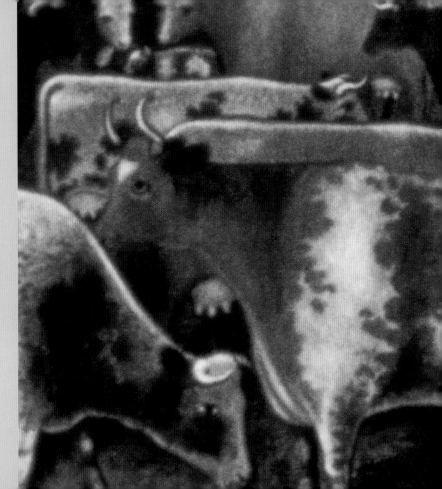

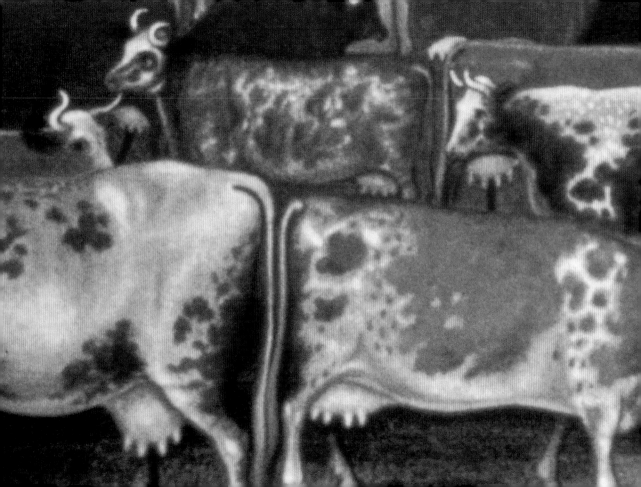

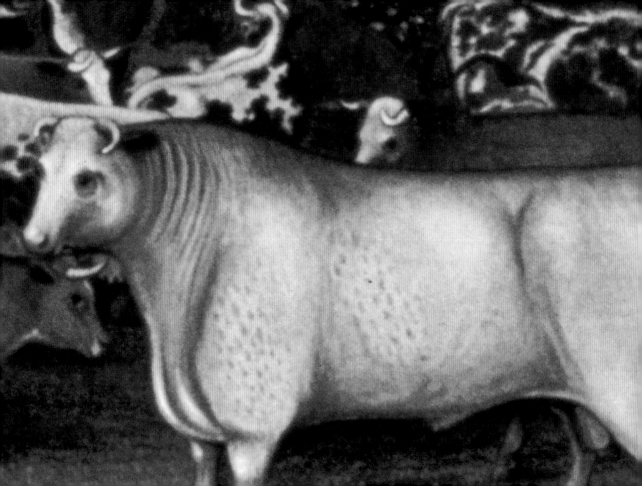

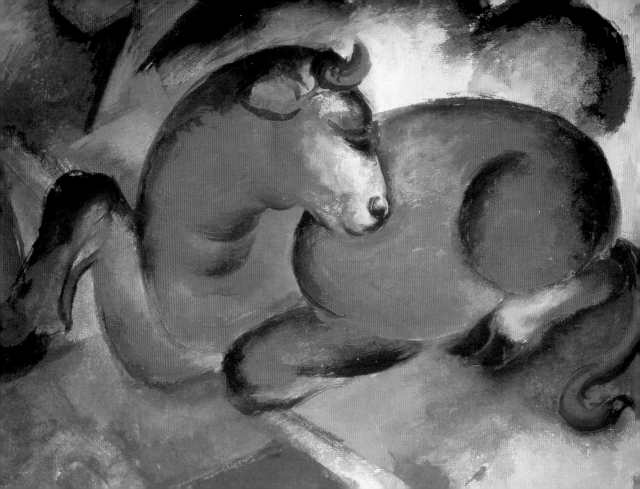

MARC
The Red Bull
1912

● Animals had a profound meaning for Franz Marc and were the subjects of his most important paintings. He shared the belief of the German philosopher Arthur Schopenhauer (1788–1860) that the animal realm symbolizes a unity with nature that human beings have forsaken. Marc's colleague and friend Wassily Kandinsky (1866–1944) spoke of Marc's "profound organic relationship with the entire animal world."

Franz Marc (1880–1916)

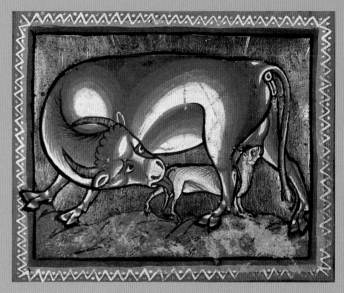

ENGLISH
Early 13th Century

● Bestiaries, popular throughout most of the Middle Ages, were collections of stories about animals, plants, and even stones. Based on the supposedly typical qualities of the animal (or other subject), these stories presented Christian allegories with improving morals. This illustration is from *The Ashmole Bestiary*.

MINOAN

Rhyton in the Form of a Bull's Head
1700–1400 B.C.

● Found in the great Cretan palace of Knossos, this drinking vessel seems to have been connected with the Minoan cult of the bull, which has come down to us in literary form in the legend of the Minotaur, the man-bull hidden in a labyrinth (the palace itself) who demanded human sacrifice, but was eventually killed.

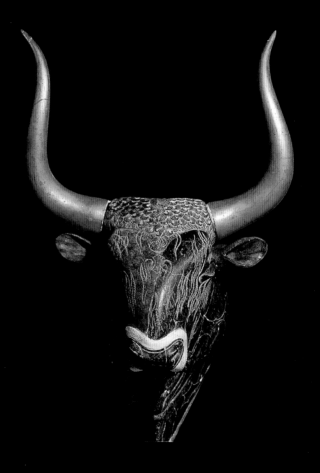

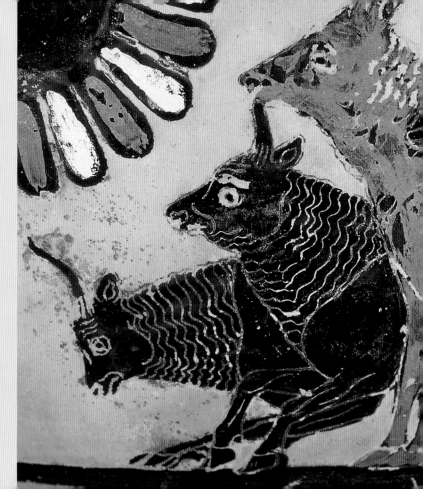

GREEK

Herd of Cattle

c. 550 B.C.

● This detail from an Attic vase painting found at Cervetri in Etruria shows the cattle stolen by the trickster god Hermes from his fellow Olympian, Apollo. Apollo had been condemned by Zeus to serve King Admetus as a herdsman as punishment for killing the Cyclopes, the giants who made Zeus's armor.

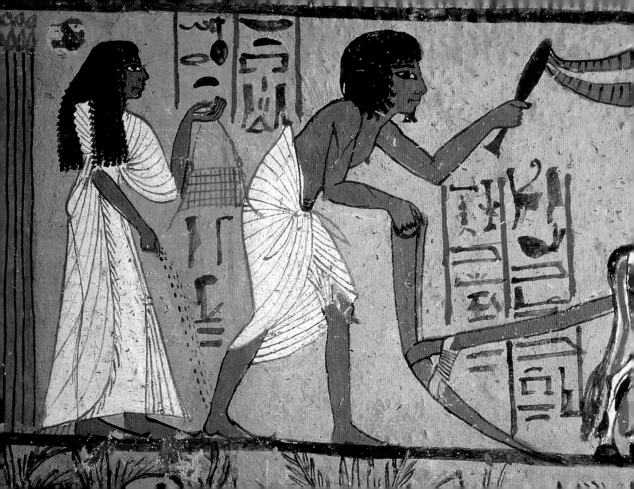



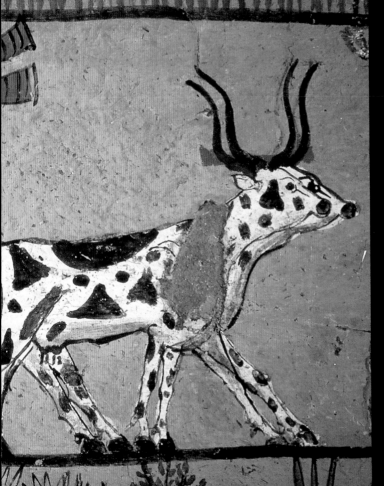

ANCIENT EGYPTIAN

Plowing with Oxen
18th Dynasty, 14th Century B.C.

● From the tomb of Sennedjem, an officia[l]
responsible for administering the royal
necropolis at Thebes, this tomb painting
illustrates the ancient Egyptian belief that [the]
afterlife would correspond, in all its details[, to]
life as it was lived on earth. The natural-lo[oking]
scene is created with an extremely limited
palette of earth colors.

> 66
>
> A HORSE IS
> *dangerous*
> *at both*
> *ends and*
> *ncomfortable*
> *in the*
> *middle.*
>
> 99
>
> n Fleming (1908–64)

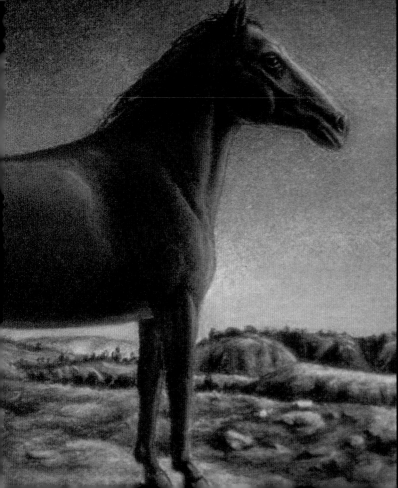

horse

GALLOWAY
Long Horse
1994

● A contemporary artist has
here taken hints from Paleolithic
painting—the earliest of all art—
which sometimes shows horses and
other animals elongated in the same
fashion. The artist has chosen a
deliberately "primitive" medium,
charcoal—drawing with what is
in effect a charred stick—to
accentuate the effect.

Steve Galloway (b. 1952)

55

DE DREUX

*Bolting Horse,
with a Greyhound
19th Century*

● By a well-known French animal painter of the first half of the nineteenth century, this is a Romantic image of freedom—a horse who has rid himself of his rider. The flying gallop attitude of horse and hound was later shown to be impossible by the scientific photographs of animals in motion made by the English photographer Eadweard Muybridge (1830–1904) in the late 1870s.

Alfred de Dreux (1810–60)

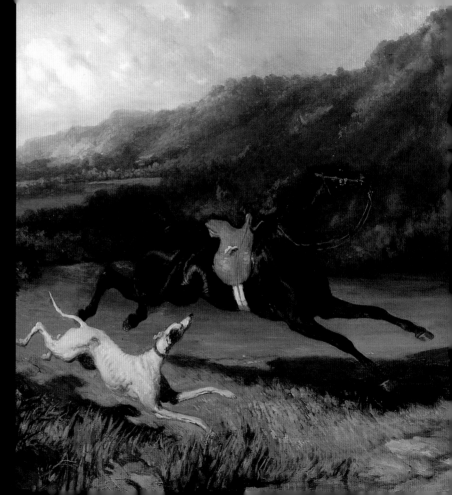

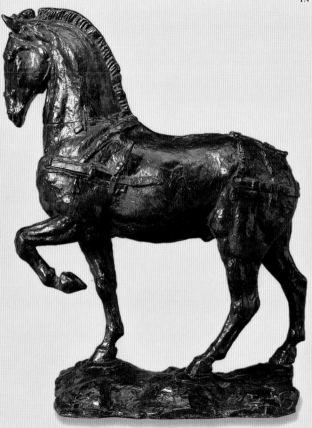

BOURDELLE

Horse without a Saddle
c. 1915

● This bronze by a leading pupil of Auguste Rodin (1841–1917) shows the influence both of Classical Greek art and of the sculptors of the Renaissance. The forms are much more stylized than those of Rodin or Edgar Degas (1834–1917), despite the liveliness of the surface modeling.

Émile-Antoine Bourdelle (1861–1929)

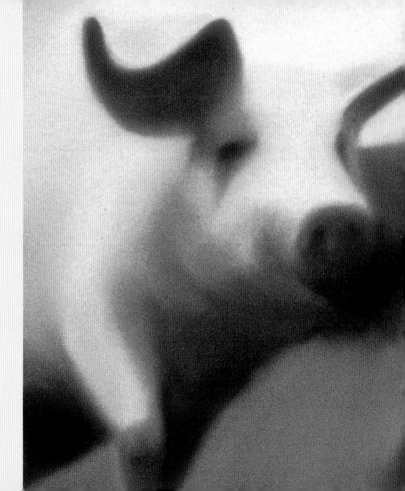

*The pig exclaimed,
on seeing the slicer:*

*'I think this world
might well be nicer!*

*Which of us, should
a vote be taken,*

*Would want to finish
up as bacon?'*

Edward Lucie-Smith

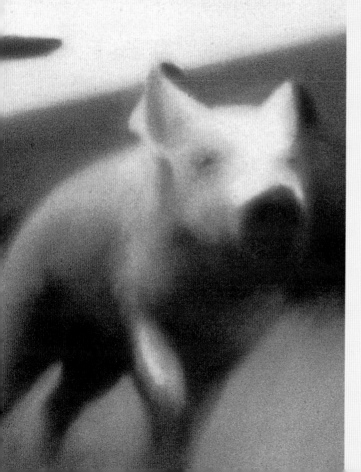

PALANKER

Two Pigs
1988

● An unexpected view of a very familiar animal, inspired by the pig races that take place at the Los Angeles County Fair. The work was part of a show entitled *The School of Velocity,* which dealt with the idea of contrapuntal movement.

Robin Palanker (b. 1950)

fowl

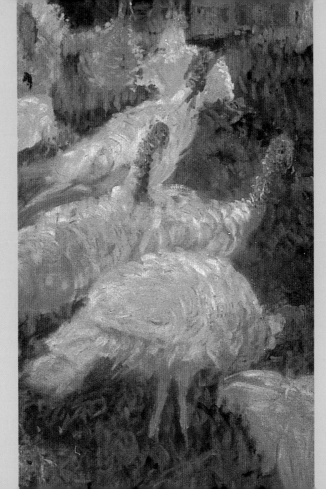

MONET

Turkeys
1877

● Painted at the height
of the Impressionist period,
this is a wholly unexpected
subject for one of France's
most important Impressionist
masters. Monet was perhaps
attracted by the pattern of
whites made by the flock
as they spread out across
the grass.

Claude Monet (1840–1926)

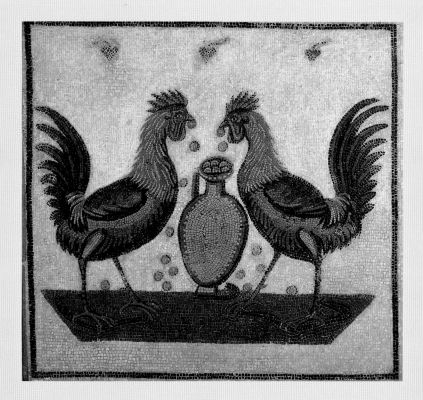

ROMAN

*Two Roosters Dropping
Coins into a Vase*
4th Century A.D.

● This late Roman mosaic
comes from North Africa.
Roosters, when associated with
coins, must be read as emblems
of Hermes or Mercury, the god
of trade, one of whose familiars
is a rooster. But Hermes was
also the messenger who
conducted the souls of the dead
to the underworld, and roosters
were sometimes thought of as
performing this function in their
own right. So there may be a
double meaning in this picture.

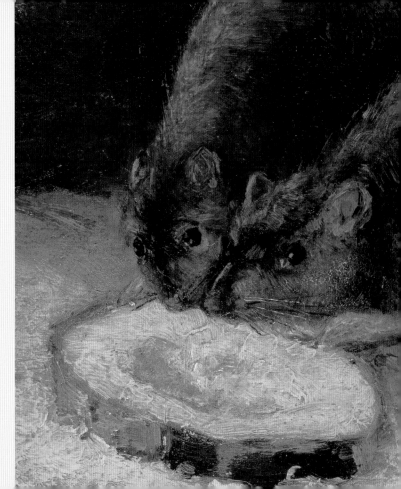

VAN GOGH
Two Rats
1884

● From van Gogh's early Dutch period of 1884–85, an intense image that shows the artist's self-identification with the hardships of peasant life in his village in Brabant. Behind it lurks a burning sense of social injustice. The rats allegorize those who exploit the poorest classes.

Vincent van Gogh (1853–90)

THE RAT IS THE
concisest tenant.

He pays no rent,——

Repudiates the
obligation,

On schemes intent.

Emily Dickinson
(1830–86)

PENG

The Traitors
1997

● According to the artist, the rats here represent "the indifference of attitudes towards cultures and the natural world. They are displayed as if they are on an examination table waiting to be preserved and catalogued. There is a sense of agony and struggle for these hapless creatures, seemingly being re-animated for understanding and ultimately, progress. In the process of understanding nature (and ultimately culture), we have rendered it sterile."

Heng Peng (b. 1971)

KIRBY

Prospect of the Sea
1988

● Kirby frequently paints figures in association with a rat, which serves as a personal symbol. Sometimes, as here, the rat is a pet or alter ego. When it appears in the same artist's work on other occasions, it seems to be dead and serves as an emblem of mortality.

John Kirby (b. 1949)

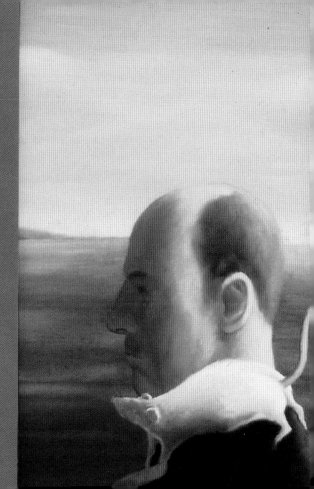

THE ENTERTAINERS

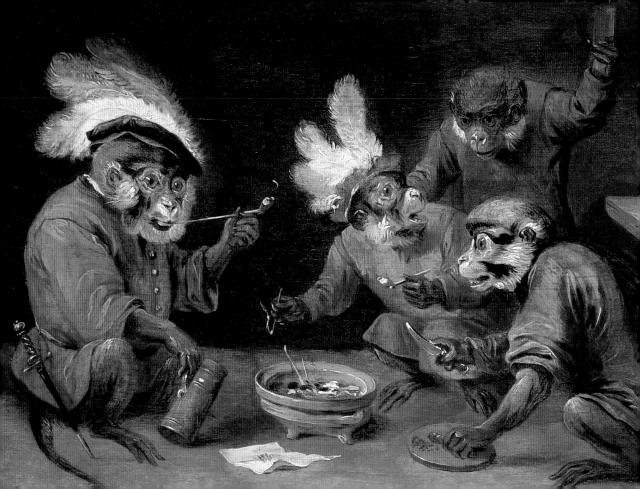

VITTORE CARPACCIO
Two Courtesans 1495

A NIMALS AS ENTERTAINERS OCCUPY *a somewhat ambiguous position in the moral cosmos. Humankind has always delighted in teaching animals to perform stunts or play tricks.*

The most spectacular instances are the animals that appear in the circus—large and sometimes dangerous beasts (such as lions and tigers) obeying the orders of their human masters, who are physically much weaker. These demonstrations of control are emblematic of the superiority of the human species, and emphasize the division between animal and people, implying that it is a fixed, immutable frontier. Meanwhile, the roars and snarls of the animal performers, and their apparent reluctance to perform, stress the thrilling precariousness of the control exercised over them by their trainers.

In other instances, the tricks performed—by trained dogs or trained monkeys, for instance—often seem like parodies of human behavior. The "superior" race laughs to see itself satirized in this way, and at the same time sentimentalizes the animal actors, endowing them with versions of human feelings.

Some tricks, however, require only that the animal remain completely passive, like the traditional rabbit that the conjurer produces from a hat, or animals in the zoo, separated from the curious by the bars of their cages.

Entertainments of this kind belong to an entirely different category from those associated with the word "sport." Such sports involving animals include those in which animals compete to see which is the speediest—horse racing, greyhound racing, and

After **LOUIS-LÉOPOLD BOILLY**
Traveling Entertainers *1801*

camel racing, for example. Since the beginning of the eighteenth century, European and North American artists have taken a particular delight in depicting the first of these sports. The sporting picture, originally commissioned to celebrate the prowess of some particularly notable animal, gradually widened its scope until, in the hands of an artist like Edgar Degas (1834–1917), it became a celebration of a particular kind of spectacle, where horses played the central role.

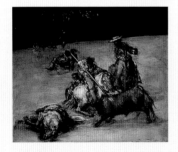

FRANCISCO DE GOYA
The Bullfight *1825*

The same could perhaps be said about another variety of sporting picture—those that depict fox and stag hunting. Here, however, it is a little difficult to think of the desperate quarries as "entertainers."

Hunting scenes in the broad sense have a long pedigree. Indeed, we can perhaps classify some of the very earliest

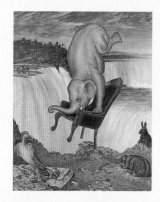

RANDALL LAVENDER
On the Edge *1995*

works of art, Paleolithic paintings on the walls of caves, in this way. Egyptian tomb paintings show wild fowl being hunted in the marshes; Assyrian reliefs depict royal lion hunts; Roman mosaics give us animal hunts in the arena.

The modern descendant of the Roman circus is not the big top of the modern circus, but the bullring, where the bloody ritual of the fight is acted out today. Bullfights, mingling human and animal courage, cruelty, and death, have fascinated a number of great artists, chief among them being the two Spaniards Francisco de Goya (1746–1828) and Pablo Picasso (1881–1973).

EDGAR DEGAS Horse and Jockey *19th Century*

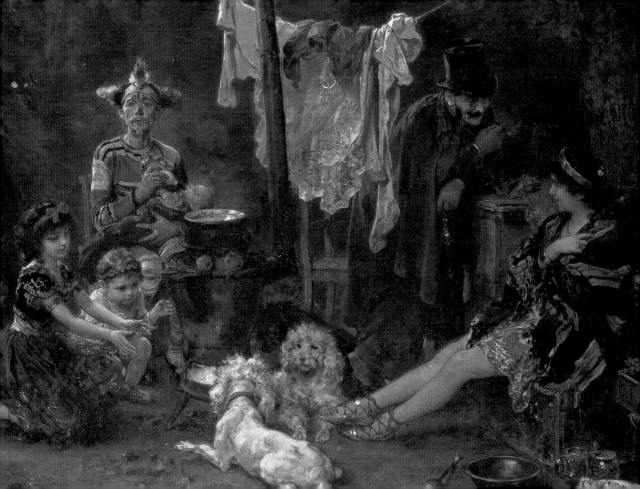

KNAUS
Behind the Scenes
1880

● This sentimental German genre scene,
dating from 1880, offers a glimpse of the
lives of the wandering mountebanks who
had already largely been driven out of
business by industrialization. At the center
of the picture are two important family
breadwinners—a pair of performing dogs.
Picasso (1881–1973) used similar subject
matter twenty years later, in the paintings
of his Blue Period.

Ludwig Knaus (1829–1910)

> 66
>
> *Thousands are collected from the*
> *idle and the extravagant for seeing*
> *dogs, horses, men and monkeys*
> *perform feats of activity, and, in*
> *some places, for the privilege only*
> *of seeing one another.*
>
> 99

Soame Jenyns (1704–87)

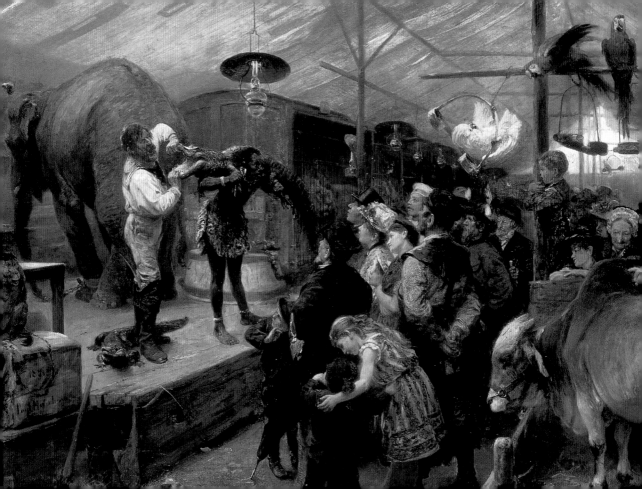

MEYERHEIM
The Animal Booth
1894

● Visitors to a traveling menagerie inspect various exotic species, among them a crocodile, whose jaws are pried open by an attendant so the visitors can admire its teeth.

Paul Friedrich Meyerheim
(1842–1915)

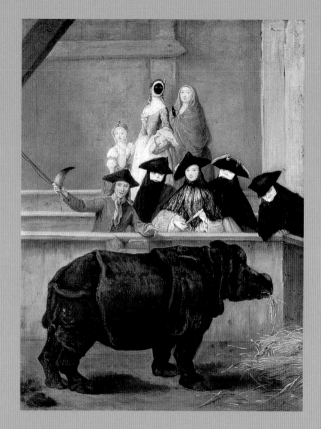

LONGHI
The Rhinoceros
c. 1751

● This famous painting, which exists in several versions, shows members of the Venetian aristocracy inspecting a rhinoceros in a showman's booth. Some are wearing the masks adopted for Carnival. These masks were originally for purposes of concealment, for example, when visiting gambling houses or carrying out romantic assignations, but were later worn as items of everyday costume.

Pietro Longhi (1702–85)

66

'WHERE ARE
you riding to?'

'Don't ask me,
ask the horse.'

99

Sigmund Freud
(1856–1939)

BROWN
The Bareback Riders
1886

● Painted in the late nineteenth
century, this work by an
American naive painter has
many affinities with the art of
Henri Rousseau (1844–1910).
It is probable that primary
sources for the artists were
the chromolithographic
prints produced in vast
quantities at the same epoch.

William Henry Brown (1808–82)

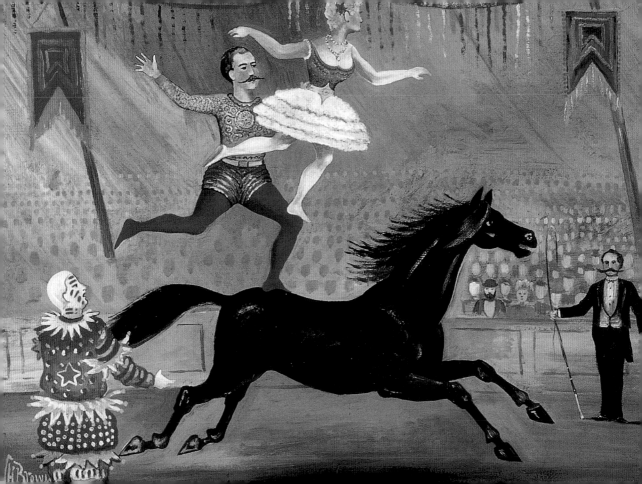

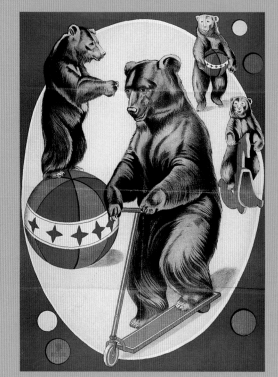

GERMAN
Performing Bears
c. 1905

● Though without text, this is evidently a poster for a traveling circus, featuring bears that ride a scooter and a rocking horse, and balance on a large ball. The poster artist successfully removes any hint of compulsion, just as he suppresses any suggestion of danger.

THEGEN
Showing a
Dancing Bear
19th Century

● The deliberately childlike style adopted by the artist cannot quite disguise the cruelty of the performance. The unfortunate bear wears a muzzle and harness, and also has a ring through its nose. The showman is an itinerant gypsy. A woman plays the tambourine to accompany the show.

Carl Christian Thegen
(1883–1955)

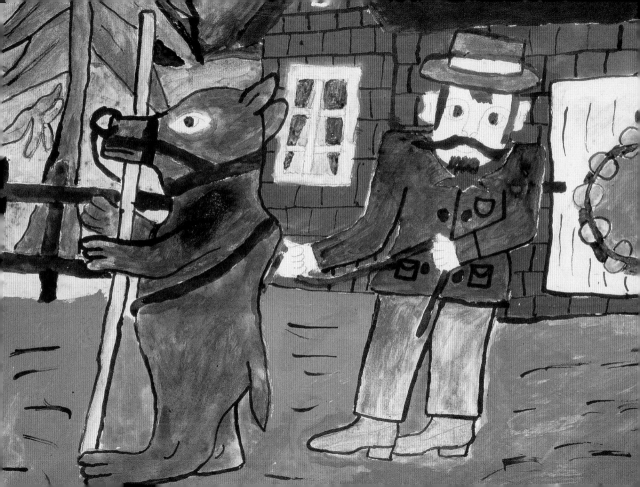

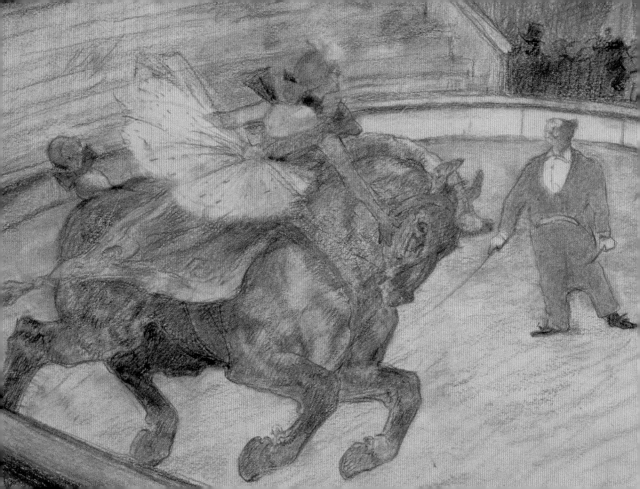

GREEK

A Racing Chariot
6th Century B.C.

● Chariot races played a prominent part at the major Greek games, and only the very rich could afford to fund teams for competitions. Races could be for chariots with two, four, or six horses. The long garment worn by the driver is the same as the one worn by a bronze charioteer at the museum at Delphi.

TOULOUSE-LAUTREC

At the Circus
1899

● This is one of a series of circus scenes created by Toulouse-Lautrec in 1899, when he was in a clinic recovering from a mental collapse triggered by the death of his mother. They were entirely done from memory, which makes their vivid immediacy all the more astonishing.

Henri de Toulouse-Lautrec (1864–1901)

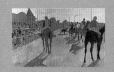

horse

DEGAS

*Horses on the Course
in Front of the Stands
1879*

● Painted in 1879, this belongs to a group of
racetrack scenes produced by Degas in the
middle period of his career, when he was
closely associated with the French Impressionist
Movement. Characteristically, Degas chooses a
transitional, non-dramatic moment—the horses
are seen not racing, but before the start.

Edgar Degas (1834–1917)

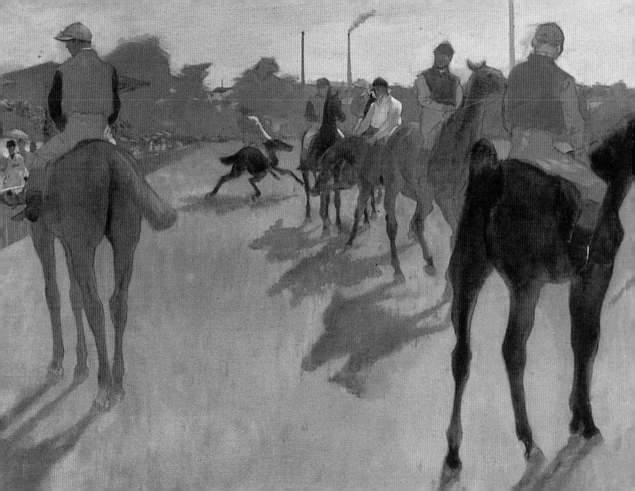

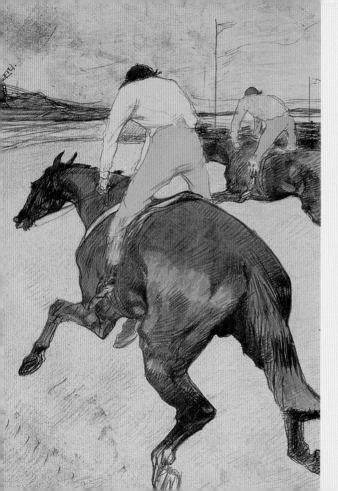

TOULOUSE-LAUTREC

The Jockey
1899

● Degas complained that Toulouse-Lautrec had "picked his pockets," and this lithograph shows why the complaint was made. It also shows the influence of Toulouse-Lautrec's first teacher, René Princeteau, a painter of military and equestrian subjects who was a friend of his family. The horses adopt the traditional flying gallop beloved by nineteenth-century sporting artists.

Henri de Toulouse-Lautrec (1864–1901)

66

There is no secret so close
as that between a rider
and his horse.

99

R. S. Surtees (1803–64)

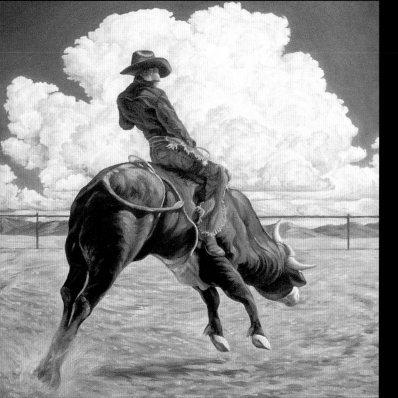

HOWE
Bull Rider
1992

● Bull riding, like
bronco riding, is one
of the traditional
rodeo sports. Riders
score points both for
their style and for
how long they manage
to stay on the bull's
back. The rider here
is dressed in full
cowboy finery, with
a pair of ornamental
chaps. The depiction
of the western
image is the
artist's trademark.

Delmas Howe (b. 1935)

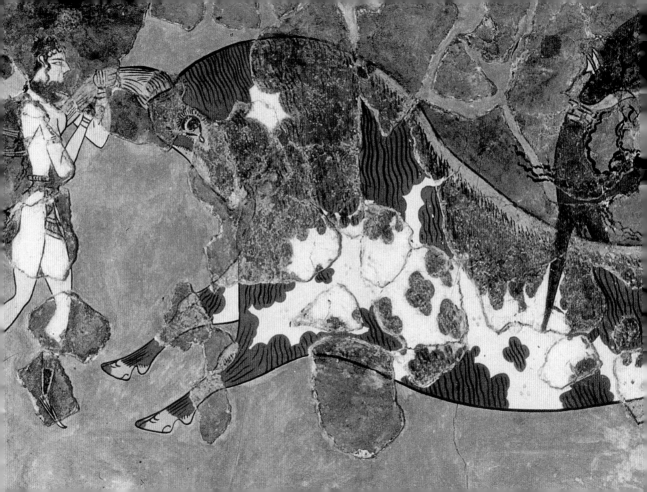

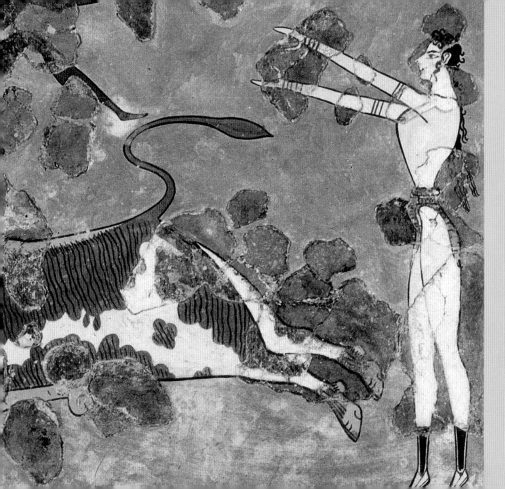

MINOAN

Bull Leaping
16th Century B.C.

● For the Minoans,
playing acrobatic
tricks with bulls,
and in particular
somersaulting over
their horns as they
charged, seems to
have been a mixture
of religious ritual
and sporting event. This
fresco comes from
the palace at Knossos,
where there was an
arena set aside for
the ceremony.

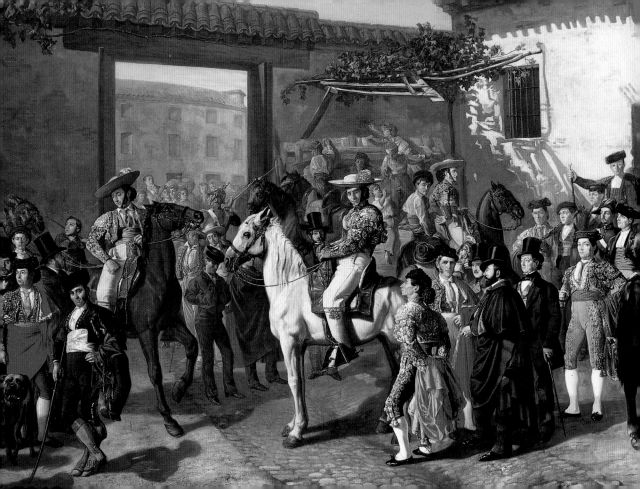

CASTELLANO

*Horsemen Waiting
to Enter the
Madrid Bullring
1855*

● Another representation
of the bullfight—this time,
the mounted picadors
and matadors on foot are
waiting to enter the ring
before the corrida begins.
A crowd of curious
onlookers is kept back by
a uniformed soldier with
a rifle and fixed bayonet.
The men in top hats are
either managers or
privileged aficionados.

Manuel Castellano (1828–80)

GOYA

*The Novillada
1779*

● A *novillada* is an event
for apprentice bullfighters in
Spain, who practiced their
skills on young bulls without
killing the animals. Goya
shows the event taking place
in a rough-and-ready way,
with only a few spectators
looking over a broken wall.

Francisco de Goya (1746–1828)

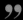

"

THE LIFE OF THE TOREROS
mingled with the lyrical
exaltation of the corrida
considered as a survival of
the ancient rites
of sun-worship.

"

Henri de Montherlant
(1896–1972)

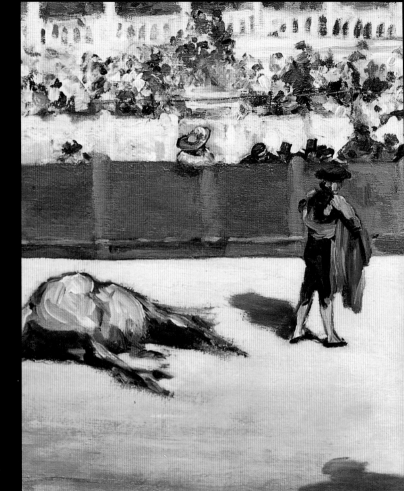

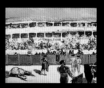

MANET
A Bullfight
1865–66

● Painted as a result of Manet's visit
to Spain in 1865, this canvas shows the
profound influence on him of Spanish
art, and in particular that of Goya
(1746–1828). Manet reported in a letter
to his friend Zacharie Astruc: "The unique
spectacle is the bullfight. I saw a superb
one and plan on my return to Paris to
put on canvas that fast-moving aspect of
that variegated assemblage of figures
without overlooking the dramatic part."

Édouard Manet (1832–83)

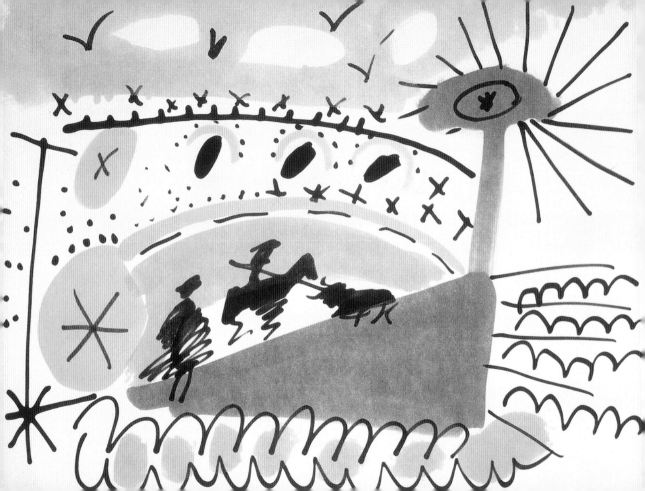

bull

PICASSO

The Corrida
1955

● Though he never returned to
Spain after the Spanish civil war
(1936–39), Picasso kept his love
of the bullfight and often attended
such events when they took place
in France. In this lithograph made
in 1955, he reduces the elements
of the fight to their very simplest
terms. The picador sticking the bull
and the matador waiting with his
cape are mere scribbles. The packed
spectators are reduced to crosses
and dots. But all the liveliness of
the event is preserved.

Pablo Picasso (1881–1973)

> **THAT SUDDEN HEAD-LOWERING,**
> *horn-rearing, quick cat-gallop*
> *that stopped your heart dead*
> *when it started.*

Ernest Hemingway (1899–1961)

WORKERS AND PETS

PIA STERN
Promise
1997

D. R. VELÁZQUEZ
The Infant Don
Fernando *1635*

IT IS HARD TO *separate beasts that are portrayed as working animals and those that are simply pets. In so many cases, the work that the animal does depends on its rapport with a human being—shepherds and sheepdogs are a team, gundogs work closely with those people who fire the guns, horses and their riders seem to be as one, as do elephants and their mahouts.*

One of the things we have to remember, when we look at the members of the animal kingdom and the way artists have portrayed them, is that the relationship between humans and animals began in circumstances where there was no room for superfluity. Animals were tamed and became part of the human tribe because of the services they provided. If they were not to be eaten, if they did not offer furs, hides, or wool for clothing, then they must help people in other ways—by carrying burdens,

INDIAN MINIATURE
Mullah Riding on a Donkey
17th Century

providing transportation, pulling plows, or guarding flocks, for example. The jobs they did often meant a degree of intimacy with human thought processes, just as human beings, in turn, learned how animals reacted to particular situations. From this, in turn, sprang a kind of identification.

This process, the product of many thousands of years of intimacy, was interrupted, and perhaps even put into reverse, by the Industrial Revolution, which began in the mid-eighteenth century. Essentially, one of the chief features of this revolution was to assign functions that had once been performed by animals to machines. As more and more of the population moved into cities, as rural occupations like farming became mechanized,

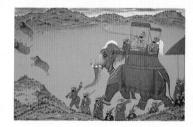

RAJA SARUPSINGH
Udaipur on a Boar Hunt *1855*

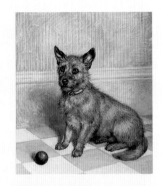

FRANK PATON
Waiting to Play *19th Century*

humans lost their sense of intimacy with the animal world because they were no longer using many species as working partners. This led to a shift in emphasis. An animal within the human sphere was no longer a partner, but a pet—that is, a creature kept for the pleasure of its company rather than its usefulness.

Today the chief domestic pets are undoubtedly dogs and cats. People who like the one are often supposed to dislike or be indifferent to the other. Dogs are seen as slavishly dependent on the whims of their masters and mistresses, cats as essentially independent. In fact, the distinction between the two species can be pushed much farther than this. One of the chief features of the canine race is the large number

M. HANZAN
Cats on the Roof *1846*

of different breeds. Some were bred specially for different tasks, but others were selected to match different aesthetic canons. The Pekingese, for example, seems to have been bred as a miniature version of the Chinese version of the lion.

Cats fall into a different category. To begin with, there are fewer breeds of cats, and they are less distinct from one another. Though the ancient Egyptians, as is well known, worshipped them, their utility to humans is less specific than that of the various breeds of dogs, though they have of course been valued for their talents as mousers. They have a much greater ability than dogs to survive on their own, as the feral cats found in cities like Venice prove. Cats seem to be valued as companions not for their apparent closeness to human ways of thinking, but for the constant reminder they provide of animal otherness.

JUDY CHICAGO
Trio from Autobiography of a Year *1993*

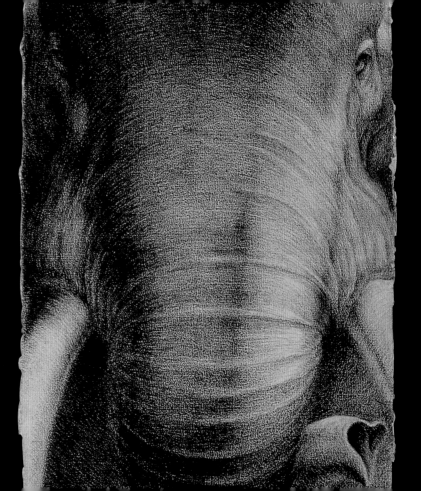

KNECHTEL
Under the Elephant
1995

● Modern wildlife photography has inevitably affected the way in which artists depict animals. It seems unlikely that an elephant would have been portrayed in this fashion before the advent of the telescopic lens.

Tom Knechtel (b. 1952)

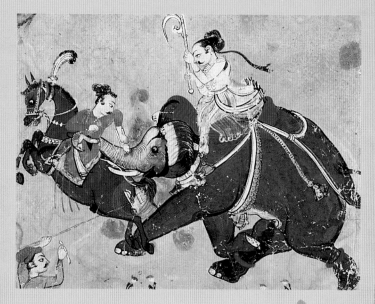

INDIAN

*Rampaging
Elephant
1675*

● Indian miniature painters always delighted in portraying elephants, which were considered the noblest of beasts and an adjunct to royal power. Here a mahout and several other attendants frantically try to control an elephant that is running wild.

elephant

elephant

MADZO
Weighty Measures
1993

● In this faintly sinister image, an elephant crushes an unidentifiable beast between two boards. The artist has used an unusual mixture of materials—acrylic (quick-drying synthetic resin) paint on paper overlaid with cotton thread.

Michael Madzo (b.1950)

ONLY AN ELEPHANT
can bear an
elephant's load.

Indian proverb

Camel

ARABIC

A Herd of Camels
1237

● An illustration to the *Maqat (Assemblies)* of Abu Muhammed al-Kassim Hariri (1064–1122). The *Assemblies* is a collection of humorous tales in which the narrator repeatedly meets the sly confidence trickster Abu Zayd as-Saruji, who on each occasion dazzles his listeners with poetic tales of his misfortunes, then disappears with the presents they have given him.

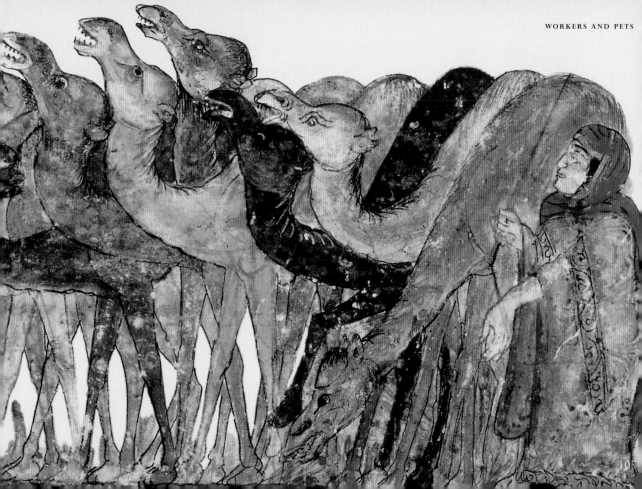

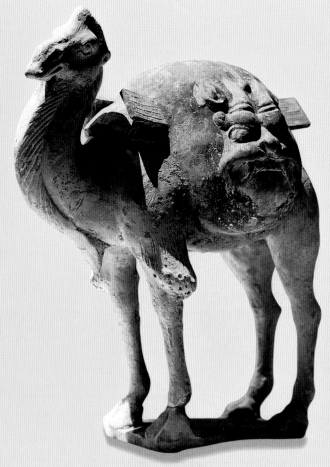

CHINESE
Camel with Pack
T'ang Dynasty A.D. 618–905

● This exceptionally fine tomb figure commemorates the busy trade across the Gobi Desert between China and Turkestan. The city of Hsian, in northwestern China, near where this figure was found, was an important entrepôt for goods.

LAZERGES
Crossing the Desert
1892

● Part of a typical late nineteenth-century Orientalist painting showing an Arab camel train crossing the Sahara. The French public's interest in subjects of this type was aroused by the French conquest of Algeria.

Jean-Baptiste-Paul Lazerges (1845–1902)

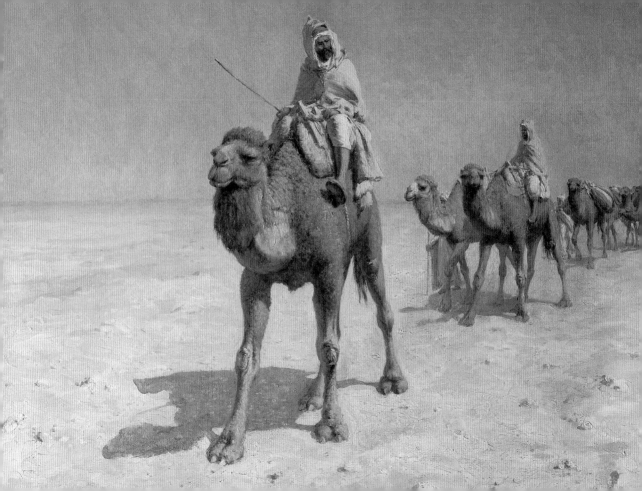

MARC

The Leaping Horse
1912

● Another of Franz Marc's
mystical renditions of animals.
In a letter to a friend written
in December 1908, he said:
"I am attempting to enhance
my sensibility for the organic
rhythm that I feel in all things;
and I am attempting to feel
pantheistically the rapture of
the flow of 'blood' in nature,
in the trees, in the animals,
in the air."

Franz Marc (1880–1916)

> **A HORSE! A HORSE!**
> *My kingdom for a horse!*

William Shakespeare (1564–1616)

INDIAN

*Indian Prince
Speaking to a Dervish
Mid-17th Century*

● The prince in this miniature is almost certainly Dara Shikoh, the expected successor to his father Shah Jahan (1628–58), who was defeated and later executed by his brother Aurungzab in 1659, in the concluding stages of the succession struggle between four of the emperor's sons. The miniature, in the finest Mogul court style, shows the prince, mounted on a white horse, halting respectfully to speak to a dervish (a wandering holy man).

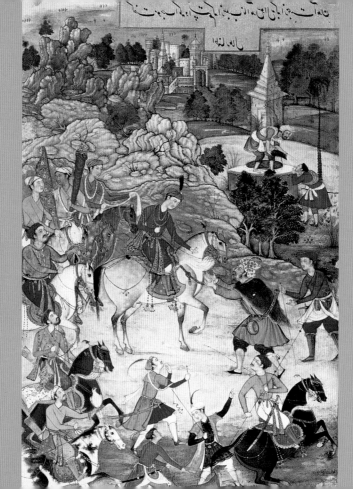

ARABIC

A Procession at the End of Ramadan
1237

● The illustrations to this manuscript were made very shortly before the Mongols under Genghis Khan took Baghdad in 1258 and overthrew the Abbasid Caliphate (the spiritual leadership of the Arab world). Here a group mounted on horses and mules marks the end of the annual Muslim fast of Ramadan, a familiar spectacle in Baghdad at this time.

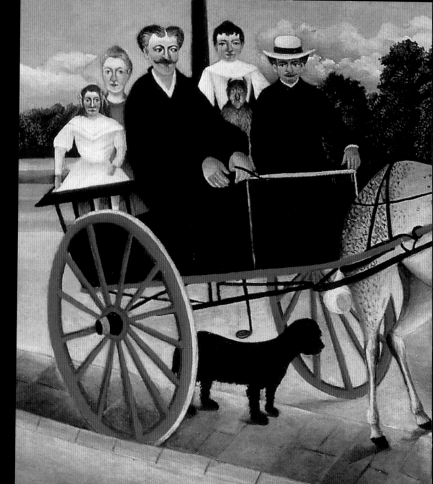

66

There are no handles
to a horse, but the
1910 model has a string
to each side of its
face for turning its
head when there
is anything you
want it to see.

99

Stephen Leacock (1869–1944)

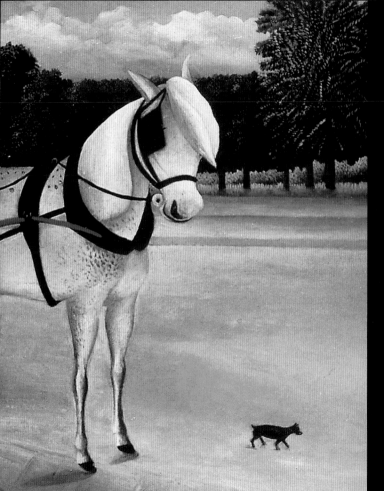

ROUSSEAU

The Cart of Father Junier
19th Century

● Not all of Rousseau's subjects are exotic.
A large number of his paintings, though
usually the less ambitious ones, are attempts
to render what life he saw around him.
Light, two-wheeled carts of this type were
popular vehicles in the country rather than
in town. Because dogs were trained to run
beneath them, as shown here, they were
often described in English as dogcarts.

Henri Rousseau ("Le Douanier") (1844–1910)

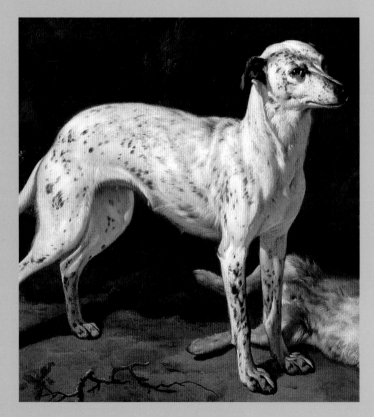

WEENIX

*Dog Standing by
a Dead Hare*
17th Century

● Weenix is one of
the great Dutch still-life
painters of his period,
and although still lifes
often feature animals,
this is an unusual work
for him. It is clearly
meant to commemorate
a favorite dog used
for coursing hares.

Jan-Baptist Weenix
(1621–63)

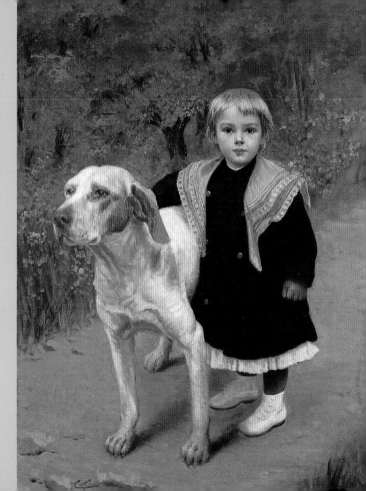

TORRO

Child with a Hound
19th Century

● The dog the child is embracing appears to be a foxhound—in which case the picture can be seen as a tribute to the Anglophilia that swept European, and in this particular case Italian, artistocratic circles in the late nineteenth and early twentieth centuries. Despite the apparently female dress, the child is probably a boy.

Luigi Torro (1836–1900)

dog

> ❝
>
> ## COWARDLY DOGS BARK LOUDEST.
>
> ❞
>
> John Webster (c.1580–c.1625)

LEVIEUX

Still Life with Macaw, Squirrel,
and Two King Charles Spaniels
17th Century

● As much Spanish as it is French, this still
life celebrates an aristocratic lifestyle. Squirrels
had long been domesticated as pets and appear
in this role in fifteenth- and sixteenth-century
portraits. The macaw is an expensive exotic
import. Miniature spaniels were also favorites
with aristocratic women because of their small
size and docile natures.

Attributed to Reynaud Levieux (1613–after 1694)

GOYA

Boys with Mastiff
18th Century

● Mastiffs are one of the oldest known breeds of dog—visual records of them go back to 3000 B.C. Though used for bull- and bear-baiting, they are gentle and good with children, despite their size. Sir Anthony Van Dyck (1599–1641) painted the children of Charles I with a mastiff, and Goya's painting may allude to this.

Francisco de Goya (1746–1828)

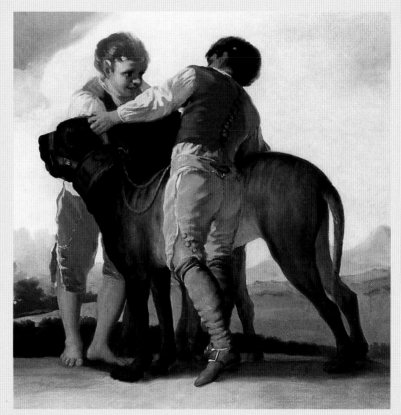

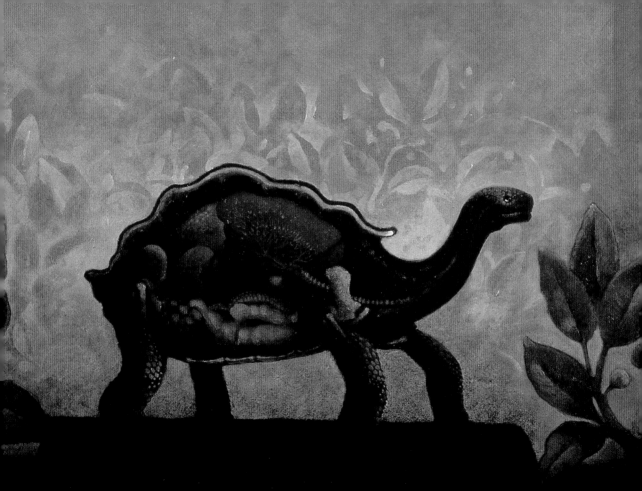

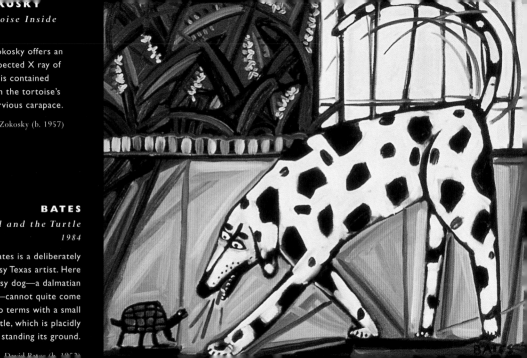

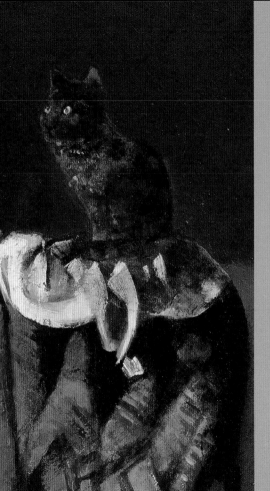

cat

BALTHUS

Girl with Cat
1989–94

● Balthus once portrayed himself as the "King of the Cats," and a large part of his subject matter throughout his career has been pubescent girls. Here, in a late work, the two themes are combined. The girl, enraptured, looks at herself in a hand mirror, and the cat, somewhat sardonically, gazes at her.

Balthus (Balthasar Klossowski de Rola) (b. 1908)

WARHOL
Cat
1982

● An atypical but
rather endearing example
of Warhol's art. However,
Warhol, with his sharp eye
for commercial success,
was undoubtedly aware of
the fact that it is always
easy to sell images of cats.
The image is a silkscreen.

Andy Warhol (1928–87)

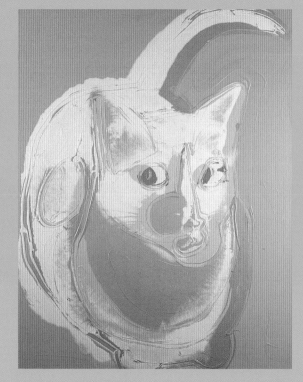

PICASSO
Cat Catching a Bird
1939

● This harsh image is one of a
series of paintings that reflect
Picasso's unease concerning the
world situation in the year in
which it was painted.

Pablo Picasso (1881–1973)

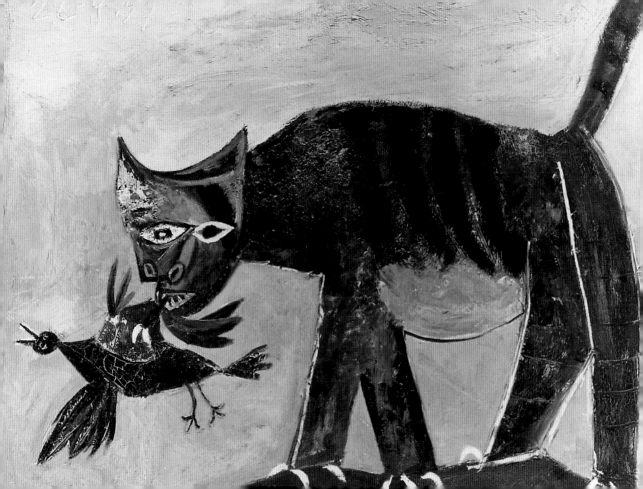

mostly
she lays around
waiting to have her
Ears
scratched

CHICAGO
Cat Family # 1
(from Autobiography of a Year)
1993

● The feminist artist Judy Chicago is a
devoted cat-lover. This portrait of Inka, one of
her family of cats, comes from a very personal
series of annotated diarylike drawings that are
reflections on her life in New Mexico.

Judy Chicago (b. 1939)

FOUJITA
Cat
1947

● Foujita was a Japanese-born artist who settled in
Paris during the early Modernist epoch. His technique
mixed Western and Japanese influences. This ink-
painting, done entirely with various hues of ink and
executed with the point of a fine brush, is one of a
large number devoted to the theme of cats.

Tsugouharu Foujita (1886–1968)

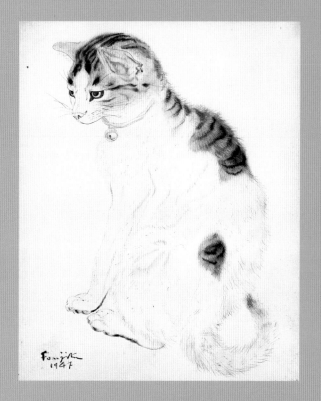

CREATURES OF THE AIR

WALTER LEISTIKOW
Swans
19th Century

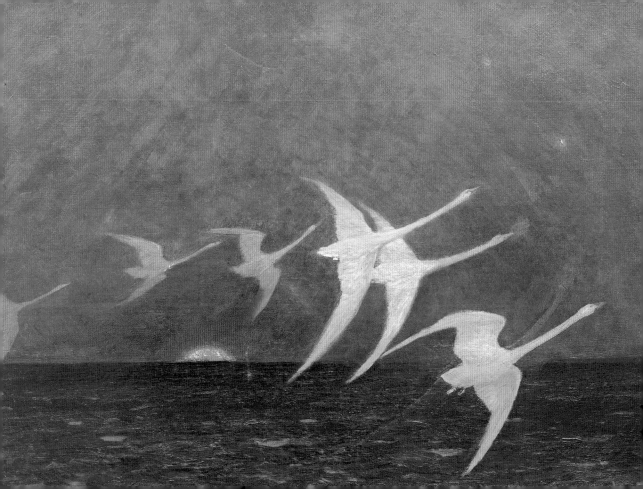

ZOO

B IRDS HAVE LONG BEEN *thought of as magical or legendary creatures. In many cultures they are seen as the embodiment of higher forms of being. They are links between the earthly and the heavenly spheres, bearers of omens, messengers of the gods.*

ROBIN PALANKER
Scrutiny 1996

The eagle is universally considered the noblest of all birds—variously the attribute of Zeus (the ruler of the gods), the Roman emperors, and Christ. As an emblem of contemplation, a creature that can stare directly at the sun, it is also the symbol of St. John, the most mystical of the four gospel writers.

Almost equal in prestige to the eagle is the swan, which in legend has a curious hermaphroditic quality. Sometimes, as in the ballet Swan Lake, *they are beautiful maidens in another guise; or they are an emblem of*

JAPANESE Vase *17th/18th Century*

male, solar energy. For example, the Greeks thought of the male swan as a companion of the sun god Apollo, and Zeus turned himself into a swan in order to impregnate Leda, who gave birth to Helen (who was a cause of the Trojan War).

Other birds frequently represented in art are the dove, the peacock, and the pelican. The dove bringing the olive branch back to Noah in his Ark was a symbol of the renewal of the covenant between God and the human race; later it became the universally accepted emblem of the Holy Spirit. Christians also made a pair of doves the emblem of fidelity in marriage. In classical mythology, doves were the birds of Aphrodite, the goddess of love, and the decorative image of doves drinking from a vase, often found in Roman mosaics and frescoes, was symbolic of lovers drinking from the fountain of memory.

FRENCH Illustration from the
*Book of Hours of Antoine le Bon,
Duke of Lorraine 1533*

J. WALTER The Birds *16th Century*

The peacock, now commonly seen as an emblem of vanity, was originally seen as a solar symbol, because of the way it spread its tail in the shape of a wheel. It was also, perhaps paradoxically, seen as an emblem of the starry night sky.

The pelican, erroneously supposed to feed its young on its own flesh and blood, became an emblem of parental affection. Because people thought it wounded itself in the heart in order to nourish its young, it was also used as a symbol of Christ.

Many other birds also have legends attached to them. The woodpecker, for example, is the bird of the god of war, Mars, and was believed by the Greeks and Romans to have prophetic powers. It was

GALOYER Marabou *20th Century*

also the woodpecker that flew with food to the cave where the twins Romulus and Remus, the founders of Rome, lay hidden.

ANTONIO DA NEGROPONTE
Detail of a Bird from Mary and Child *1470*

Flightless birds, like the ostrich and the dodo, have enjoyed a considerably less glamorous reputation.

The ostrich, which is native to southern Africa, became known to Europeans only at the end of the fifteenth century. It tends to be associated with stupidity, having acquired such a proverbial reputation because, when danger threatened, it would stick its head in the sand (or so it is said).

The docile dodo, native to Mauritius, was first seen by Europeans around 1507 and was extinct by the 1600s, hunted to death by sailors in search of provisions. "Dead as the dodo" became a proverbial phrase soon after.

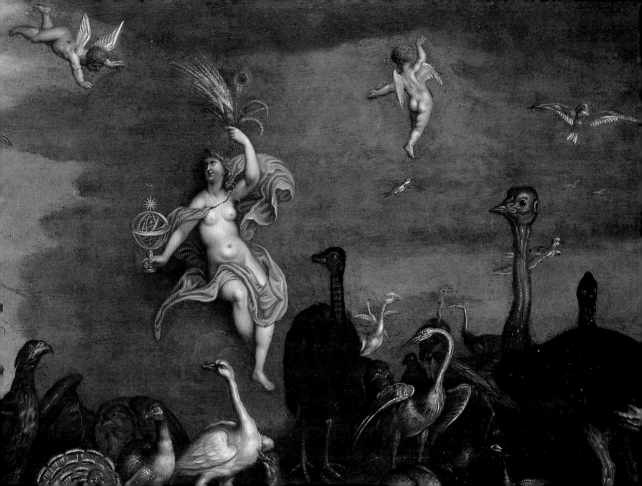

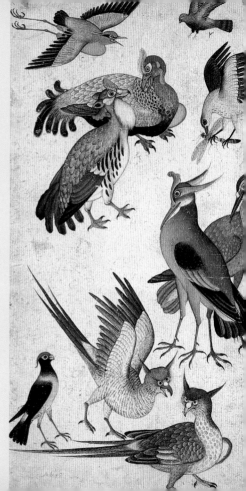

BOET

Allegory of Air
17th Century

● From a set of Flemish paintings representing the Four Elements—earth, air, fire, and water. The goddess is Juno, characterized as such by peacock's feathers. One notable feature is a cassowary from Australia—perhaps one of the earliest representations of this bird in European art.

Pieter Boet (1622–74)

MOGUL

Ten Birds
c. 1590–1600

● This is an early Mogul miniature, made in the reign of Akbar (1556–1605), who was himself a trained painter. All the Mogul rulers took a keen interest in the beauty of the natural world, and leaves of this sort, with no narrative, were collected in large miscellaneous albums that featured portraits as well as animal studies. Among the birds shown are rare eared pheasants from Tibet.

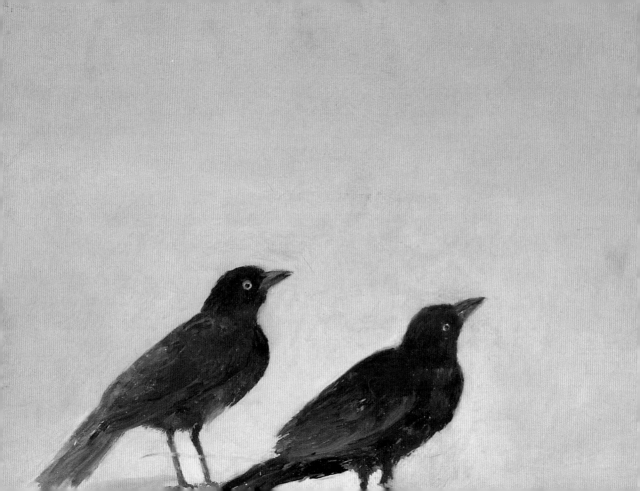

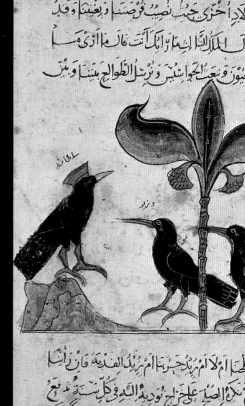

ARABIC
Council of Ravens
c. 1350

● Arabic literature has its share of beast fables, and this is an illustration to one of them. The idea that birds and animals behave in a quasi-human way seems to be deeply implanted in the human psyche.

SANCHEZ
Two Black Birds
1995

● This painting shows the influence of the senior West Coast artist Morris Graves (b. 1910), whose work, in turn, shows strong affinities with Asian art. Many American artists have followed Graves' example in preaching unity with nature.

Stephanie Sanchez (b. 1948)

SERRANO

The Scavenger
1993

● An effective image of a
crow picking at a dollar bill
which summarizes an ironic
ecological consciousness.
Serrano has artfully
simplified the bird's form,
leaving only the essentials.

Luis Serrano (b. 1955)

CHINESE

Legend of the Nine Suns
Han Dynasty 200 B.C.–200 A.D.

● A detail from a Han scroll painting found in a tomb in Hunan. A blackbird or raven is seen silhouetted against the blazing orb of the sun. The sensitive handling of outline and keen observation of natural forms show that the Chinese love of nature was already fully established at this very early period in Chinese history.

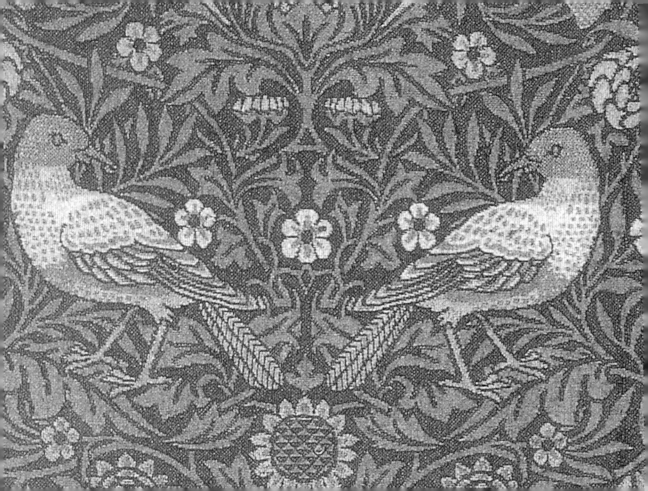

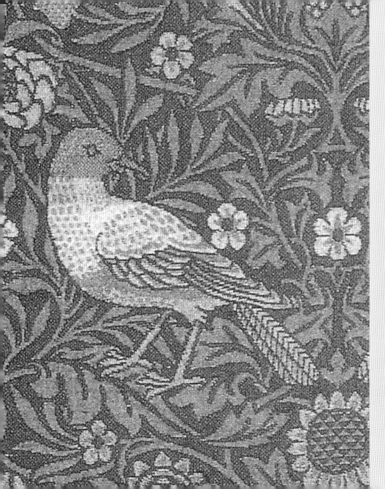

66

NEAR ALL THE BIRDS
Will sing at dawn

99

Elizabeth Barrett Browning
(1806–61)

MORRIS

Bird (from a
Woven Wool Double Cloth)

● Morris & Co. was a firm of
prolific British pattern designers.
The heraldically confrontal birds
seen here derive from Byzantine
and medieval fabrics showing
confrontal birds and beasts.
However, Morris, while stylizing
the foliage that surrounds them,
gives his birds a much greater
degree of naturalism than can
be found in his exemplars.

William Morris (1834–96)

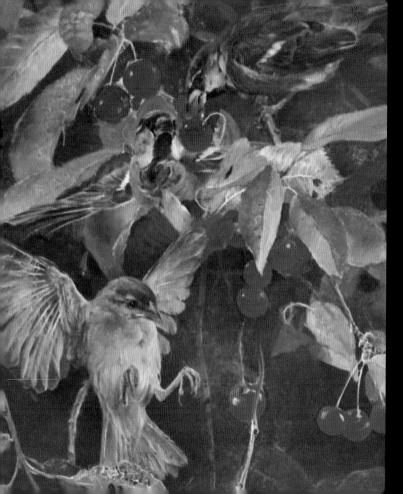

LILJEFORS

Sparrows in a Cherry Tree
1885

● Typical of late nineteenth-century
Scandinavian taste, this depiction by a
Swedish artist combines simplicity, sharp
observation, and conscious restraint. A
comparison can be made with the traditional
bird and flower paintings of Chinese art.

Bruno Andreas Liljefors (1860–1939)

> They quarrel as the light
> Awakes them, and they curse
> At the approach of night.
> They hate the universe.
> And so perhaps they
> are just
> Echoes of our own life,
> Fluttering there in
> the dust,
> Perpetually at strife.

Edward Lucie-Smith

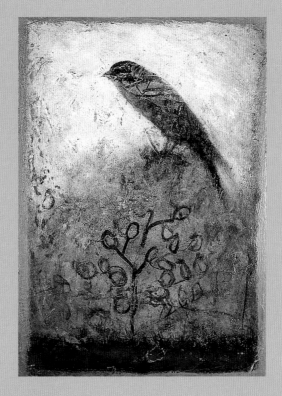

birds

MUSANTE

Bird / Red Stripe
1993

● A linnetlike bird
completely dwarfs the tree
it perches in. The disparity
of scale seems to symbolize
the intensity of the artist's
interest in the bird itself
rather than its surroundings.

Ed Musante (b. 1942)

GAUGUIN
Geese and Goslings
19th Century

● This charming album page belongs to Gauguin's Breton period in the late 1880s. The careful stylization and simplification of the forms of the birds reflects the influence of Japanese art, which had a great impact in Europe at this time.

Paul Gauguin (1848–1903)

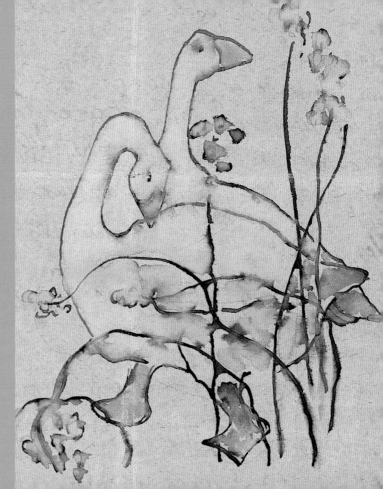

duck

MOGUL

Drake at a Lake
c. 1633–42

● This Mogul miniature
shows the eclecticism of
Mogul art. The drake and
the waterlily in front of it
clearly owe a good deal to
Chinese painting.

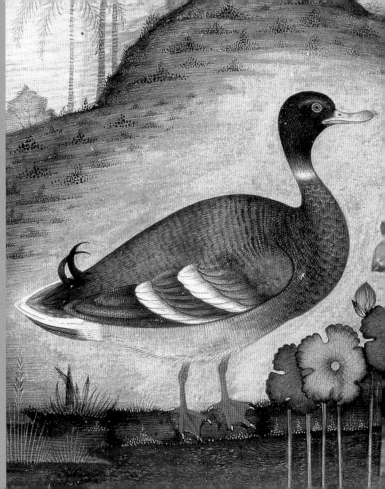

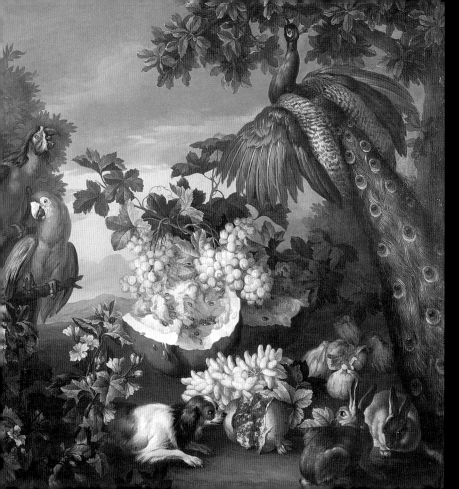

MONNOYER

*Fruit and Exotic Birds
in a Landscape*
17th Century

● The chief aim here is
decoration, rather than
symbolism or allegory. The artist
has assembled all the sumptuous
things he can think of: flowers,
fruits, a peacock and macaws.
Monnoyer is the best known
French specialist in rich
decorative composition
of this type.

Jean-Baptiste Monnoyer (1636–99)

POOR

Macaw and the Moon

1997

● This is a painting in enamel on metal. The technique the artist uses seems wonderfully well-suited to the mystical atmosphere she wants to evoke, since it allows her to create both the intense colors of the bird in the foreground and the ethereal quality of the figure symbolizing the moon in the background.

Kim Poor (20th Century)

parrot

"

REMEMBER THAT THE *most beautiful things in the world are the most useless; peacocks and lilies for instance.*

"

John Ruskin (1819–1900)

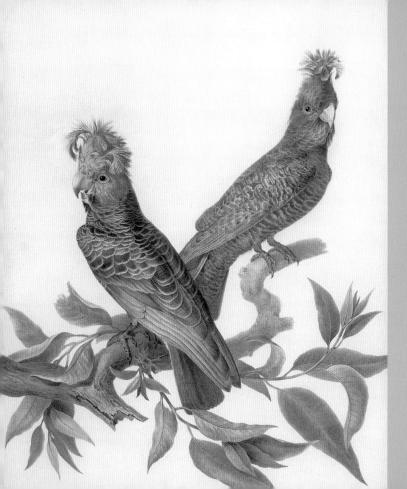

BESSA
Grey Cockatoos
18th Century

● Bessa was one of a long series of artists who painted flowers, animals, and birds in gouache (opaque watercolor) on vellum. The aim was to make a quasi-scientific record, but the artists were also very aware of the decorative potential of their subject matter. Usually kept in albums, many of these drawings survive in a wonderfully fresh state.

Pancrase Bessa (1772–1835)

parrot

"

THE PARROT IS A THIEF.

No word

Is safe in earshot

Of that bird.

"

Edward Lucie-Smith

BOGDÁNY

Scarlet Macaw in a Landscape
17th Century

 Bogdány's paintings survive in many large
country houses. English patrons of the late
seventeenth and early eighteenth century
preferred portraits, and works of this kind were
usually adjuncts to larger decorative schemes.
This one is unusual, since it seems to have been
produced as a work of art in its own right.

Jacob Bogdány (c.1660–1724)

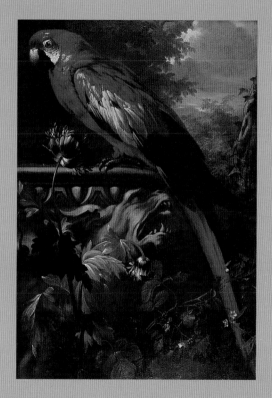

149

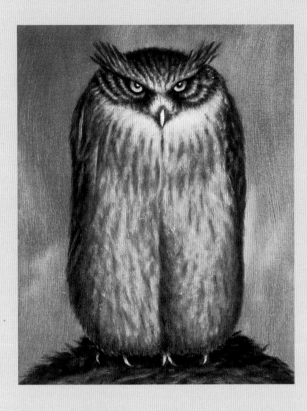

> *Alone and warming*
> *his five wits,*
>
> *The white owl in*
> *the belfry sits.*

Alfred, Lord Tennyson
(1809–92)

BLECKNER
Mantle
1988

● Bleckner is fond of making mystical compositions of this type. Here an owllike creature, perhaps derived from the lithographs of the great Symbolist Odilon Redon (1840–1916), manifests itself above a burning brazier and seems created from its fumes.

Ross Bleckner (b. 1949)

LAVENDER
Owl
1992

● Owls have long been favorite subjects with artists, because the owl is a traditional symbol of wisdom. This is a successful rendering of the creature's personality, and also of its strangely monumental form.

Randall Lavender (b. 1956)

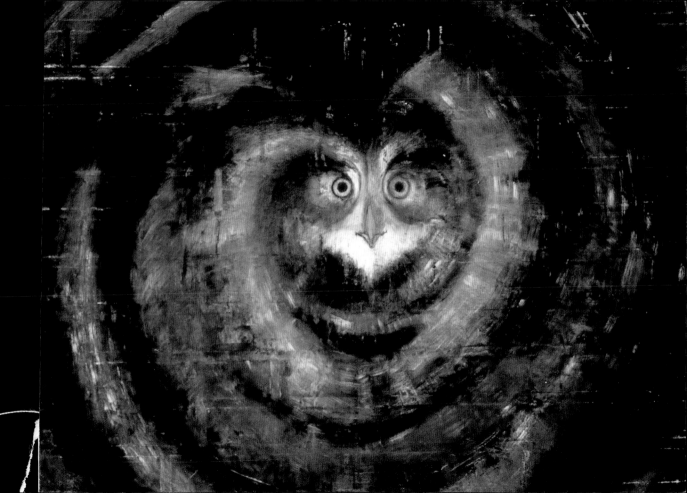

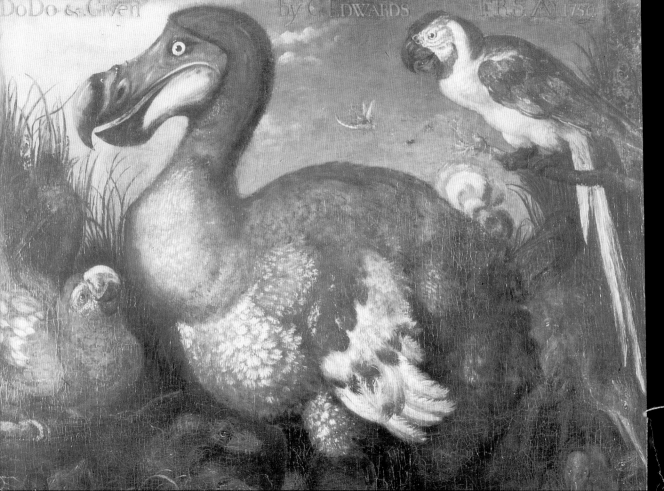
DoDo & Given by C. Edwards F.R.S. AN 1759.

THE DODO WAS

(perverse distinction)

Immortalized by

his extinction.

Edward Lucie-Smith

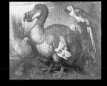

EDWARDS

Dodo

1759

● Edwards is perhaps the
best-known specialist painter of
birds of the late eighteenth
century, but it is certain that he
never saw a live dodo, since the
species was extinct by the 1680s.
This painting, dated 1759, was
done using earlier prints, and
perhaps the skins and bones of
the bird taken back to Britain
by sailors.

George Edwards (1694–1773)

WATER WORLD

PETER ZOKOSKY
Serpent
1989

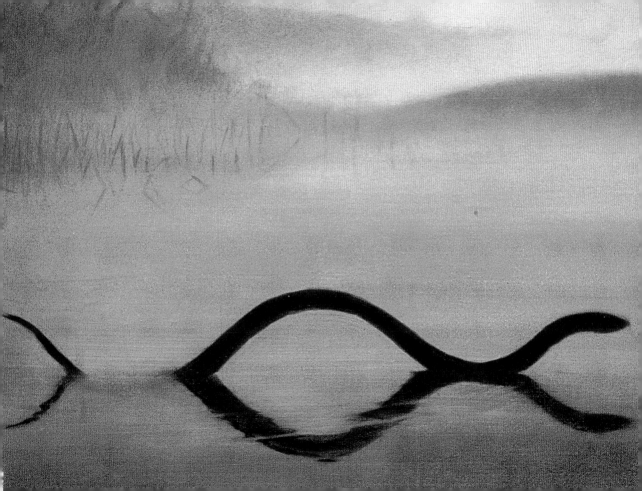

Fish, both freshwater *and saltwater varieties, plus crustaceans such as lobsters and* crabs, traditionally formed an important part of the repertoire of subjects used by painters of still life. These still lifes were already being created by the artists of classical antiquity, and returned to fashion in the seventeenth and eighteenth centuries, where they were especially favored by artists working in

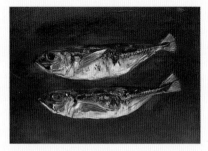

STEPHANIE SANCHEZ
Mackerel/Red Ground *1993*

places with strong maritime connections: in the Netherlands and in Naples, at this time the most important seaport in the Mediterranean.

In European paintings lobsters are always the bright pink color that indicates they have already been boiled

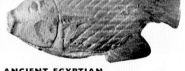

ANCIENT EGYPTIAN
Fish of the Nile *1070–525 B.C.*

and are ready for the table. In this guise a lobster often forms the centerpiece for a sumptuous Dutch "banquet-piece," and is shown surrounded by precious silver and porcelain as a celebration of bourgeois prosperity and the wealth brought by overseas trade. Live lobsters are seldom represented, except by Japanese artists, who have a liking for lobsters and also for crayfish.

GERMAN Book Illustration from Brehm's *Tierleben 1893*

Although fish in art are most often represented in groups, the crab sometimes appears as an independent subject. This is because the crab, Cancer, is one of the twelve signs of the zodiac. Another such sign is Pisces, a pair of fish usually shown swimming in opposite directions to each other to indicate the contradictory nature of the Piscean temperament. But the exact species of these fish is never specified. Even more generic and abstract is the fish that appears as a Christian

emblem, so used because its Greek name, ichthus, *formed an anagram for a declaration of faith:* Iesu Christos Theou Uios Soter—"Jesus Christ God's Son Savior."

Other sea creatures endowed with emblematic significance are the dolphin, the turtle, the whale, and the sea-serpent, though the sea-serpent is perhaps better categorized among fantastic or mythological creatures.

The dolphin, sometimes spoken of in ancient legends as the guider of boats and

rescuer of drowning sailors, became a generalized symbol of salvation. In emblem books it is sometimes shown twined around an anchor, another symbol with the same sort of meaning. The conjunction of the two can, however, be interpreted in a different way: the anchor restrains the dolphin's playful impulsiveness, and the two placed together symbolize the value of prudence.

GREEK Vase Painting of
The Sea Voyage of Dionysus
c. 550–10 B.C.

The turtle is regarded in Asia, and particularly in China, as an image of the cosmos, with a shell that is rounded on top to represent heaven, and flat underneath to represent the earth. The whale is also a symbol of the cosmos and, as in the familiar story of Jonah, plays a part in myths of death and resurrection.

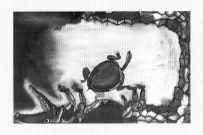

FRANCISCO TOLEDO
Lagarto y Tortuga *1987*

Among river-dwelling animals, the two most prominent in art are the hippopotamus and the crocodile, in both cases largely because of their significance for the ancient Egyptians. In Egyptian hieroglyphs, for example, the hippopotamus was the sign for strength and vigor. On the other hand, the crocodile was an object of terror, since, as Sobek, he was the devourer of unrighteous souls.

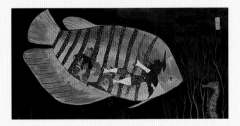

LUIS CHAN Sea Horse Meeting a Fish *1978*

159

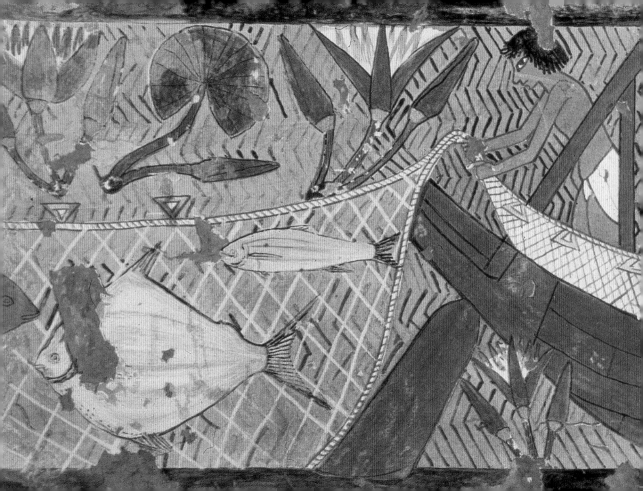

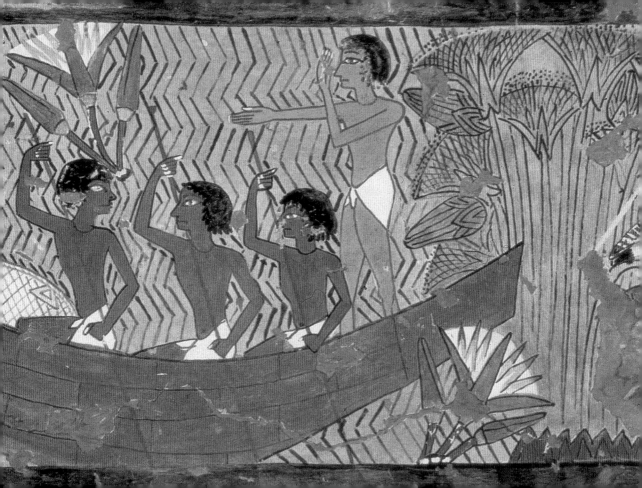

ANCIENT EGYPTIAN

Fishing in a Papyrus Thicket
c. 1000 B.C.

● The ancient Egyptians were
clearly fond of fishing as a pastime,
and tomb paintings often show
fishing and bird-snaring in the
papyrus thickets of the Nile delta.
Here both occupations are shown—
fish are being netted on the left, and
birds are flying into a bird trap, also
made of netting, on the right.

66

HAPPY, THEY LEAP
Out of the surface
Of waves reflecting
The sun fragmented
To broken glass
By the stiff breeze
Across our bows.

99

Stephen Spender (1909–95)

fish

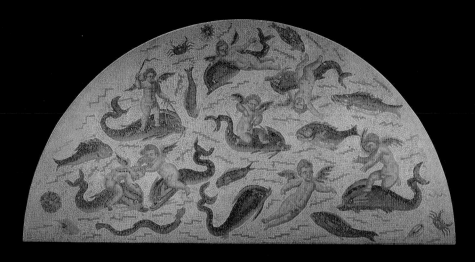

ROMAN

Cupids and Dolphins
2nd Century A.D.

● Since Venus was reputedly born from sea foam, both cupids and dolphins—shown in this Roman mosaic—are her emblems. Dolphins were in any case thought of as friends of humanity because of legendary accounts of shipwrecked mariners being rescued by dolphins and carried safely to shore.

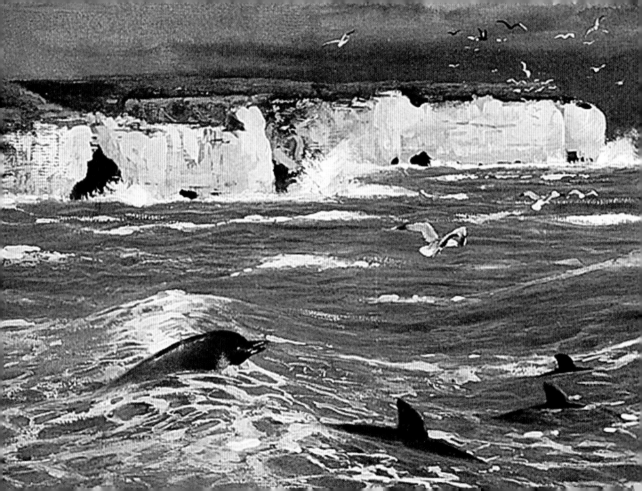

KUHNERT

Porpoises and Gulls
off a Rocky Coast
c. 1900

● A watercolor that
makes the most of the actual
"wateriness" of the technique
itself, with a particularly
effective rendering of
the glassy waves in the
foreground, through which
a school of porpoises leaps
and plunges.

Wilhelm Kuhnert (1865–1926)

FRENCH

Destroyers Hunting
Porpoises
1903

● This was published
in a French illustrated
paper, *Le Petit Journal,* as
something that would
interest and amuse its
readers. The ruthless
slaughter depicted clearly
shocked and disturbed
nobody. One can imagine
the indignation if a
photograph of a similar
scene, involving the
personnel of any
Western navy, were
published today.

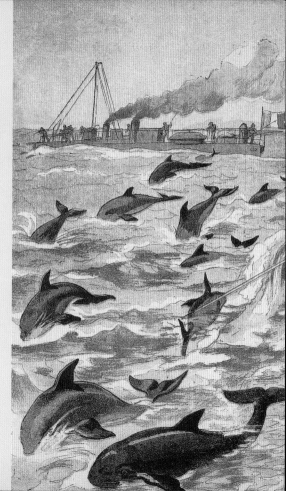

BATES

Deep Sea Fish
1984

● Painted in Bates's typical quasi-folk style, this selection of sea creatures includes a pipefish. As slow-swimming bottom feeders, they are found in warm tropical waters such as those of the Gulf of Mexico.

David Bates (b. 1952)

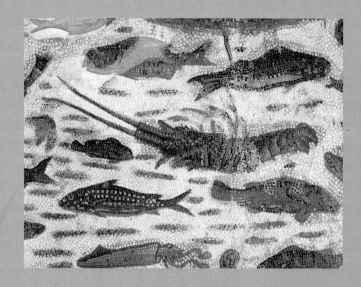

ROMAN

Mediterranean Fish
Late-2nd Century A.D.

● This Roman floor mosaic, from the Catacombs of Hermes at Sousse, Tunisia, gives a good impression of how rich the Mediterranean was in marine life in antiquity. Visible, in addition to various species of fish, are a cuttlefish and a lobster.

PEDERSEN

Koi 2
1995

● Like the smaller goldfish, the koi is an ornamental species of carp, which has been intensively bred in Japan. Koi are valued both for their markings and for their size. Large, splendidly patterned specimens are worth substantial sums of money.

Kirk Pedersen (b. 1959)

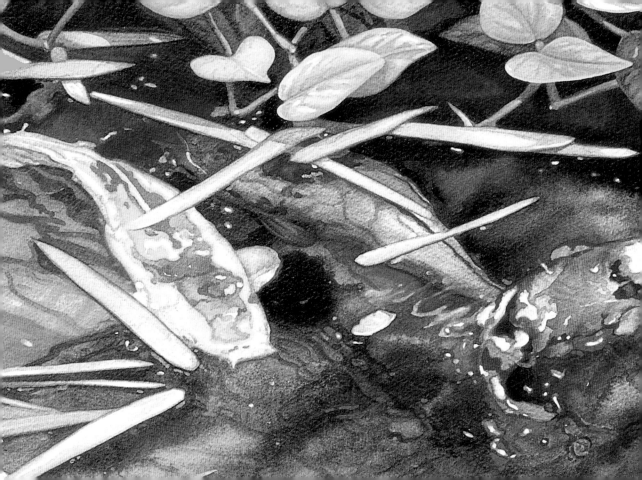

STERN

China Moon
1992

● Animals have featured in this contemporary American artist's work for many years. The animals are viewed, as the artist says, "from somewhat of a Jungian perspective . . . serving as some kind of a reflection for different aspects of myself."

Pia Stern (b. 1952)

ANCIENT EGYPTIAN

1st Millennium B.C.

Oxyrhynchus

● Also known as the bolti fish, the oxyrhynchus is an easily raised and harvested food fish. Because of its importance as a food source, the ancient Egyptians regarded the species as sacred. This is stressed here by the emblem—the twin horns of the cow-goddess Hathor, also an emblem of fertility.

ARCIMBOLDO
Water
1566

● The Milan-born artist
Arcimboldo spent much of
his career working for
Emperor Rudolph II in
Prague. These extraordinary
composite heads, each made
from a single category of
objects—cooking implements
to symbolize a cook, books
emblematic of a scholar or
librarian—are the works on
which his fame chiefly rests.
They are typical of the more
recondite aspects of late
sixteenth-century taste.

Giuseppe Arcimboldo (1527–93)

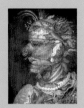

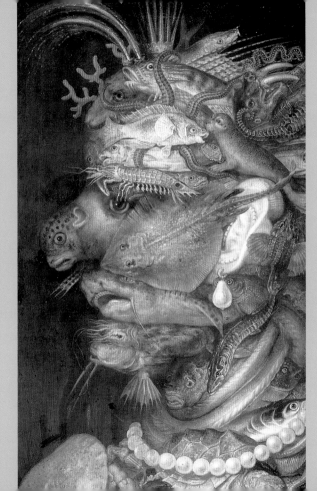

> **THE**
> *uncommunicating*
> *muteness*
> *of*
> *fishes.*

Charles Lamb
(1775–1834)

ROMAN

Still Life with Marine Creatures
1st Century A.D.

● This still life from a wall painting at Pompeii seems to represent a fish seller, and gives a good idea of the various kinds of fish Roman housewives would have found for sale in their local market. They include a cuttlefish, a large clam, and some red mullet.

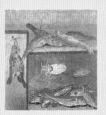

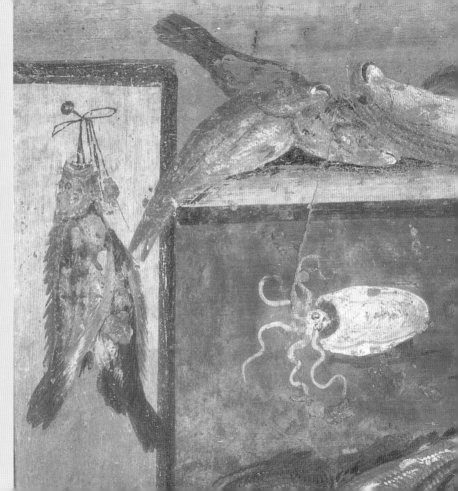

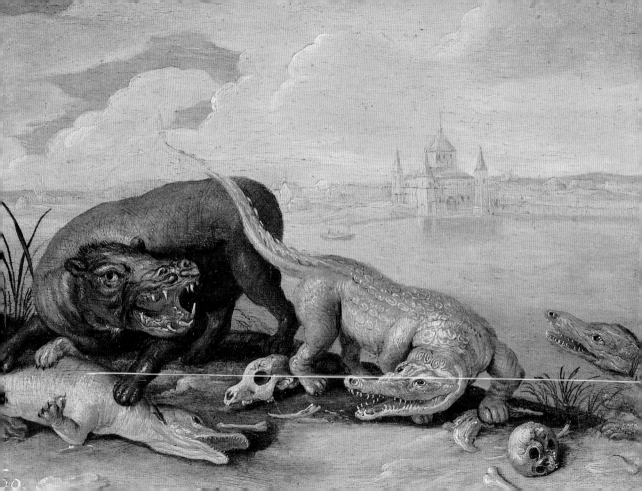

VAN KESSEL

An Allegory of America:
Combat of Crocodiles
and the Hippopotamus
17th Century

● Either this painting has
come down to us with the
wrong title, or else van
Kessel had very fanciful
notions about American
fauna. The creatures shown
in combat here—crocodiles
versus a hippopotamus—are
typical of Africa. The distinctly
European-looking fortress
on the far side of the river
emphasizes the mythical
nature of the representation.

Jan van Kessel the Elder (1626–79)

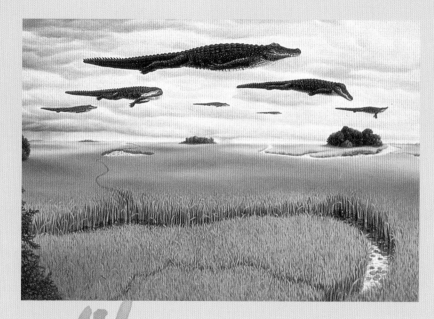

GALLOWAY

Scheme
1992

● A surrealist variant on the saying "If pigs
could fly." A formation of alligators wings its
way across the marshlands of a river valley.

Steve Galloway (b. 1952)

Crocodile

PAI-SHIH
Crabs
19th Century

● The Chinese associate
the growth of crabs with the
phases of the moon. The crab
is also the symbol of the fifth
hour of the day. In autumn, it
was customary to celebrate
the harvest moon reaching
fullness by eating a feast of
crabs. The painting is done in
traditional style, with washes
of ink on absorbent paper.

Ch'i Pai-Shih (1863–1957)

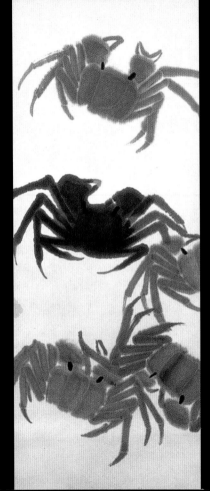

FLEGEL
Still Life with
Fruit and Shellfish
c. 1620

● By a German rather
than a Dutch artist, this
picture is nevertheless
closely associated with the
earliest phase of Dutch
seventeenth-century still-life
painting, where objects are
seen from above, with the
picture plane slightly tilted
upward toward the spectator.
The cooked shellfish have no
symbolic meaning; they are
included purely for their
decorative value.

Georg Flegel (1563–1638)

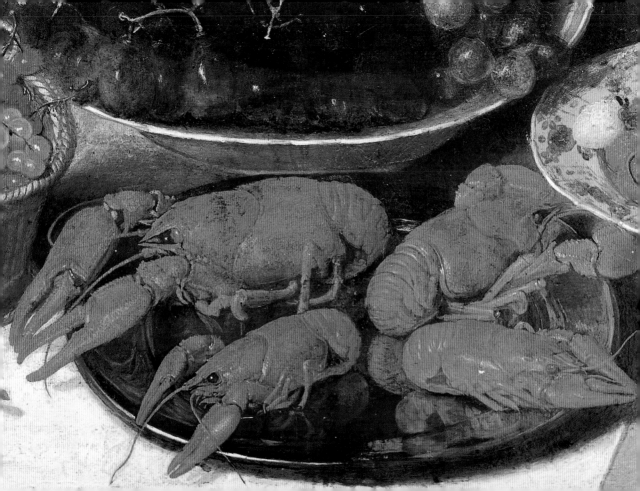

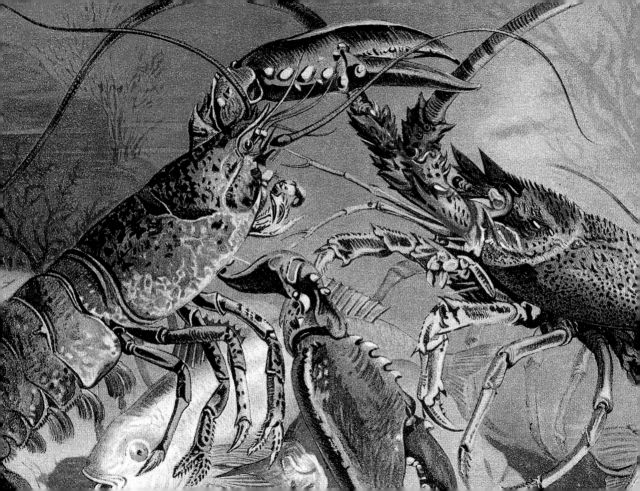

GERMAN

Lobster and Langouste
1893

● A subtly formalized representation from Brehm's *Tierleben* that marks the difference between the two species by posing them as if they were having a conversation with each other. Even at the end of the nineteenth century, the impulse to humanize animals—even unlikely candidates such as these—remained strong.

66

I LIKE LOBSTERS, WHO ARE PEACEFUL,

serious, know the secrets of the sea...

99

Gérard de Nerval (1808–55)

179

LOATHLY CREATURES

TOM KNECHTEL
The Toad
1994

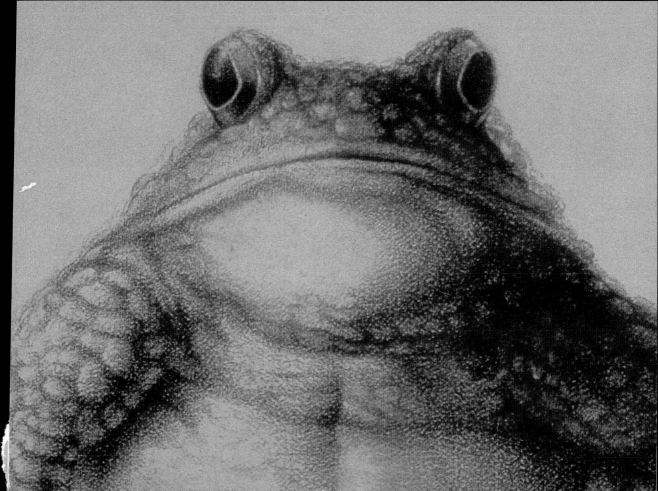

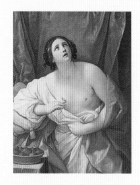

GUIDO RENI The Death of Cleopatra *17th Century*

CERTAIN CREATURES HAVE ALWAYS *excited horror, some simply because of their appearance, others because of their mythological or religious associations. Chief among these is the snake or serpent, seen as the embodiment of evil, the tempter of Eve in the Garden of Eden. At the same time, however, the snake also represents wisdom, sexual power, and perpetual regeneration (in this third instance, because of its ability to shed its skin to reveal a new one underneath). A snake eating its own tail is one of the emblems of eternity.*

In Minoan art, the earth goddess or mother goddess is shown brandishing a pair of snakes as the symbol of her power over sexuality and over all hidden things that exist in darkness. In mystical religions in India, experts demonstrate the powers

EGYPTIAN Woman with Three-Headed Snake *400–350 B.C.*

given them by the god or goddess by their ability to handle poisonous snakes in safety. This usually happens when they themselves are possessed by the god or goddess and are in an ecstatic state. Two snakes twined around a rod in opposite directions become a caduceus, the emblem of the Greek god Hermes and a symbol of the power to heal and reconcile through the union of opposites. The symbol is in fact more ancient than Greek classical civilization: it has been found on a goblet of c. 2600 B.C., dedicated by a Mesopotamian king. It is thought that, in its original form, the emblem showed the snakes twined around an erect phallus.

ANONYMOUS
Engraving of a
Snake *undated*

The toad repels with its ugliness, and in European tradition toads have a close association with witchcraft, not least because of the two horns that some species have on their heads. Witches were said to make toads their familiars

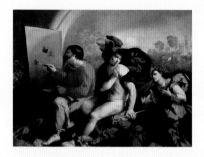

DOSSO DOSSI
Jupiter, Mercury, and Virgo c.1529

(supernatural companions and helpers). They were carried on the left shoulder, dressed in black velvet, and adorned with little bells, which jingled when the creatures were made to dance. It was believed that the witches suckled these toads on the extra nipples that the devil made on their bodies.

Toads have also been associated with the stars and the moon. In the Middle Ages it was thought that toads could intercept starlight and swallow it, and the Chinese believed that a lunar eclipse was a toad eating the moon.

Frogs and toads are frequently confused, but frogs, being smooth-skinned rather than warty, excite much less distaste than toads. In the West, frogs, because of their life-cycle, beginning with the egg,

CHINESE Frog-Shaped Snuff Bottle
Quin Dynasty 18th/19th Century

then the tadpole, are sometimes regarded as resurrection symbols. The Chinese, on the other hand, used to regard them as rainmakers, placing their image on bronze rain-drums.

Other creatures that evoke distaste and dismay are spiders and bats. Arachnophobia is a common form of irrational fear and can be aroused by pictures of spiders as easily as by their living presence. On a higher level, and especially in India, spiders are seen as the weavers of maya, the illusions that blind men to the presence of the divine. To the Aztecs, the spider was the symbol of the god of the underworld.

ENGLISH Book Illustration from *Little Miss Muffet* 19th Century

Bats, as creatures of the night, are usually seen as dark and threatening. For the Jews the bat was unclean, a symbol of idolatry. For the Chinese, its significance was entirely the contrary: it was the traditional emblem of good luck and longevity.

ROMERO

Frogman Standing 8
1996

● Taken from a series of monotypes inspired by Frog Town, the "gang district" where the artist's studio stands. This figure represents an *anima* wearing patterned shoes resembling webbed feet, with his genitals showing.

Frank Romero (b. 1941)

CHINESE

Inkstone with a Lid
Featuring a Frog in a Pond
Reign of Ch'ien Lung, 1735–96

● A charming decorative conceit typical of later Chinese art. Since the wet ink on the stone forms a sort of pond, it seemed natural to the artist to represent a pond on its lid. In Chinese mythology frogs were lunar creatures and corresponded to the yin element, water.

FRENCH

Eve and the Serpent
1533

● This marginal decoration from the *Book of Hours of Antoine le Bon, Duke of Lorraine* is by a French illuminator indebted to the work of Italian painters. Eve's proportions, with a high waist and small breasts, look back to the art of the Middle Ages, but the erotic emphasis with which the snake bites her breast is something new.

snake

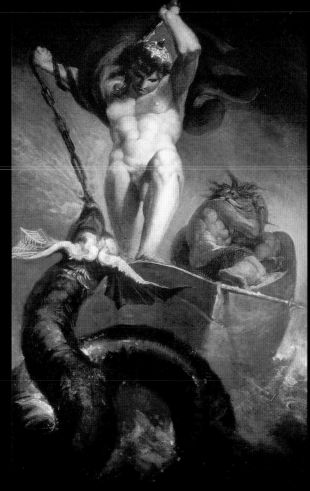

> *And there the*
> *snake throws her*
> *enamelled skin,*
>
> *Weed wide enough*
> *to wrap a fairy in.*

William Shakespeare
(1564–1616)

FUSELI

Thor Fighting the
Midgard Serpent
1788

● In Norse mythology, Thor, the god of thunder, fights the midgard serpent, the personification of evil, but fails to kill him. Their combat will be renewed in the Ragnarök, which will mark the end of both gods and humans. Fuseli was a pioneer in the renewal of interest in the old Norse legends, a feature of the so-called *Sturm und Drang* (Storm and Stress) movement that preceded the full flowering of Romanticism.

Henry Fuseli (1741–1825)

189

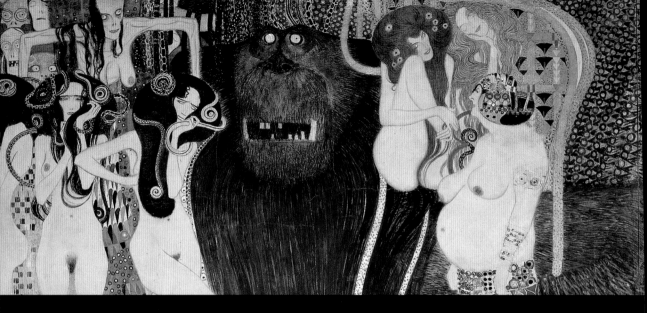

KLIMT

The Forces of Evil
1902

● This detail from the *Beethoven Frieze* is one of the
most important works by the senior figure in the Vienna
Secession, which bridged the transition between Art
Nouveau and fully developed Modernism in central Europe.
The massive creature, part bear, part ape, beside the three
female figures is intended as a personification of Lust.

Gustav Klimt (1862–1918)

BLAKE
Elohim Creating Adam
1795

● Elohim is one of the Hebrew
names for God, representing the
deity in his aspect as a dispenser of
justice. Blake, however, here
stresses the negative aspect of
God's creation of man. Human
enslavement to mortality is
symbolized by the worm that
entwines the body of Adam.

William Blake (1757–1827)

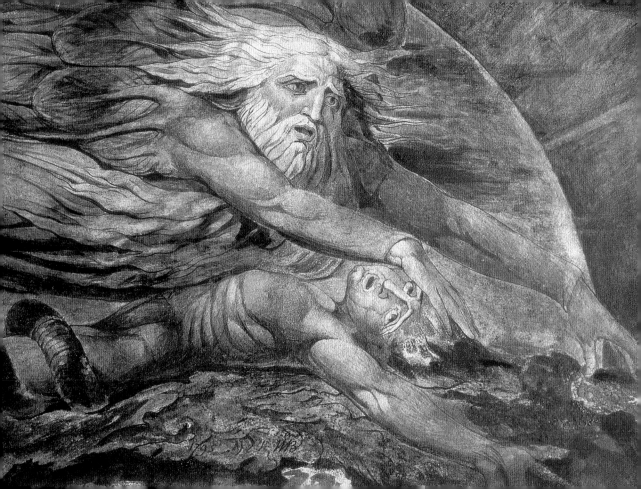

WEINSTEIN
Untitled
1997

● This is a hand-tinted photograph from a series entitled *Interior Zoo*, which the artist describes as "an ongoing photographic exploration of archetypal imagery. In making these photographs I have attempted to give form to a collection of animals which inhabit the human psyche at the unconscious level."

Margo Weinstein
(20th Century)

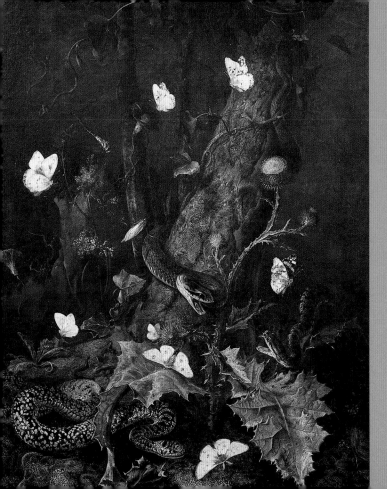

TENIERS

The Temptation of St. Antony
17th Century

● The story of the Egyptian hermit saint Antony Abbot (251–356) offered artists a chance to paint a range of bizarre creatures, depicting St. Antony's vivid hallucinations as shown here (see overleaf).

David Teniers the Younger (1610–90)

VAN SCHRIEK

Snakes and Butterflies
1670

● The flower and still-life painters of the seventeenth century often enjoyed making the spectator feel uneasy—none more so than van Schriek, who was a specialist in close-ups of this sort that reveal the underlying menace of the natural world.

Otto Marseus van Schriek (c.1619–78)

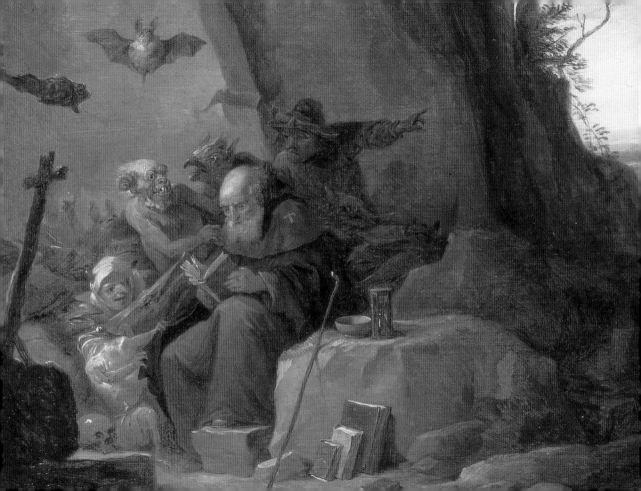

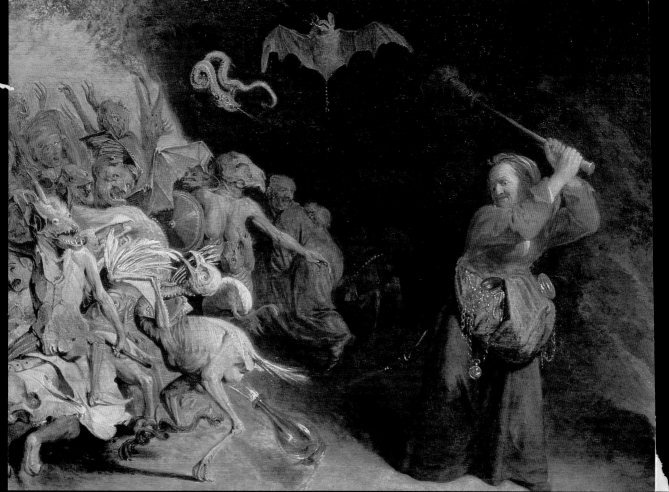

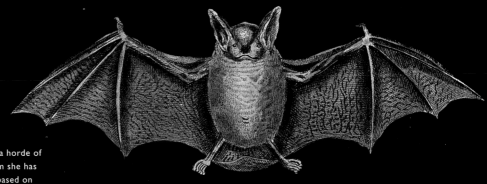

RYCKAERT
The Witch
c. 1650

● The witch drives off a horde of fantastic creatures whom she has conjured up. Most are based on reality. Prominent in the foreground, for example, is a live but plucked chicken. However, above the scene is one completely "real" animal, a bat, which is probably the witch's familiar. Scenes of this sort derive from the even more fantastic representations made in the sixteenth century by Hieronymus Bosch (c. 1474–1516) and Pieter Bruegel the Elder (working 1551–d. 1569).

David Ryckaert III (1612–61)

GERMAN
Common Bat
1792

● A hand-colored engraving from a picture book for children. Bats are often represented in this way—as if pinned on a specimen board—perhaps because it is so difficult to represent them convincingly in flight. The artist has given the creature a quasi-human expression, which may have given a number of children nightmares.

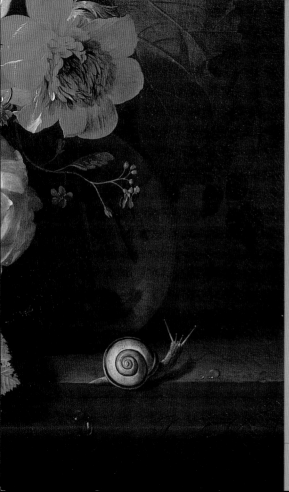

HUYSUM
Flowerpiece
17th Century

● Van Huysum represents the fullest, most opulent development of Dutch flower painting—he is one of a handful of painters who prolonged the glory of Dutch seventeenth-century art. The snail, the fretted leaf, and the wilted rose are intended as reminders of mortality.

Jan van Huysum (1682–1749)

GARZONI
A Pomegranate
with Chestnuts
and a Snail
17th Century

● Giovanna Garzoni was one of the leading Italian still-life painters of her time. The color scheme of this painting is cheerful and light, and the artist may have intended a sexual allegory. The pomegranate is Venus' fruit, and, split open, resembles a vulva. The two chestnuts can be read as metaphors for testicles.

Giovanna Garzoni (1600–70)

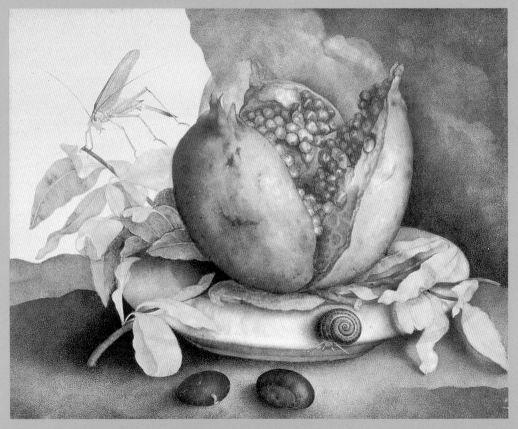

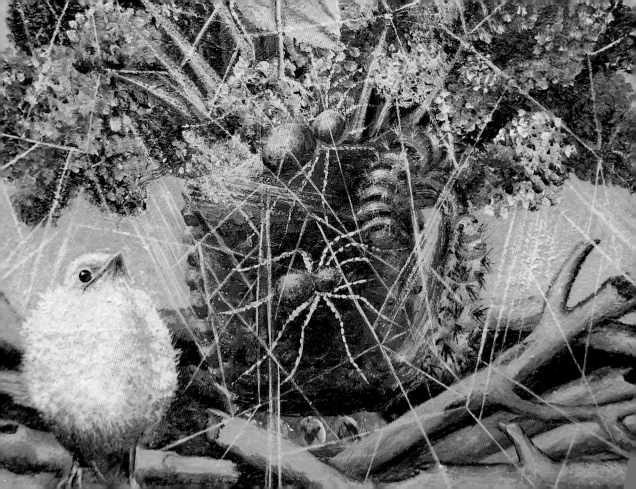

KAHLO

*The Baby
of the Family*
1945

● A characteristically
vivid composition in which
a chick is menaced by two
spiders. A caterpillar and a
leaf insect lie already dead
in their web. It is the
sheer intensity of Kahlo's
imagination that makes the
image so sinister—baby
chicks, however small,
do not usually have much
to fear from spiders.

Frida Kahlo (1907–54)

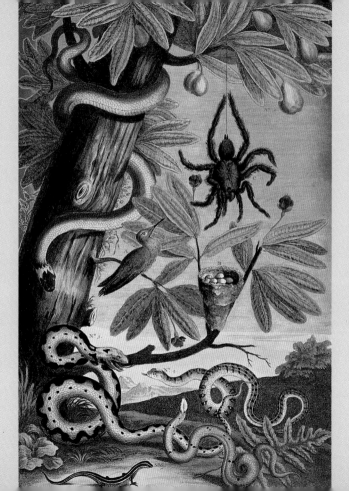

SEBA

Spiders and Snakes
c. 1750

● This hand-colored
engraving from an
eighteenth-century
natural history book,
*Locupletissimi Rerum
Naturalium (A Very Rich
[History] of Things
Relating to Nature)*, gives
a surprising emotional
charge to what is
supposedly purely
scientific subject matter.
The snakes writhe
vigorously, and an
enormous spider
hovers menacingly
over a bird's nest.

Albert Seba (18th Century)

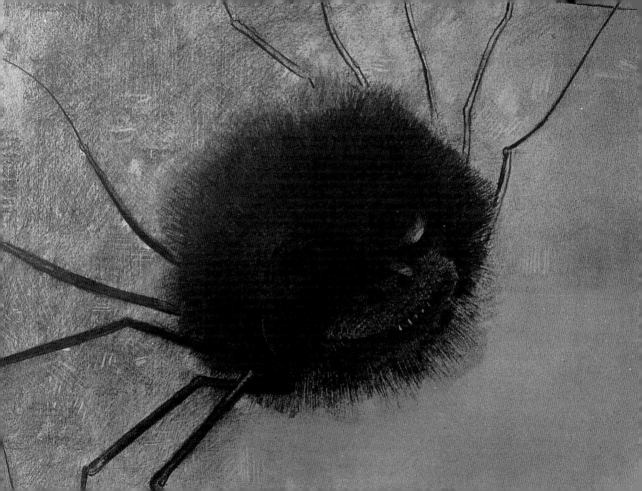

REDON

Smiling Spider
1881

● One of Redon's
most celebrated images,
this humanoid spider is
mentioned by Joris-Karl
Huysmans (1848–1907) in
his novel *À Rebours* (*Against
the Grain*, 1884), which
set the tone for the late
nineteenth-century
Decadent Movement. The
drawing also foreshadows
the Surrealist Movement
of the twentieth century.

Odilon Redon (1840–1916)

“

'WILL YOU WALK INTO MY PARLOUR?'

said a spider to a fly:

'Tis the prettiest little parlour
that you ever did spy.'

”

Mary Howitt (1799–1888)

FAMILIAR BEASTS

PAUL GAUGUIN
Loss of Innocence
19th Century

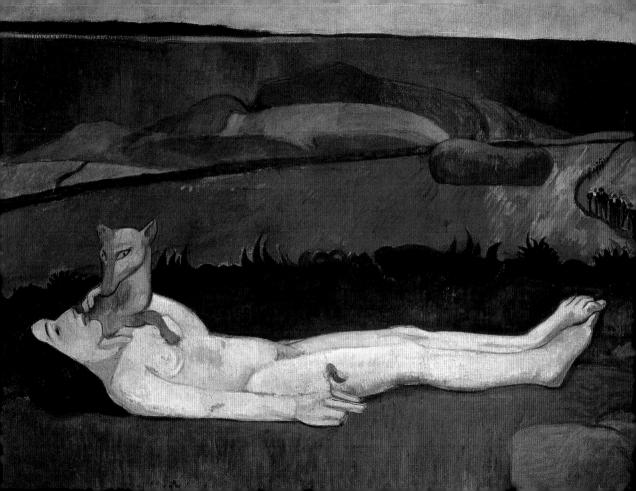

FRENCH Poster of the
Acrobatic Rabbit *c. 1900*

I T IS ENTIRELY TO *be expected that art should feature chiefly beasts that have long been familiar to the great civilizations. The wolf, deer, fox, bear, rabbit, hare, squirrel, and even the porcupine are all embedded in the collective psyche. They appear as personages in fables and are part of the common stock used by artists. As such, their appearance is often reduced to a kind of artistic shorthand. This is especially the case when they are depicted not for their own sake, but for some symbolic reason—as heraldic supporters or crests, for example, or as part of some scheme of decoration that in essence has nothing to do with the artist's own response to the natural world.*

Because these creatures have emblematic power, the spectator very often is not concerned with whether or not the actual situation seems

JAPANESE Inro decorated
with a Rat *undated*

plausible. That is, the animal forms become no more than envelopes for human essences. Illustrations to fables and moral tales, in particular, tend to depict animals that are simply humans conveniently clad in animal skins and behaving in an almost completely human fashion.

The tendency for animals to be seen behaving as humans is pushed still further when the animals are used as vehicles for satire. When people speak of caricature, they are actually describing two separate traditions in art which are now rather uneasily intermingled with each other. Caricature on the one hand is an extremely long-established tradition of allegorical illustration, which can in fact be traced back to ancient Egypt. Some papyri contain humorous illustrations to beast fables, in which animals behave in a more or less human way.

ALBRECHT DÜRER *Hare 1502*

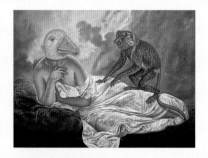

RANDALL LAVENDER
The Last Masquerade 1992

Papyri of this kind are the ancestors of the cartoon strips that appear in modern newspapers, and also of cartoon films featuring bird or animal characters such as Mickey Mouse, Donald Duck, and Goofy. Similar narratives can also be found drawn in the margins of medieval manuscripts.

The other tradition is that of caricature in a much stricter sense of the word—the "charged" portrait that exaggerates physical characteristics. Where the two traditions come together is in the way satirical artists, intent on ridiculing some particular individual, often fasten on what seem to them animal-like traits. A man's

FRENCH Illustration from Bestiary 1564

profile may strike them as being like that of a pig or a horse while a tall, thin personage may recall the silhouette of a stork, so they stress these resemblances.

FREDERICK MORGAN
Feeding the Rabbits *19th Century*

More insidious has been the practice, particularly among nineteenth-century artists but not unknown at the present day, of endowing animals with what seem to be peculiarly human feelings, showing them as amorous, noble, grief-stricken, or defiant. These feelings are essentially projections: we may think that a particular animal shares a human emotional state, but we can never truly be certain of it. The beast fables of the ancient Egyptians and the medieval illuminators preserve this distance—it is always clear that the image is being used for a moral or satirical purpose. The sentimentalization of animals seems to be a post-Renaissance invention.

211

EECKHOUT

Two Brazilian Tortoises
17th Century

● Eeckhout was one of a number of Dutch artists who accompanied an expedition to Brazil. Eeckhout's painting combines scientific and artistic impulses in a way typical of the mercantile Protestant culture in the Netherlands during the seventeenth century.

Albert Eeckhout (d. 1663)

LAVENDER

Learning to
Slow Down
1992

● An amusing take on the old fable. It will be remembered that the hare was beaten in the end by his slow-moving rival.

Randall Lavender
(b. 1956)

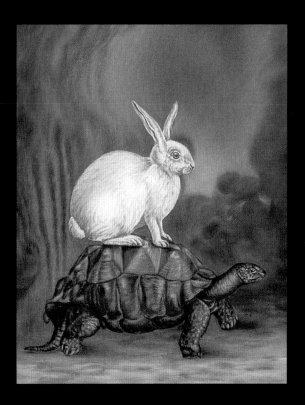

213

ARABIC

The Fox and the Empty Drum
c. 1350

● From Aesop (c. 620–560 B.C.)
onward foxes were favorite
characters, often as examples of low
cunning, or of cunning that
overreaches itself.

BAERT

Two Rabbits
c. 1842

● The artist's flashy technique,
emphasizing the texture of the
rabbit's fur with visible
brushstrokes, is based on that of
fashionable portrait painters
such as Sir Thomas Lawrence
(1769–1830).

H. Baert (fl. 1842)

215

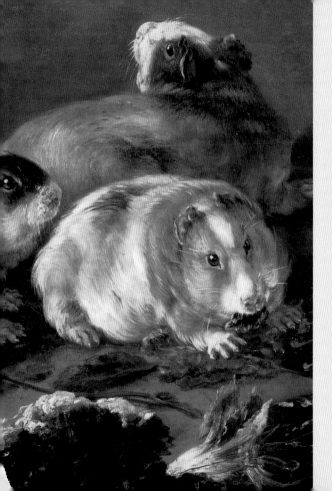

BRANDI

*Six Guinea Pigs
with a Chicken
and a Rooster
17th Century*

● A Neapolitan artist who later worked with one of the chief painters of the late Baroque period in Rome, Benedetto Luti (1666–1724), Brandi steered clear of the "grand" subjects beloved by the Baroque masters and specialized in animals and birds. Guinea pigs were domesticated in South America some time before the rise of the Inca empire in Peru and were introduced into Europe shortly after the Spanish conquest. They are a very unusual subject in art.

Domenico Brandi (1683–1736)

RUBENS
Child with a Bird
c. 1624–25

● This may have been a study for a painting of the Madonna and Child, since it was a tradition to portray Christ with a bird, usually a goldfinch. The legend was that the goldfinch flew down when Christ was on the road to Calvary and drew a thorn from his brow.

Peter Paul Rubens
(1577–1640)

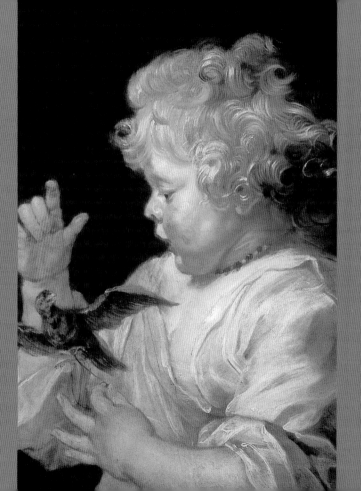

" **ALL CATS**

love fish

but fear

to wet

their paws.

"

English proverb

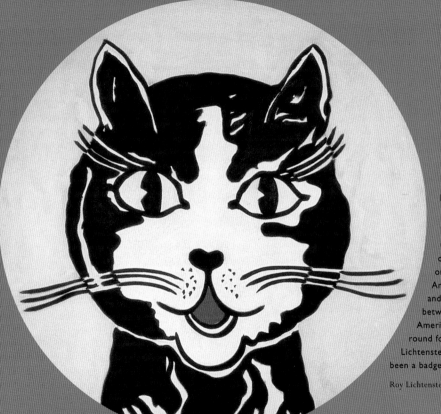

LICHTENSTEIN
Felix the Cat
c. 1961

● This study of the famous cartoon strip character was once in the collection of Andy Warhol (1928–87), and forms a fascinating link between the two best-known American Pop painters. The round format suggests that Lichtenstein's model may have been a badge or a lapel button.

Roy Lichtenstein (1923–97)

219

ROMERO
Scamp in Red Saltillo
1992

● This is a serigraph—in other words, a silkscreen print—made using a version of the technique adopted by Warhol for his print of a white cat.

Frank Romero (b. 1941)

o

220

cat

"
Dreaming cats assume
the noble poses

Of great sphinxes sprawled
in the depths of solitude.

Apparently drifting off
into an endless dream.
"

Charles Baudelaire (1821–67)

FRENCH
Cats and Rats
16th Century

● Illuminated manuscripts frequently have marginal decorations that have little to do with the text. Here cats are attacking rats that have taken possession of an orb that represents the world. The scene may illustrate some proverbial saying or political comment now lost to us.

HUGHES

The Woodman's Child
1860

● This appealing work by the
minor Pre-Raphaelite Arthur
Hughes was painted too late
to be in full Pre-Raphaelite
style and reverts to the
conventions of Victorian
genre painting. Like many such
works, it stresses childhood
innocence, as the sleeping
infant is fearlessly surveyed
by a squirrel and a robin,
while the parents work
in the background.

Arthur Hughes (1832–1915)

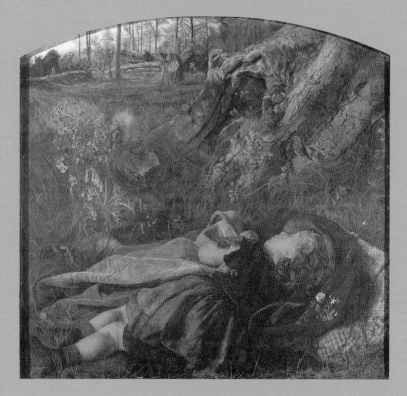

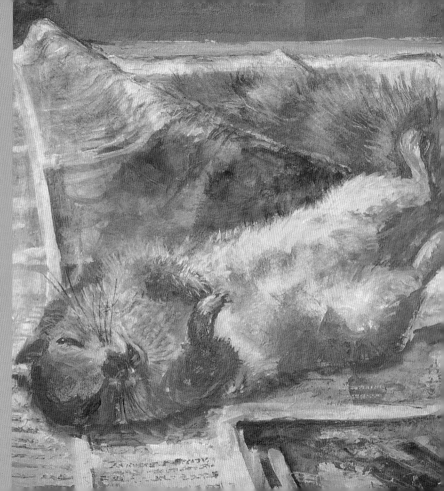

SERRANO

Squirrel
1995

● A slightly ambiguous
image: is the squirrel
lying dead on its bed of
newspaper, or is it so
confident of its
surroundings that it is
rolling playfully?

Luis Serrano (b. 1955)

題
卯春月
波湯
須老吏
起身遠竄
而長自
拖

CH'IEN

Squirrel on a Peach Branch
13th Century

● A distinguished painting by
an artist of the Southern Sung
Dynasty, working in the tradition
of "bird and flower" painting
established by the painter-emperor
Hui Tsung (reigned 1100–25). In
Chinese art the peach is a symbol
of longevity. If the painting was
made as a gift, it expresses the
wish that the recipient enjoy a
long life.

Ch'ien Hsüan (c. 1235–1300)

225

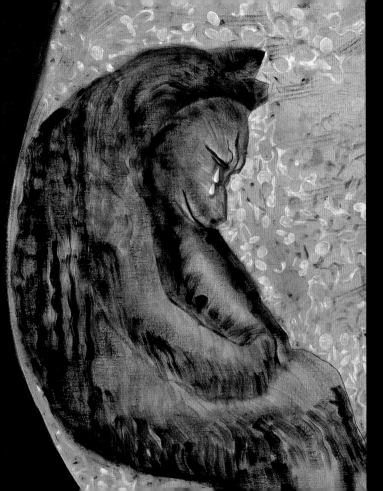

> 66
>
> AS SAVAGE AS A BEAR
>
> *with a sore head.*
>
> 99

Frederick Marryat (1792–1848)

CLEMENTE
Honey and Gold
1988

● Clemente, a member of the Italian Trans-Avant Garde group, is interested in esoteric symbolism. This weeping bear, in its womblike enclosure, may be intended as an emblem of the unconscious, surrounded by riches it cannot utilize.

Francesco Clemente (b. 1952)

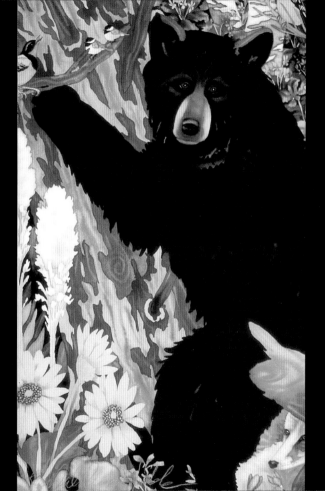

JUBB

Spring Gulch 4
1997

● The bear emerging from
its hibernation to find itself
surrounded by flowers is
seen as an image of Spring.
The technique is transparent
watercolor on white paper,
which brightens all the hues
with reflected light.

Kendahl Jan Jubb (b. 1957)

bear

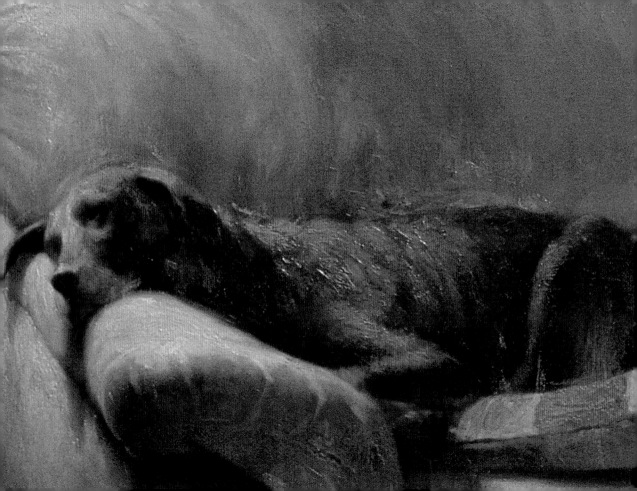

WINSRYG

Three Poodles
1996

● Poodles were originally bred as water retrievers, so their coats were clipped for practical reasons—to increase their efficiency in the water. Only later did this clipping become elaborately ornamental. Poodles are among the most intelligent of all dogs and are therefore often trained as performers.

Marian Winsryg (b. 1941)

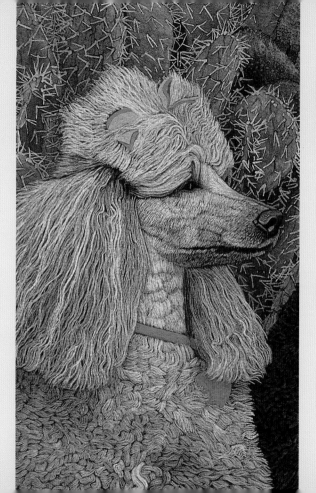

YASKULKA

Portrait of Lana
1996

● This is a painting of the artist's own dog, a Labrador Retriever. Here the dog is given almost human qualities as it relaxes on the sofa.

Hal Yaskulka (b. 1964)

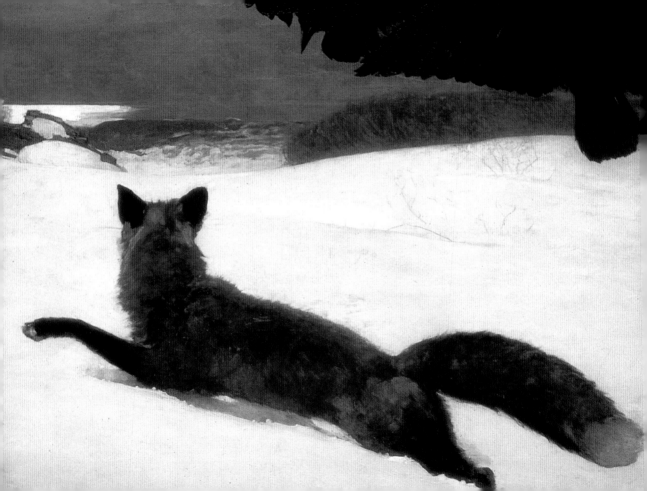

HOMER

The Fox Hunt
1893

● Homer, mainly known for his depictions of the sea, is, with Thomas Eakins (1844–1916), one of the two greatest American artists of the late nineteenth century. His *Fox Hunt* has many affinities with the work of Gustave Courbet (1819–77). It is simultaneously realist and symbolist. The black crow flying above the fox announces its tragic fate.

Winslow Homer (1836–1910)

66

A WISE FOX WILL NEVER ROB
his neighbour's roost.

99

English proverb

231

HUNTERS AND HUNTED

LEONARD KOSCIANSKI
Nocturne
1984

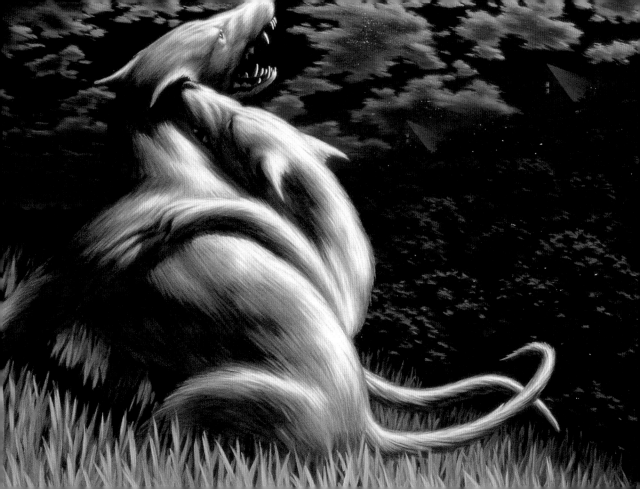

MOGUL Illustration of Rajput Princes Hunting Bears *19th Century*

ONE OF THE CHIEF categories *in animal art has always been concerned with the pursuer and the pursued, the hunter and the hunted. It is not merely that human hunters like to have their sport recorded, but that the motif of one animal pursuing another is one of the most constant in all art and seems to have been used by artists in almost all cultures.*

Often the pursuit is endowed with allegorical meaning. The gazelle in flight from a lion or panther is often intended as an allegory of the soul fleeing from the passions that seek to devour it. For artists touched by Romanticism, such as George Stubbs (1724–1806) and Eugène Delacroix (1798–1863), a lion attacking a horse or stag became an emblem of the relentless violence of nature.

ARABIC Illustration of a Sacrificed Camel *c. 1350*

This symbolism can be reversed, however. In certain depictions of flight and pursuit, it is actually the pursued who is representative of evil. This is especially true when the animal being chased is a hare, since the hare—particularly in Celtic or Nordic mythology—is sometimes seen as the embodiment of the devil. The human hunter or the pursuing hound endlessly chases this quarry to the neglect of spiritual things, and the hunt becomes an allegory of bondage to the material world. An example of such a theme is the phantom huntsman, condemned to pursue his quarry until the end of time.

VENEGAS Martires *1983*

During the Middle Ages, hunting was also presented by moralists as an example of the triumph of worldy pleasures over spiritual duty. St. Hubert, for example, was a young man neglecting his religious duties who, having encountered a white stag

with a crucifix between its antlers during a hunt, converted to Christianity and ended his life as a bishop.

In ancient societies, however, the hunting of large and dangerous beasts was also a form of exorcism. In destroying the beast in question, the hunter was symbolically destroying the presence of evil. Or else, confrontation with a particularly dangerous variety of wild animal becomes an important rite of passage—the means whereby, for example, a young man shows his worthiness to become a fully accepted member of his tribe.

ED MUSANTE Deer *1995*

The dramatic tension involved in the act of hunting has meant that hunting scenes of all kinds provide some of the finest material for animal art. If they have currently somewhat fallen from favor, this is because of the squeamishness of urban societies, which are removed from

GERMAN
Illustration of the Eleventh Psalm *17th Century*

these bloody aspects of the natural world, and because many of the animals being hunted are becoming scarce.

There is now a whole category of traditional still-life painting by artists such as Frans Snyders (1579–1657) featuring dead birds and dead animals that offends and indeed nauseates many modern spectators. For those who originally commissioned them, paintings of this kind were usually seen as emblems of success and plenty, or participation in the bounty of nature. It is only occasionally, and quite late in the development of the still life as a separate genre, that artists—Francisco de Goya (1746–1828) is one example—seem to have begun to think of paintings featuring dead beasts or dead birds as a variant of the traditional memento mori, a reminder of the inevitability of death.

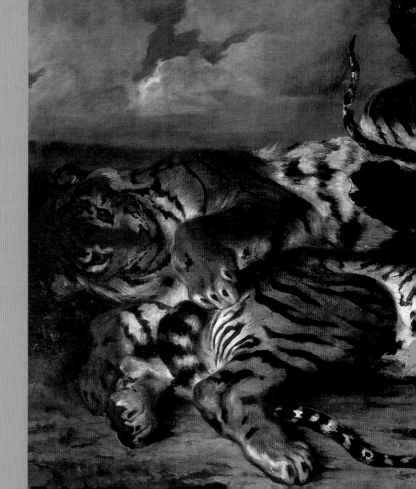

> THE TIGER, ON THE
> other hand, is
> kittenish and mild,
>
> He makes a pretty
> play fellow for any
> little child;
>
> And mothers of large
> families (who claim to
> common sense)
>
> Will find a Tiger
> will repay the trouble
> and expense.

Hilaire Belloc (1870–1953)

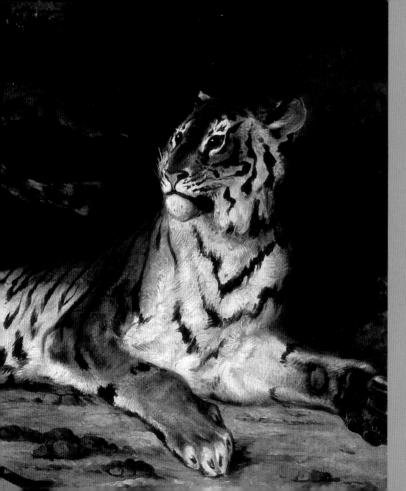

Tiger

DELACROIX

Tigress Playing with Her Cub
19th century

● Romantic artists like Delacroix felt a
particular affinity with animals like lions
and tigers, which they equated with ideas
of personal power and freedom. Here the
liberty of the beast of prey is transmuted
into a charming domestic scene that
evokes empathy rather than fear.

Eugène Delacroix (1798–1863)

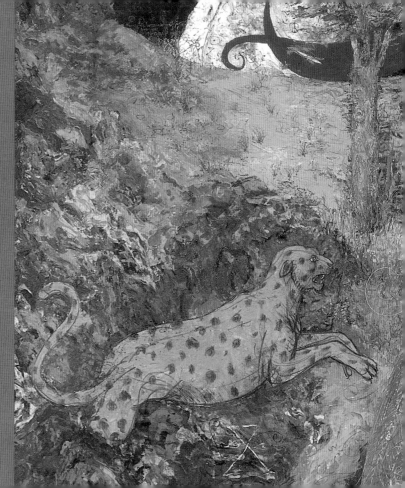

WILEY

Saving Stag from Jaguar
1995

● This is a typically willful, semi-surrealist work by the artist—its willfulness emphasized by the fact that the toylike "jaguar" much more closely resembles a leopard.

William T. Wiley (b. 1937)

MILLER

Leopard Dance
1983

● In the 1980s a leading Texas artist, Melissa Miller, painted a series of ambitious animal scenes of this type. Their theme is a feeling of mystical union with the wildness and freedom of the non-human world.

Melissa Miller (b. 1951)

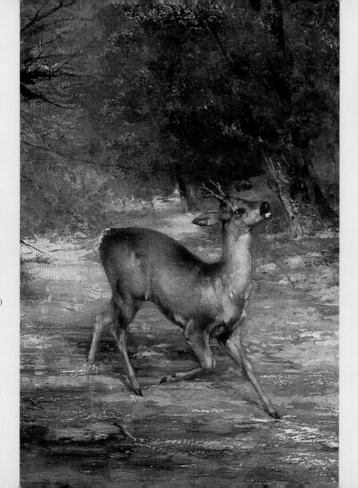

> 66
>
> **THERE IS A**
> *poignancy*
> *in all*
> *things clear,*
> *In the stare*
> *of*
> *the deer*
>
> 99
>
> Richard Wilbur (b. 1921)

COURBET

The Hunted Roe
1866

● Courbet is generally regarded as the key figure in the nineteenth-cenury Realist Movement, but his artistic roots were in Romanticism. The roe deer shown here is a typically Romantic image of danger and solitude. It is deep in the woods of Courbet's native Franche-Comté, still one of the more remote and rural regions of France.

Gustave Courbet (1819–77)

FRENCH

*View of the Château
of Rosny
1820s*

● This Sèvres porcelain plaque shows
the residence of the Duchesse de Berry
(1798–1870). She and her children can
be seen in the distance. At this time,
there was a fashion in France for
English parks rather than formal
gardens. This taste is symbolized
by the presence of the two deer.

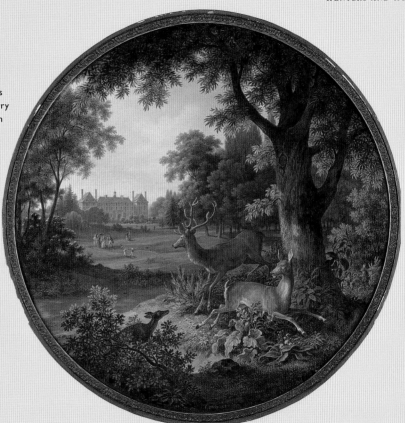

deer

243

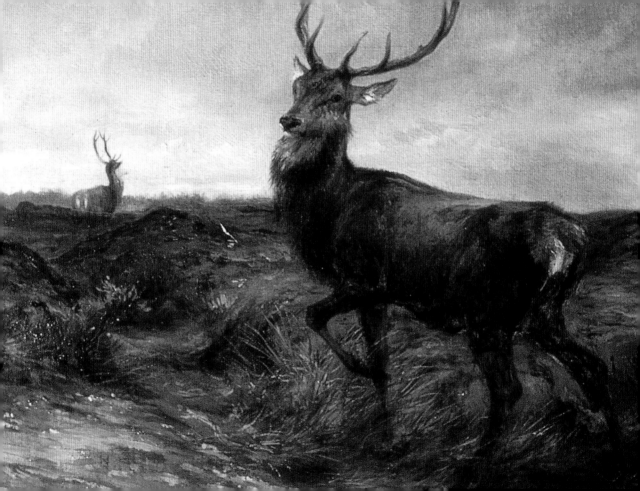

BONHEUR

Deer on the Alert
1887

● The most successful female artist of her time,
Rosa Bonheur became celebrated for her skill in
portraying both wild and domestic animals,
though her pictures now look labored when
compared to those of Delacroix (1798–1863)
and Courbet (1819–77). Courbet, almost her
exact contemporary, is an evident influence in
her work, as are Dutch seventeenth-century
animal painters like Paulus Potter (1625–54).

Rosa Bonheur (1822–99)

deer

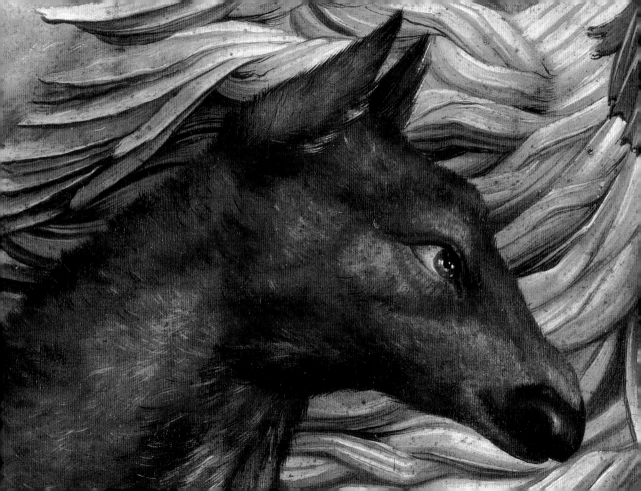

GRÜNEWALD
The Deer (from the Isenheim Altarpiece)
c. 1505–16

● This is a detail from Grünewald's vast folding altarpiece. St. Antony Abbot and St. Paul the Hermit are shown in conversation, and the deer nestles under St. Antony's arm, apparently as an emblem of their unspoiled natural surroundings. St. Antony is more usually shown with a pig, apparently because the pigs belonging to Antonite communities were allowed to scavenge at will.

Matthias Grünewald (c. 1470/80–1528)

TAMAYO
Animals
1941

● Tamayo was the contemporary of the great Mexican muralist Diego Rivera (1886–1957), but was usually much less influenced by pre-Columbian themes. Here, however, he seems to refer to Aztec sculpture, depicting beasts that are a sinister mixture of dog, jaguar, and coyote.

Rufino Tamayo (1899–1991)

247

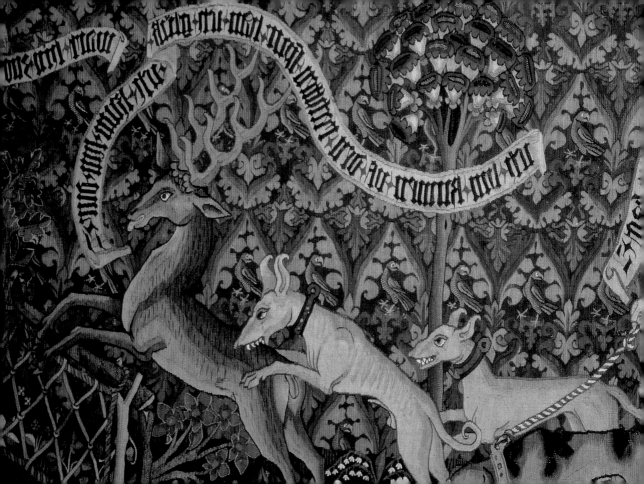

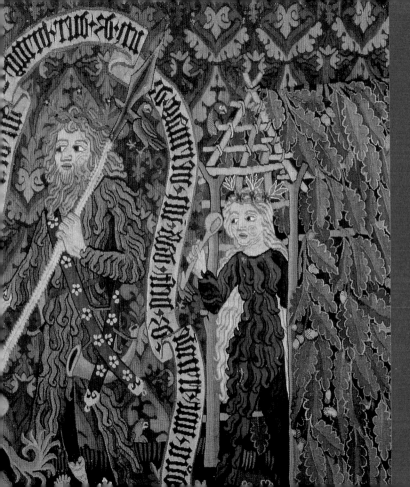

SWISS
Deer Hunt
1468–76

● In this detail from a Swiss tapestry, the huntsman is a wildman, with a crown of green leaves. He is also clearly a man of noble birth, with a horn on an embroidered baldric and a lady to see him off. He is therefore probably the Green Knight, Gawain's opponent from the Arthurian romance *Gawain and the Green Knight*, best known from the Middle English poem that is almost exactly a century older than this tapestry.

ENGLISH

The Hyena
Mid-13th Century

● This illumination
from a bestiary
shows a hyena in
its most terrifying
aspect, digging up and
devouring a corpse
in a churchyard. The
Latin text beneath
the image describes
these activities with
some relish.

VERNET

Boar Hunt
in Poland
1831

● From a family of
painters, Carle Vernet
began his career by
painting battle scenes
for Napoleon, then
became court painter
to Napoleon's
successor, Louis XVIII,
specializing in sporting
pictures featuring
horses. Here he
combines several
specialties in a
composition heavily
influenced by Rubens
(1577–1640).

Carle Vernet (1758–1836)

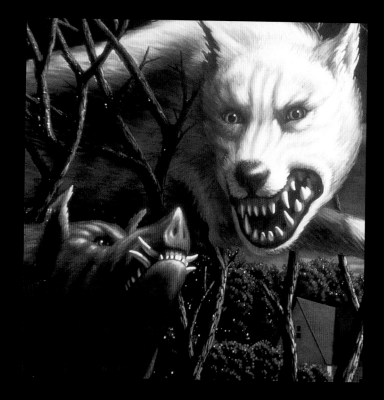

KOSCIANSKI

Modern Living
1989

● Koscianski expresses feelings about the mindless savagery of the modern world by inventing terrifying wolflike and hoglike beasts. The boar at the lower left, for example, with four projecting fangs in its lower jaw, has no counterpart in nature.

Leonard Koscianski (b. 1952)

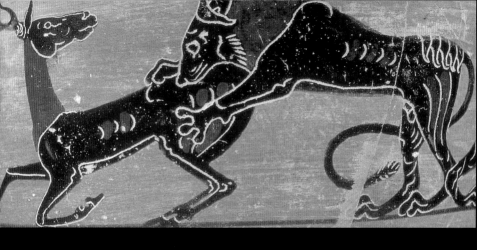

ETRUSCAN

*Hyena Attacking
a Gazelle*
6th Century B.C.

● The choice of a hyena depicted on this
Etruscan vase painting is unusual. The more
usual formulation for scenes of this kind is a
lion attacking a deer or a gazelle. In any case,
hyenas generally hunt in packs. It is altogether
possible that the vase painter working here

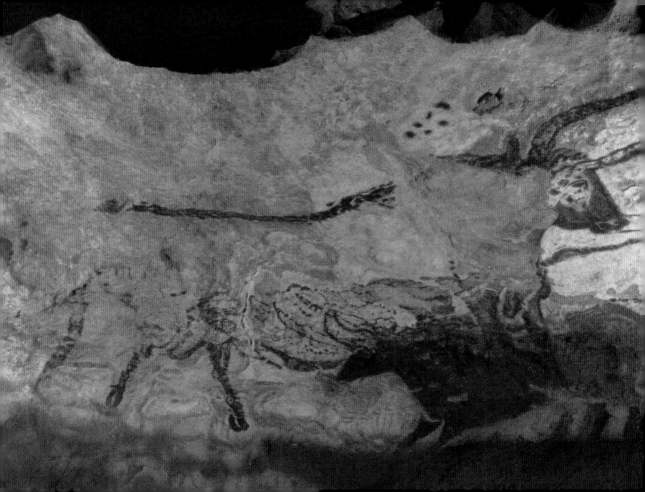

PALEOLITHIC
Big Bull
12,500 b.c.

● A detail taken from the Lascaux
cave paintings discovered in the 1940s.
The purpose of these astonishingly lifelike
representations remains unknown, though
it is assumed they were connected with
fertility and hunting magic.

MUSANTE
Plains Buffalo
1994

● The image of the buffalo is intimately linked
to the whole American myth of conquest and
settlement. The aim in this painting is to
emphasize the mythological aspect, the feelings
the creature arouses within the artist himself.

Ed Musante (b. 1942)

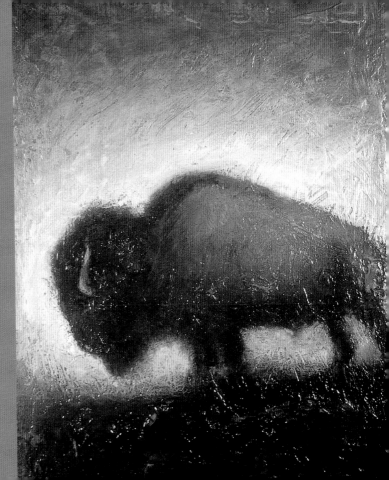

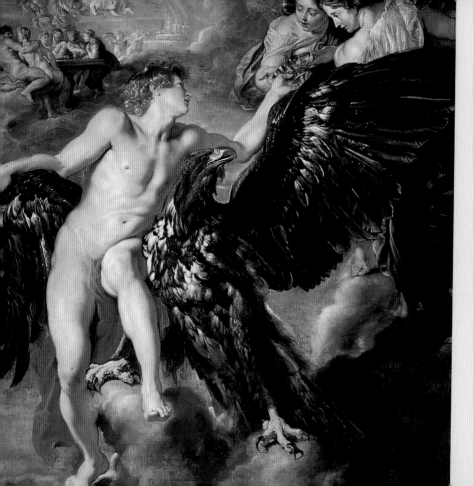

RUBENS

The Abduction of Ganymede
c. 1620

● The superb eagle here
shows how well suited
Rubens' Baroque style was to
the representation of fierce,
proud creatures of this sort.
He brings immense conviction
to the depiction of an
improbable mythological
event. The eagles are symbolic,
as Ganymede is being taken to
Zeus, the king of the gods.

Peter Paul Rubens (1577–1640)

> 66
>
> **SOMETIMES EAGLES'**
>
> *wings,*
>
> *Unseen before*
> *by gods or*
> *wondering men,*
>
> *Darkened the place.*
>
> 99

John Keats (1795–1821)

MENZEL

Falcon Pursuing a Pigeon
1844

● Menzel was one of the most important German painters of the nineteenth century, less known than he should be largely because of his immense variety of style and subject matter. This picture is part of his Romantic vein, showing predatory cruelty in pursuit of innocence.

Adolph von Menzel (1815–1905)

OBJECTS OF WONDER

VICTOR VASARELY
Zebras
1950

A S WESTERN KNOWLEDGE OF *the world expanded, so did Western acquaintance with new and exotic species. Many animals came to the notice of Western scholars, and then of a wider public, only as a result of the Age of Exploration that began with Columbus' journey of discovery to the Americas and Vasco da Gama's voyage to India in the fifteenth century. Naturally, artists were called upon to record the new species discovered at this time. An example is the well-known print by Albrecht Dürer (1471–1528) showing a rhinoceros, intended as a record of a creature that ranked as a popular wonder. Rhinoceroses retained their attraction long after this, as can be deduced from the painting by Pietro Longhi (1702–85) showing fashionable eighteenth-century Venetians inspecting one in a menagerie .*

GERMAN Illustration from
Robinson Crusoe 1890

The eighteenth century, with its emphasis on scientific analysis and classification of natural phenomena, saw a greatly increased interest in the depiction of non-European species, especially if they were, like the zebra or the giraffe, spectacular in themselves. The ambitious Histoire Naturelle, published by Buffon (1707–88) in France in the second half of the century, stretched well beyond the confines of zoology, since it was in fact an attempt to produce an encyclopedic account of the whole of nature. But it was the types of animal life known at the time that perhaps aroused most interest. Buffon had been appointed curator of the Jardin du Roi (now the Jardin des Plantes in Paris), and the resources available to him there supplied the basis for his researches. Though generally thought of as a botanical garden, the Jardin du Roi also had a museum and, since the late seventeenth century, had

After **CHARLES HAMILTON SMITH**
Illustration of a Giraffe *19th Century*

been building up a collection of specially commissioned drawings of birds, animals, and plants, all exquisitely painted in color on vellum.

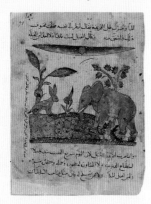

ARABIC Illustration of the Elephant and the Hare *1350*

In Britain, the explorations of voyagers like Captain James Cook (1728–79) greatly excited public curiosity, and, as both scientific knowledge and the resources of the printing industry expanded, there was an output of magnificent illustrated books in the late eighteenth and early nineteenth centuries, including **Birds of America** *(1825–1838)* by John James Audubon *(1785–1851)*, with 435 hand-colored plates.

Meanwhile, it had become fashionable among the higher ranks of British East India Company officials to commission collections of drawings by local "Company School" artists, illustrating Indian flora and fauna. Though adapted to British taste, these

drawings were in fact direct descendants of the album pages showing exotic animals commissioned by the seventeenth-century Mogul emperors.

GERMAN Illustration from Brehm's *Tierleben* 1890

When they returned home, these European "nabobs," as they came to be called, turned to established animal painters, chief among them the great horse painter George Stubbs (1724–1806), to supply similar but more ambitious images of exotic animals. This established a tradition for works of

MARIAN WINSRYG
L. A. Architecture *1987*

this kind that lasted almost throughout the succeeding century, and that eventually blended into a somewhat different, romantically inspired fashion for scenes of oriental life, usually featuring camels and other beasts that could still be qualified as "exotic."

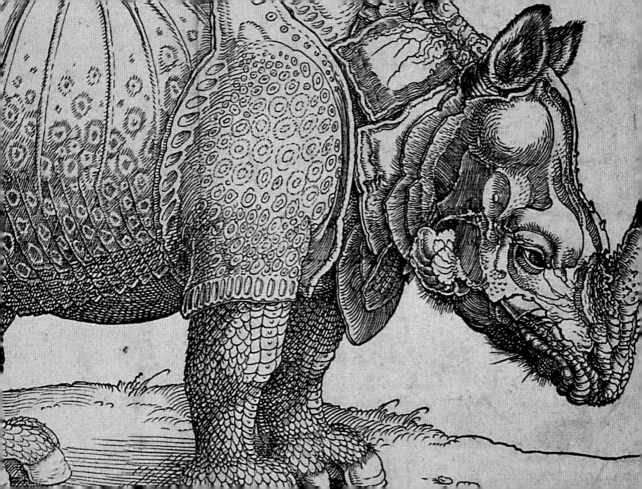

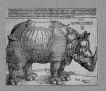

DÜRER

Rhinoceros
1515

● In this celebrated print Dürer records, with admirable accuracy, the appearance of a rhinoceros that was brought to Europe in the early sixteenth century.

Albrecht Dürer (1471–1528)

AFTER **LEUTEMANN**

Animals in the Amphitheatre
1870

● The nineteenth-century imagination was always excited by stories about the animal combats and gladiatorial shows of ancient Rome as can be seen in this spirited woodcut.

After Heinrich Leutemann (1824–1905)

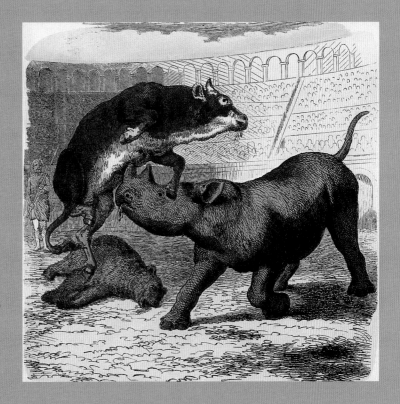

RHINO RESCUE
THIS IS AN EXTENSION OF
ATIONAL GAME RESERVE
NO FARMING

MBUTHA
Rhino Rescue
20th Century

● Modern African painting is
often filled with an exuberant
sense of humor. This Kenyan
picture owes more to the folk
tales and stories of the
African narrative tradition
than it does to traditional
African sculpture.

Mbutha (20th Century)

MATO
Meeting with the
Councillors
20th Century

● This amusing painting
from the series *Who*
Killed Achilles? is so
adroitly stylized that the
subject is not apparent
at a first glance. Only
afterward does one see
how cleverly the basic
forms have been used.

Mato (Bernard Malaquis)
(b. 1951)

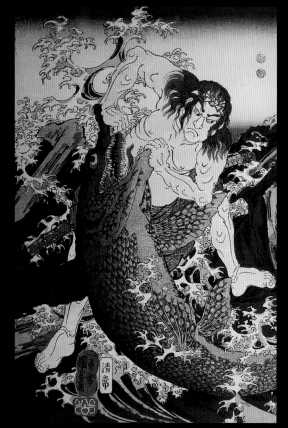
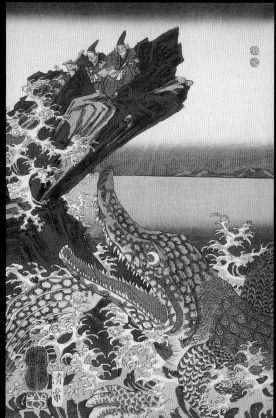

KUNIYOSHI

Asahina Samburo and the Crocodiles
1849

● Kuniyoshi, a contemporary of Hokusai (1760–1849) and Hiroshige (1797–1858), belonged to the last generation of great ukiyo-e (pictures of the floating world) printmakers. Rather than making images of landscapes or of elegant geishas, he preferred vigorous scenes of action such as this one, which has many resemblances to a frame from a modern comic strip—resemblances accentuated by the fact that the composition is a triptych, spread out over three sheets of paper. The image is printed from interlocking woodblocks, one for each color.

Utagawa Kuniyoshi (1798–1861)

MERIAN

Alligator and Snake
1730

● Merian was the daughter of the leading
German engraver Matthäus Merian the
Elder (1593–1650). It seems likely that
Maria Sibylla relied on inherited workshop
material as the source for this slightly
unlikely image, published as an engraving
some years after her own death.

Maria Sibylla Merian (1647–1717)

WEINSTEIN

Untitled
1996

● A hand-tinted photograph from the
artist's *Interior Zoo* series. "These are
animals," Weinstein says, "which we
release from their cages to wander
through our dreams and fantasies—
mysterious, frightening and beautiful."

Margo Weinstein (20th Century)

ARABIC

Saddling the Camel
1237

● Illustration from the *Maqat* (*Assemblies*) of Abu Muhammed al-Kassim Hariri (1064–1122). The camel, as a universal beast of burden, plays a prominent part in these stories.

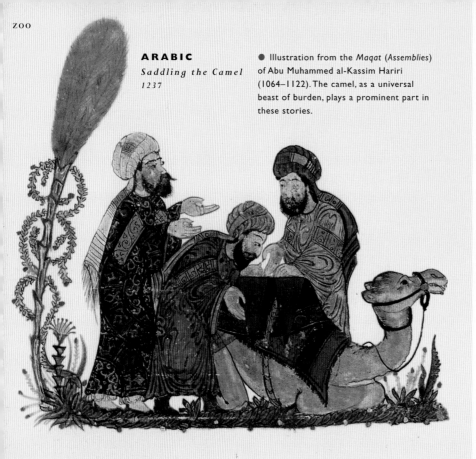

MÜLLER

The Sheik's Blessing
19th Century

● An Orientalist painter here uses the presence of two camels to stress the exoticism of his chosen scene. The location seems to be Algeria or Morocco, rather than Islamic countries farther east.

Richard Müller (1874–1930)

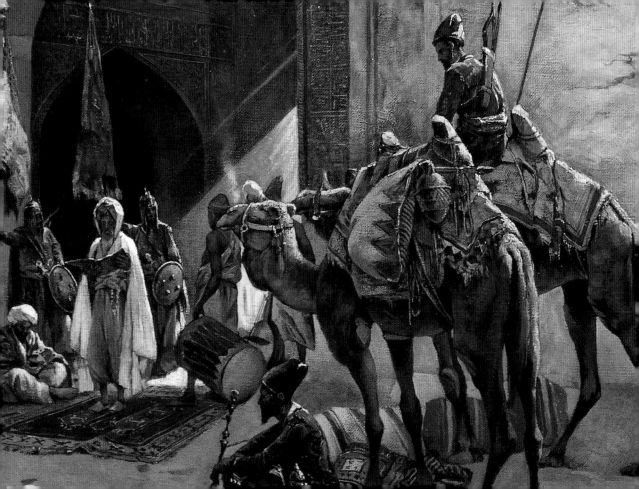

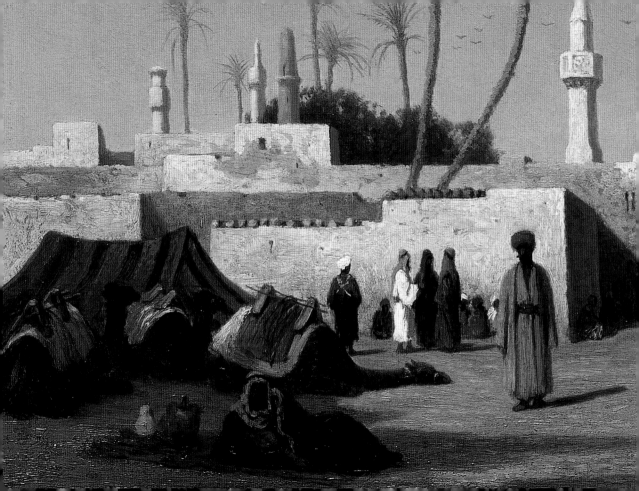

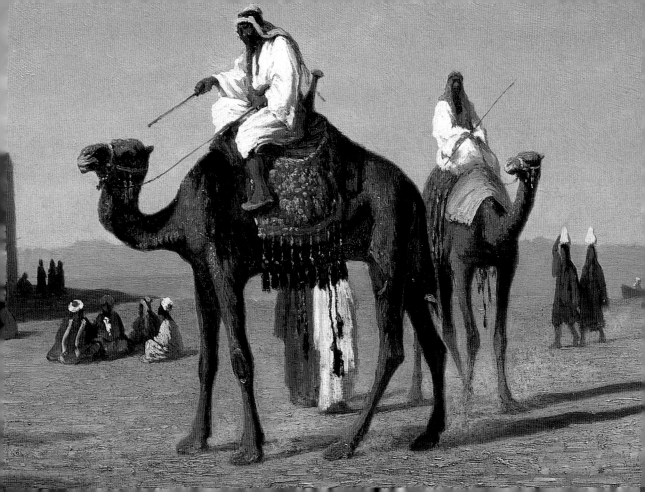

FRERE

Encampment at Beni-Souef, Algeria
19th Century

● Frere is here following in the footsteps
of Delacroix (1798–1863), his slightly
younger contemporary, the painter-critic
Eugène Fromentin (1820–76) who specialized
in Algerian scenes. The French conquest
of Algeria, from 1830 on, supplied a whole
new range of subject matter for French
artists. (see over page).

Charles-Théodore Frere (1814–88)

PERSIAN

Elephant
19th Century

● This embroidery, while delightfully naive,
still gives a strong sense of the elephant's
role as a quintessentially royal beast.

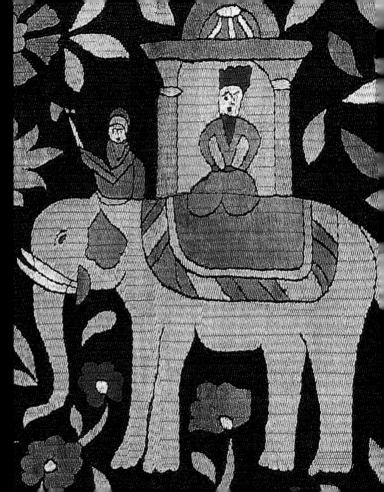

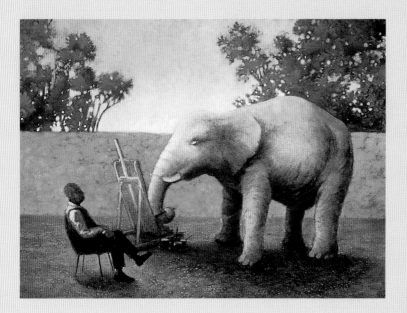

ZOKOSKY
B. J. Working
1991

● The artist here reverses the equation. It is the elephant who is busily engaged in portraying a human subject—not the other way around.

Peter Zokosky (b. 1957)

66
NATURE'S GREAT *masterpiece, an elephant,*
The only harmless great thing.
99

John Donne
(1572–1631)

elephant

277

elephant

CRANE & HOUGHTON

The Zoological Garden
19th Century

● From a series of illustrations on
the theme of London Town, this rather
self-consciously charming scene looks
forward to the work of Kate Greenaway
(1846–1901) and to the Swedish illustrator
Carl Larsen (1856–1910). The children
are without exception well dressed,
well behaved, and middle-class,
and the elephant they ride is
suitably benevolent and docile.

Thomas Crane (1808–59)
Elizabeth Ellen Houghton (19th Century)

AFTER **MANTEGNA**

The Triumph of Caesar

● This is a near-contemporary engraving, from Mantegna's own workshop, reproducing part of the very damaged *Triumph of Caesar* now at Hampton Court in England. The complete composition, on a number of canvases, forms a continuous strip tightly packed with animals and military figures. The artist based the composition on classical sources, such as the reliefs on Trajan's Column in Rome.

After Andrea Mantegna
(1431–1506)

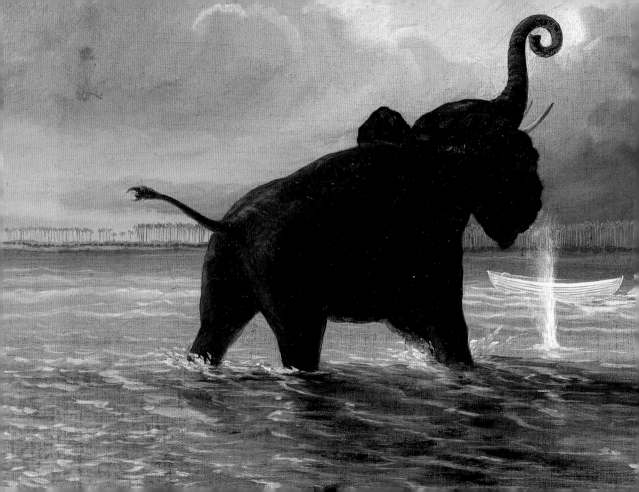

BAINES

Elephants in the
Shallows of the
Shire River
1858

● Thomas Baines was a
Norfolk drawing master.
As far as is known, he
never went to Africa,
which is where the Shire
River is. Despite the
romantic fluency of the
image, Baines is almost
certainly copying and
improving on an amateur
drawing made by a
genuine traveler.

Thomas Baines (1822–75)

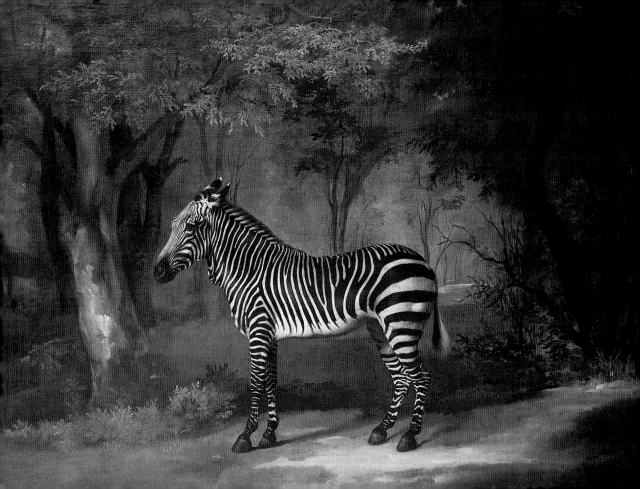

STUBBS

Zebra
1763

● In addition to painting horses, Stubbs made occasional images of more exotic animals. This is a female zebra, imported with her mate from the Cape of Good Hope (now in South Africa), and presented—accounts differ—to George III, when still Prince of Wales, or to his consort, Queen Charlotte. Despite the strong curiosity aroused in Britain by the flora and fauna of the country's rapidly expanding empire, Stubbs never succeeded in selling the painting, and it was still in his studio when he died.

George Stubbs (1724–1806)

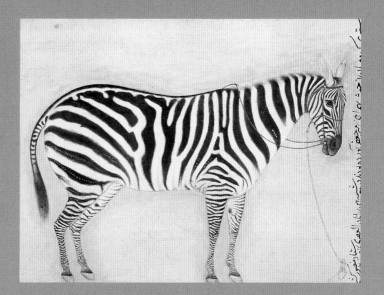

MANSUR

Zebra
1621

● Mansur was one of the chief court painters of the Mogul emperor of India Jahangir (1605–27), who honored him with the title "Wonder of the Age" and praised him in his memoirs as "unique in his generation." This drawing is attributed to Mansur in the emperor's own hand and is completely typical of his work in its understated naturalism.

Mansur (1590–1630)

283

FARTHEST NORTH
FARTHEST SOUTH

KENDAHL JAN JUBB

Portland Penguins

1989

FRENCH Illustration from
Children's Book *1894*

T HE EFFORT TO FIND *the Northwest Passage, a channel leading from the Atlantic to the Pacific around* the top of the North American continent, began in the fifteenth century. For hundreds of years, however, these attempts invariably ended in disaster.

Exploration of the Northwest Passage was difficult because of the severity of the conditions that were encountered. Sir Humphrey Gilbert (1537–83), one of the enthusiasts for such a route, drowned; Henry Hudson (d. 1611), cast adrift by a mutinous crew, discovered Hudson Bay, which turned out to be an icy dead end. Sir John Franklin (1786–1847) vanished with two ships and 128 men. The fact that there was actually a practicable sea route was not confirmed until 1906, when Roald Amundsen (1872–1928) completed an arduous three-year voyage.

Antarctica was explored much later—first tentatively by whalers and sealers (who almost exterminated the southern fur-seal in the course of the nineteenth century), then by intermittent scientific expeditions. The so-called heroic age of Antarctic exploration did not take place until later, in the first two decades of the twentieth century, which saw the expeditions of explorers such as Sir Ernest Shackleton (1874–1922) and Robert Falcon Scott (1868–1912), who became known as Scott of the Antartic.

LOUIS SARGENT Illustration
from *Wild Beasts of the World 1909*

The remoteness of these regions and the challenging conditions encountered there meant that the fauna that could be found in the Arctic and the Antarctic played a much smaller role in art than that of almost any other part of the

WESTERN ESKIMO
Snuff Box in the Form of Two Seals *19th Century*

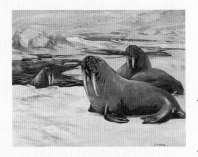

globe. In prehistoric times, the Inuit of the Dorset culture, which flourished in Greenland between 800 B.C. and 100 A.D., made small representations of animals from whale ivory and the bones of seals, fish, and polar bears. Later, in the nineteenth century, the Inuit tribe from Greenland made small carvings such as cribbage boards (the scoreboards for the card game of cribbage) in animal form, which were traded to passing European sailors. More recently still, Eskimo arts and crafts have flourished in the northern regions of Canada, and Eskimo artists have often chosen to depict the birds and animals most familiar to them in carvings and prints.

Apart from these, and somewhat similar work made by the Lapps—who occupy the regions of Sweden, Norway, and Finland within the

BRANCUSI The Seal *20th Century*

Arctic Circle—and the Chukchi in Siberia, images of Arctic and (much more rarely) Antarctic fauna seldom date from earlier than the mid-nineteenth century.

ENGLISH Polar Bear *1850*

Polar bears, because of their size, have probably attracted the most attention from European and American artists. The great Victorian animal painter Sir Edwin Landseer (1802–73) made them the subject of one of his more disturbing paintings, and in the Art Deco period there was a fashion for small sculptures of polar bears, often made in ceramic or glass. Perhaps the only undoubted masterpiece inspired by an animal from one of these regions is the smoothly simplified sculpture of a seal by Constantin Brancusi (1876–1957). This catches the paradoxically mechanistic character of many Arctic creatures—the efficiency of form that helps them survive in a hostile environment.

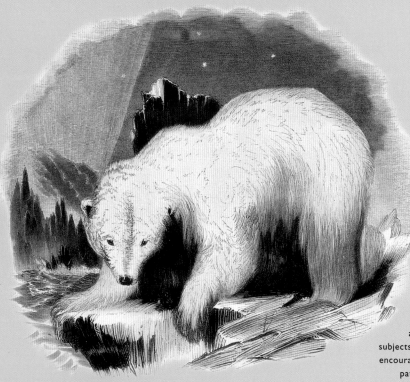

WHYMPER
The White Bear
1843

● This illustration was published by a missionary organization more than ten years before Charles Darwin's *Origin of Species* (1859). The moralizing text that accompanied it had a strangely Darwinian twist, saying there is no greater evidence of the wisdom of the creator than the adaptation of animals to their environment.

Josiah Wood Whymper (1813–1903)

RALEIGH
Chilly Observation
1889

● An excellent example of the way artists favor humanizing their animal subjects. Here the polar bear is depicted to encourage the viewer to empathize with its patient vigil on the brink of an icy sea.

Charles B. Raleigh (1831–1925)

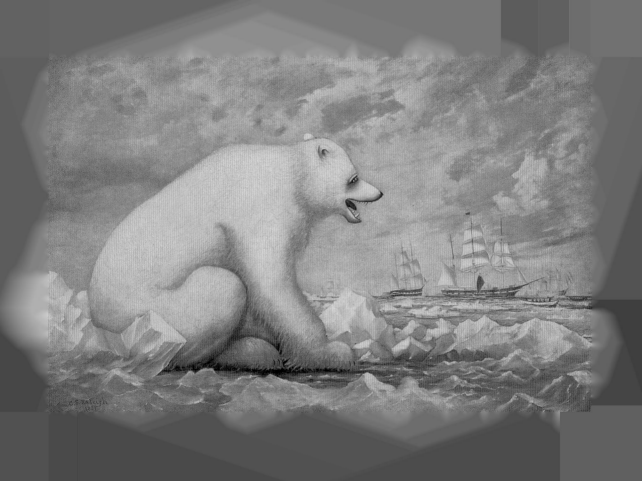

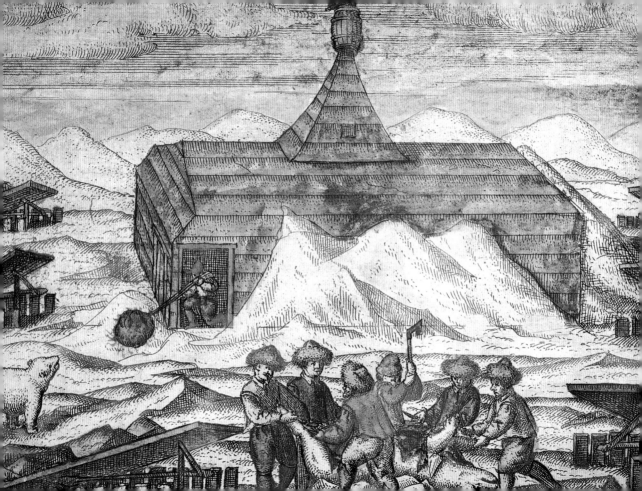

DUTCH

Willem Barents'
Hut in Novaya Zemlya
1597

● Willem Barents
(c. 1550–97) was the father
of polar exploration, a Dutch
navigator who made three
expeditions to the Arctic in the
closing years of the sixteenth
century. This illustration, from
a contemporary account of his
voyages, shows the hut built
by his last expedition, which
wintered in the north, with a
polar bear outside it. Remains
of this dwelling were
rediscovered in 1871.

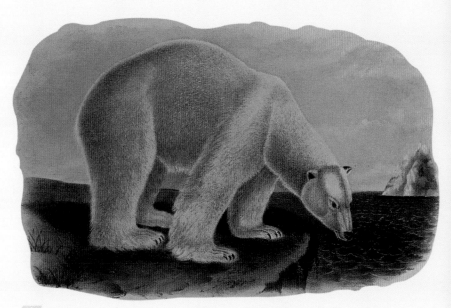

AUDUBON

Polar Bear
1842–45

This magnificent image comes from Audubon's *Viviparous Quadrupeds of North America,* which is much less celebrated than his other collection of large plates, *Birds of North America.* Audubon's images owe their attraction, at least in part, to their simplicity and monumentality—qualities that are especially conspicuous here.

John James Audubon (1785–1851)

293

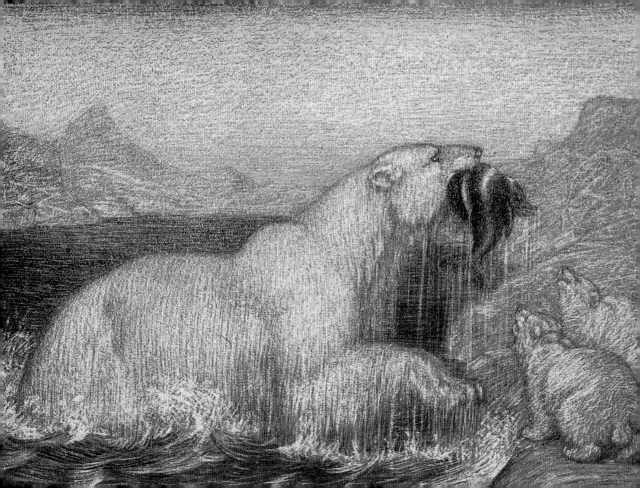

> THE POLAR BEAR IS UNAWARE
>
> *Of cold that cuts me through:*
>
> *For why? He has a coat of hair.*
>
> *I wish I had one too!*

Hilaire Belloc (1870–1953)

SARGENT
Ursus Maritimus
1909

● While a number of pictures and sculptures of polar bears and other arctic fauna anticipate the Art Deco style, here the artist reverts to the tradition of the great mid-nineteenth-century animal painter Sir Edwin Landseer (1802–73), and chooses to emphasize the physical power and potential ferocity of the animal, even when it is playing a maternal role.

Louis Sargent (20th Century)

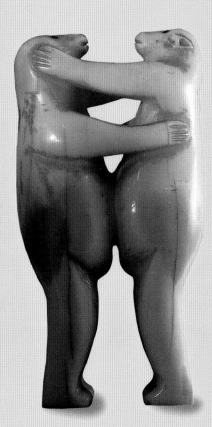

WESTERN ESKIMO
Two Polar Bears
Embracing
19th Century

● This small carving made of walrus ivory is typical of the artifacts made by Eskimo tribesmen for sale to Europeans, mostly the crews of passing whaling ships, in the ninteenth century. The carvings differ from the much older ones belonging to the Dorset Culture (800 B.C.–1300 A.D.) because they have no practical purpose in Eskimo life. The imagery, however, still refers to Inuit mythology, in which the polar bear quite naturally plays a dominant part.

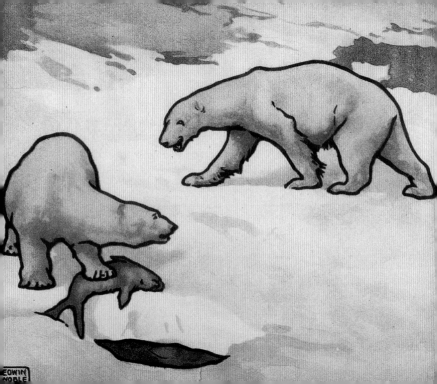

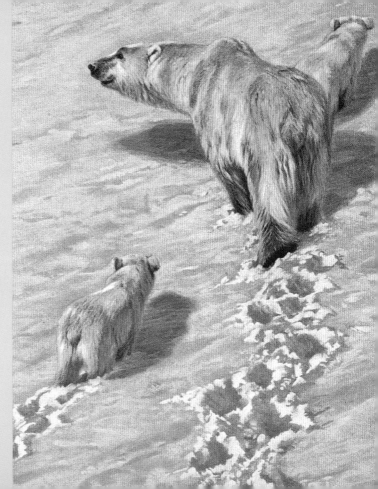

NOBLE
Polar Bears
1914

● This late-Edwardian illustration already has elements of the style that a decade later would be described as Art Deco. The streamlined simplification of the forms and use of firm outlines is typical.

Edwin Noble
(20th Century)

FRIESE
Polar Bear Family
20th Century

● The steeply tilted viewpoint owes something to the aerial photographs made by various Arctic expeditions during the early years of the twentieth century.

Richard Friese (1864–1935)

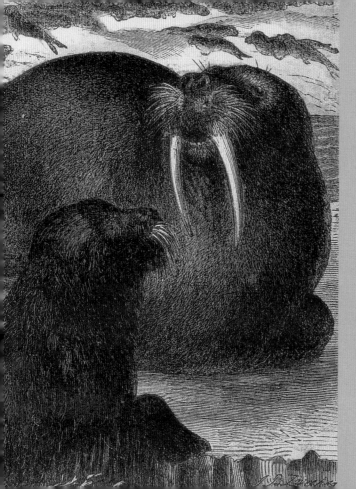

GERMAN
Walrus
1876

● The late Victorians were the first to have a nearly complete overview of the physical world they inhabited, and they felt acute curiosity about the other creatures that shared it with them. This is an illustration from one of the many popular books that fed this hunger for information.

DÜRER
Head of a Walrus
1521

● A drawing made during Dürer's journey to the Netherlands between July 1520 and July 1521. The artist, received with great honor by his Dutch colleagues, was intensely interested in everything he saw, whether these sights were buildings, paintings by leading Flemish masters, or "natural wonders," like this walrus, which he saw on an expedition to the seacoast.

Albrecht Dürer
(1471–1528)

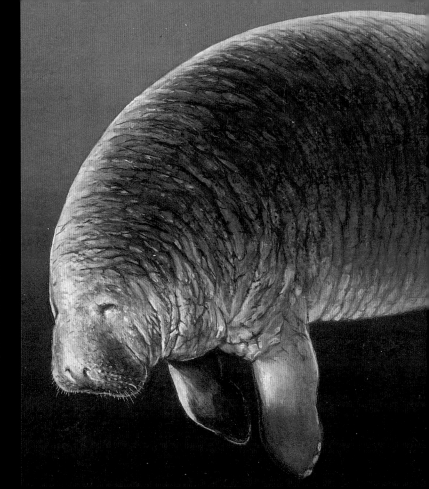

BRANDSTETTER

*Steller's Sea Cow, Bering
Sea, Extinct in 1768*
1996

● This, despite its apparent
realism, is a conceptual work that
laments humankind's destruction
of the natural environment. This
decline is symbolized by the
ghostly image of a variety of sea
cow that was discovered in 1741,
and that hungry sealers had
already hunted to extinction by
the end of the third quarter of
the eighteenth century.

Johann Brandstetter (b. 1969)

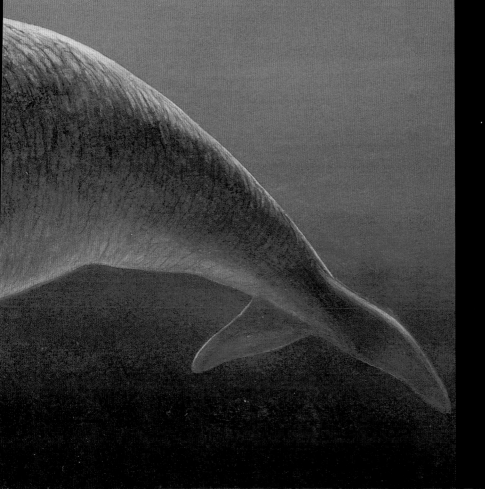

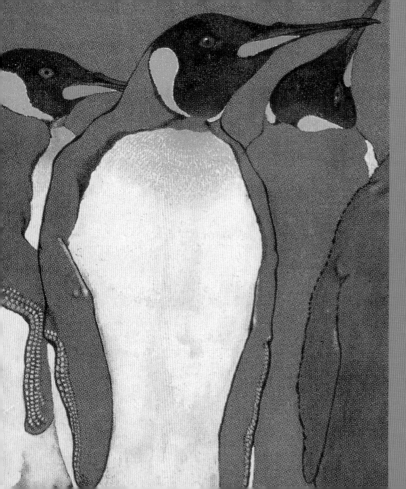

YARROW JONES

King Penguins
1912

● An illustration in a pre-Art
Deco style showing arctic
fauna. The book from which it
comes is entitled *The
Childhood of Animals*, and the
artist has been careful to
differentiate between the
mature birds in their black-
and-white livery, and the
smaller, brownish penguin
chicks.

E. Yarrow Jones (20th Century)

penguin

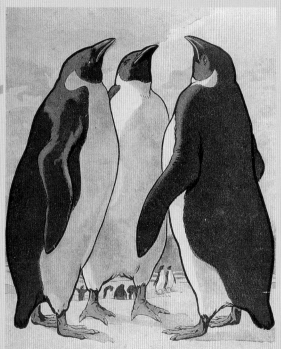

FRENCH
Penguins
c. 1910

● This picture comes from a pre-1914 French children's book. The interest in everything to do with the Arctic was particularly strong at this time because of the widely reported expeditions of men like Fridtjof Nansen (1861–1930), Roald Amundsen (1872–1928), Robert E. Peary (1856–1920), and Robert Falcon Scott (1868–1912). Penguins were particularly popular because of their comical appearance and conduct, which made them seem quasi-human.

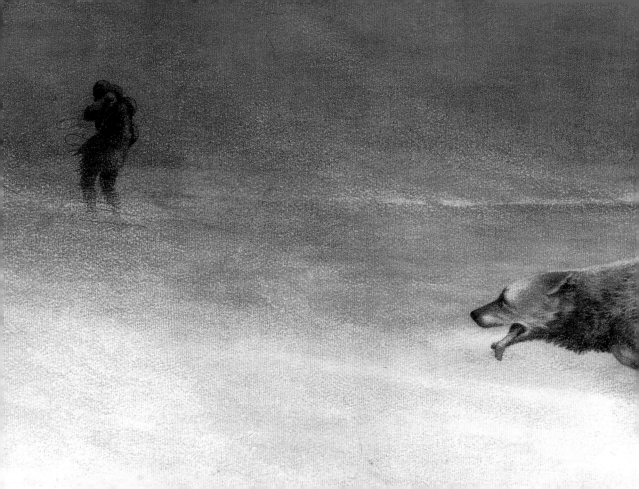

MORGAL

*Wolves Hunting
an Explorer
c. 1900*

● A painting that demonstrates the difficulties that confronted artists who wanted to make something out of this subject matter. Basically, the painter has had to do his best with what is essentially a featureless landscape. It is the well-observed pair of wolves, especially the wolf seen in detail in the foreground, that give the painting its frisson of danger.

H. Morgal (fl. c. 1900)

MICROCOSMOS

T HE WORLD OF INSECTS *was a popular sight in Ancient Egyptian and Minoan art. The Egyptians, for example, had a particular reverence for the scarab beetle, seeing in the movement of the ball of dung that the beetle rolls to its burrow a parallel with the passage of the sun across the sky. The palatial Minoan villa at Mália in Crete yielded a gold pendant that shows two bees on either side of a honeycomb. There are also numerous representations of insects on Classical Greek gems and coins—including flies, bees, and grasshoppers (the last of these sacred to Apollo because they sing in the heat of the day).*

Insects once again began to exercise a special fascination for artists in the fifteenth century, when butterflies and other creatures appeared in the decorative borders of some of the books of hours turned out by the leading

A. J. RÖSEL VON ROSENHOF
Engraving of a Caterpillar
Cocoon *1746–60*

School of **JEAN BOURDICHON**
Hours of the Virgin *1515–20*

Flemish artists such as those in the late fifteenth-century School of Bruges. Late medieval illuminators took a particular pleasure in trying to trick the spectator's eye, painting both butterflies and jeweled ornaments in such a way that they look as if they could actually be picked up and removed from the page.

Insects nevertheless did not make their fullest and most varied appearance in art until the seventeenth century. There seem to be several related explanations for this. One is that the period saw a great advance in optical science. Among the places

where this development began to emerge was the Netherlands, with its already highly sophisticated maritime and scientific tradition. Microcosm—the miniature universe inhabited by insects—was now more immediately accessible to people, and they took full advantage of this.

OTTO MARSEUS VAN SCHRIEK
Insects and Reptiles in the Wood *17th Century*

The popularity of insect painting in the Netherlands during the seventeenth century was epitomized by such artists as Jan van Kessel the Elder (1629–79). Van Kessel was famous for producing small panels on which different species of insects were represented, apparently for their own sake, but in an unsystematic way. Other Dutch artists created albums that collected together different species of moths and butterflies in much the same fashion as the tulip books of the same epoch, made as systematic catalogs of all the possible varieties of this fashionable flower.

Despite the tendency during this period to depict insects in a more scientific way than in the past, at the same time many did retain their allegorical significance. The butterfly has symbolic importance in many

A. J. RÖSEL VON ROSENHOF
Engraving of a Moth
(*Acherontia Atropos*)
1746–60

A. J. RÖSEL VON ROSENHOF
Engraving of a Moth (*Acherontia Atropos*) 1746–60

religions; for example, in Christianity, a butterfly emerging from its chrysalis was seen as the image of the soul freed from the flesh. This is why the butterfly appears as a subsidiary element in so many of the Dutch flower pieces. It also, because of the brevity of its life span, served as an emblem of the fleetingness of human life, and as such features in many Vanitas compositions, usually combined with other images of transience, including watches and soap bubbles or skulls to symbolize death.

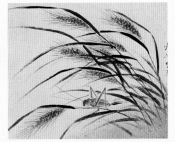

SHIBATA JUNZO ZESHIN
Grasshopper and Wheat *19th Century*

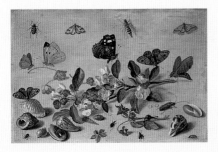

Insect symbolism also recurs in Asian art. For the Chinese, the cricket was an emblem of resurrection; for the Japanese, butterflies were the images of womanhood, while a pair of butterflies stood for marital happiness.

JAN VAN KESSEL THE ELDER
Still Life of Moth, Shell, Apple Blossom, and Beetles *17th Century*

311

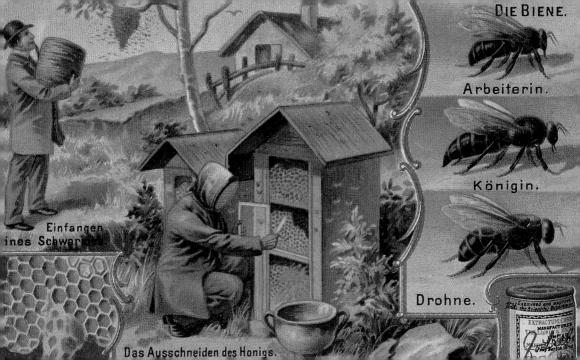

Die Biene.

Arbeiterin.

Königin.

Drohne.

Einfangen eines Schwarmes.

Das Ausschneiden des Honigs.

GERMAN

The Bee

c. 1900

● This charmingly naive poster is an advertisement for an instructional series called "Lliebig's Fleischextract." It shows a beekeeper taking a swarm, then extracting the honey from the hive, and illustrates the three types of bees—worker, queen, and drone. It also, at a time of rapid industrialization in Germany, celebrates rather nostalgically the pleasures of rural life.

bee

HOEPPNER

Heather

19th Century

● An illustration to the poem *Portrait of the Moor* by Theodor Storm, this is a coy personification of nature and natural forces in the manner of Victorian fairy pictures. Riding a leafy chariot pulled by two rabbits, the personification of heather holds out her hand to be kissed by the bees, whom she helps to make honey.

Julius Hoeppner (1839–93)

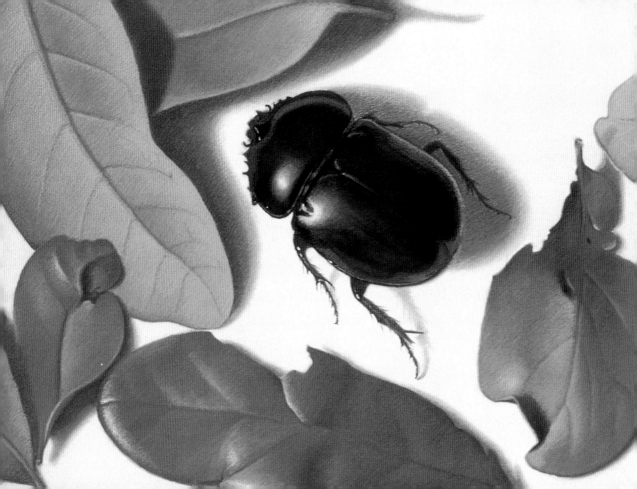

CURRIER

Beetle
1986

● In recent years a number of artists, paricularly in the United States, have retreated from Modernism and have begun to experiment with trompe l'oeil—painting that tries to trick the eye into thinking this is the real thing, not just a representation of something. Mary Ann Currier's work is an example of this tendency.

Mary Ann Currier
(20th Century)

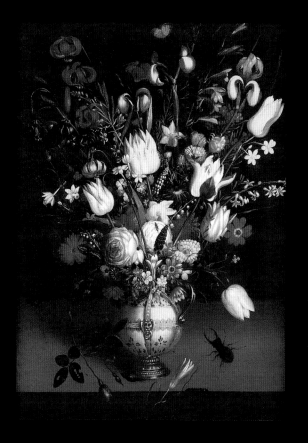

MARLIER

Vase of Flowers
with a Stag Beetle
17th Century

● Dutch artists, and French and German artists working in the same tradition, often depict insects in their opulent flower paintings as symbolic reminders of mortality.

Philippe de Marlier
(fl. 1640–77)

EGYPTIAN
A Scarab Beetle
c. 1300 B.C.

● Sacred to the Egyptians,
the scarab rolling its ball of dung
reminded them of the sun rolling across
the heavens. This handsome, slightly
stylized representation from the tomb
of Sennedjem at Thebes stresses the
scalloped edges of the creature's front
legs, which facilitate digging. Egyptian
painters used only very few earth
colors. These hues are almost
impervious to fading.

FLEGEL
Still Life with Fruit,
Nuts and a Stag Beetle
16th Century

● The stag beetle in this
picture serves as a reminder
of mortality—a popular
theme during this period.
There is also another insect
here: a bee perched on the
vine leaf at the top center of
the composition.

Georg Flegel (1563–1638).

THE CREATOR, IF HE EXISTS,

has a special preference for

beetles.

J. B. S. Haldane (1892–1964)

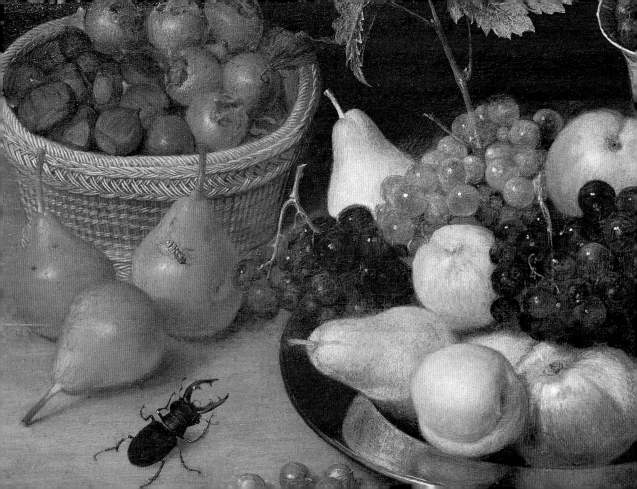

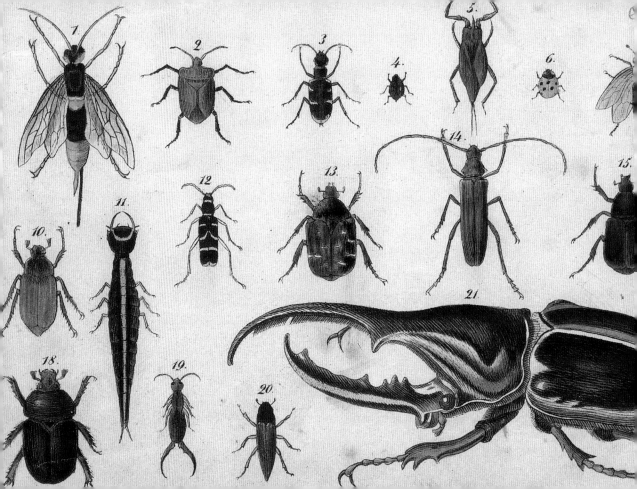

GRÜNEWALD
Insects
1841

● From an early
nineteenth-century
children's encyclopedia,
Orbis Pictus, this
lithograph offers a
classification of various
insect species with, once
again, a stag beetle taking
pride of place.

Heinrich Grünewald
(19th Century)

Gedruckt
im Deutschen Verlag
Berlin

Ein harmloser Mensch

MERIAN
*Cardos Spinosus,
with Beetles and
Caterpillars*
17th Century

● A good example of the
work of one of the most
celebrated natural history
illustrators of her time.
Women artists, forbidden by
convention to draw from the
nude figure, were forced
to find specialties
that did not require
this kind of training.
Merian's main subject
is the plant itself—a
form of thistle—
but she adorns it
with exquisitely
precise studies
of insects.

Maria Sibylla Merian
(1647–1717)

SOMERVILLE
*Don't Bother Me –
The Worms Will
Cheer—Gregor*
1995

● Made on book pages
printed in Germany, these
drawings refer, in the artist's
mind, to topics such as "the
history of plagues, their effect
on people, society … and its
institutions, such as the
church." The right-hand
drawing, showing a cockroach,
borrows its title *Gregor* from
the famous Kafka short story
in which a man awakens and
finds that he has turned into
a giant insect.

Travis Somerville (b. 1963)

321

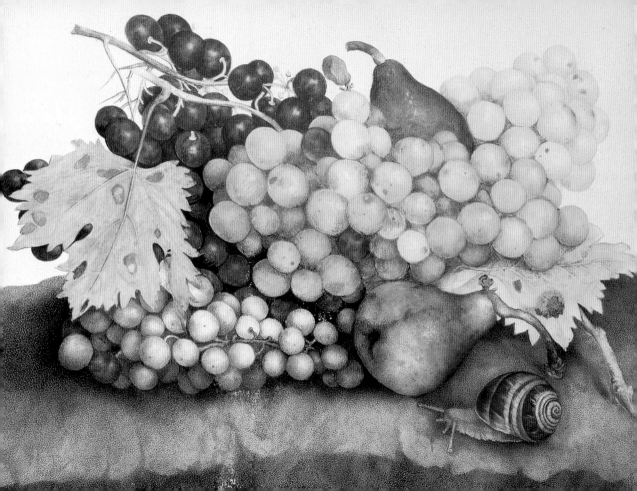

VAN DER AST

Shells and Fruit, with a
Butterfly and a Lizard
17th Century

● The painting is essentially a tribute to the
seventeenth-century Dutch passion for shell
collecting, which preceded the similar Dutch
passion for exotic species of tulip.

Balthasar van der Ast (1593/94–1657)

GARZONI

A Snail with Grapes and Pears
17th Century

● Here the snail appears to be the edible variety
often found in vineyards and often served to the
grape harvesters cooked in wine.

Giovanna Garzoni (1600–70)

VAN SCHRIEK

Butterflies in the Undergrowth 17th Century

● The artist is correct in indicating that butterflies love damp patches of soil, and are not always too fastidious about their habitat. There was a fashion in the Netherlands, toward the end of the seventeenth century, for paintings of this sort, often featuring snakes and other creepy-crawlies in addition to insects.

Otto Marseus van Schriek (c. 1619–78)

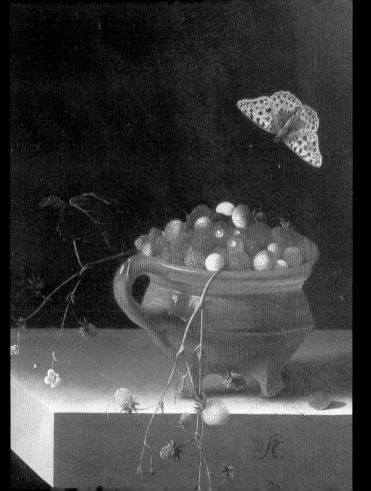

❝

FLOAT LIKE
a butterfly,
sting like
a bee.

❞

Muhammad Ali
(b. 1942)

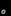

DE COORTE

A Pot of Wild
Strawberries
and a Butterfly
17th Century

● De Coorte was an artist who specialized in small still lifes featuring very few objects, painted in an extremely precise, miniaturist fashion. Here he has enlivened a corner of his composition with a pearl-bordered fritillary butterfly.

Adriaen de Coorte
(fl. 1683–1707)

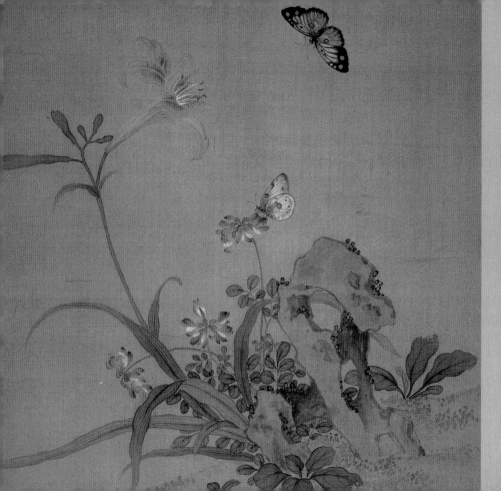

CHINESE

Butterflies and Flowers
19th Century

● This style of painting reaches back to the Sung Dynasty and in particular to the work of the unfortunate painter-emperor Hui Tsung, who ended his life as the captive of the invading Mongols. However, the painting itself is probably a nineteenth-century work. It features (top right) what looks like a marbled white butterfly, but these are not usually found in China, so both insects must be variants of the ordinary cabbage white, which has a wider distribution.

butterfly

MORRIS

*Butterflies and
Caterpillars
19th Century*

● The butterflies include—
reading from the bottom of the
composition—two painted ladies,
two large heath butterflies, two
small whites, two small blues, and
a small tortoiseshell. These are all
species commonly found in
Britain, and so they make logical
subject matter for this Victorian
amateur artist and entomologist.

Rev. F. O. Morris (19th Century)

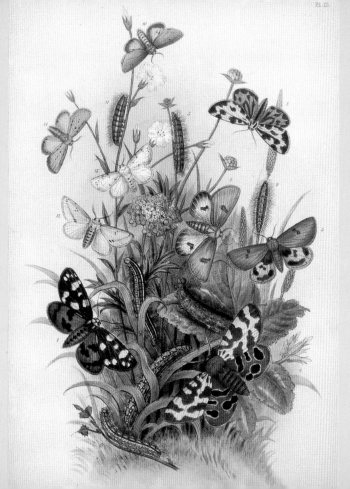

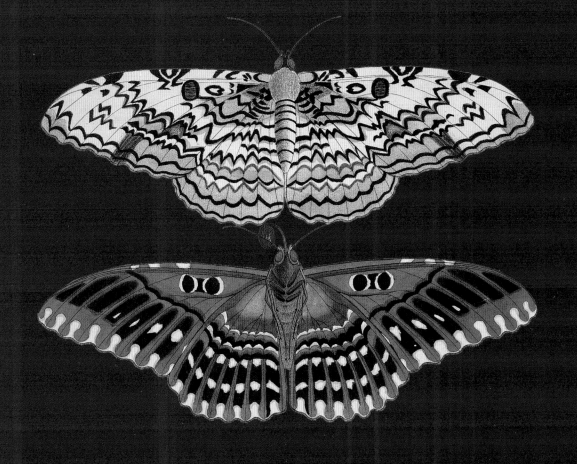

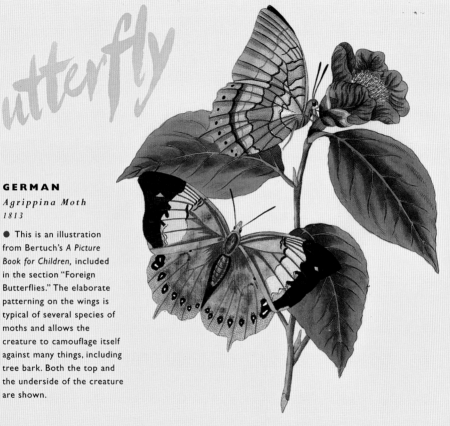

butterfly

GERMAN

Agrippina Moth
1813

● This is an illustration
from Bertuch's *A Picture
Book for Children,* included
in the section "Foreign
Butterflies." The elaborate
patterning on the wings is
typical of several species of
moths and allows the
creature to camouflage itself
against many things, including
tree bark. Both the top and
the underside of the creature
are shown.

GERMAN

Bernard's Butterfly
1809

● Also from Bertuch's *A
Picture Book for Children,* the
butterfly in this illustration
is a Chinese species
of swallowtail, now
apparently rare. In order
to symbolize its origin,
the artist has placed it
on a camellia stem. The
plant suggests that the
butterfly flourishes best in
damp, mountainous regions.

EDEN AND THE ARK

JAN BRUEGHEL THE YOUNGER
The Animals Entering the Ark
1613–15

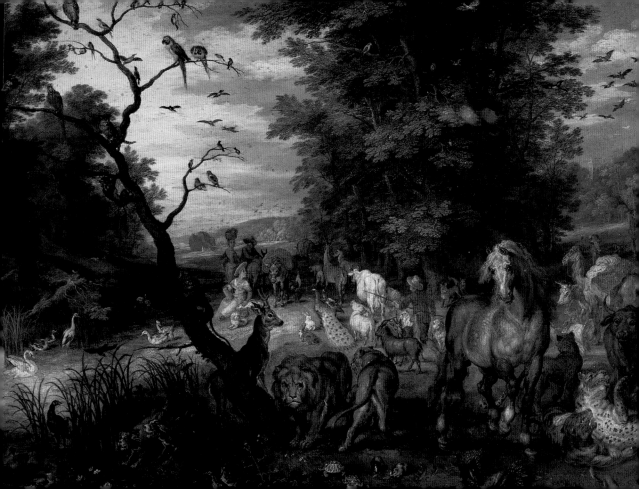

FRANS FRANCKEN THE ELDER
The Creation of Eve *1600*

THROUGHOUT THE CENTURIES *artists have always enjoyed portraying a multitude of animals and have taken full advantage of two standard biblical stories in order to do so: the Garden of Eden and Noah's Ark.*

Eden, offering an image of the world before the Fall, also reflects other beliefs. For example, by showing all types of creatures in a state of peaceful co-existence, depictions of it suggest that animal ferocity is in some way an echo of human wickedness. In other words, it occurred only after the Fall from Grace. The animals and birds in these scenes of the Garden of Eden are also commonly shown in couples. The implication is that their sexuality remains innocent, untainted by guilt or shame, while that of Adam and Eve is corrupted by their discovery of sexual self-consciousness.

FRENCH
Cathedral Choir
Stalls Depicting
Noah's Drunkenness
Early 14th Century

The legend of the Flood is as widespread as the legend of the Fall, to the point that archeologists and other professionals, especially those working in the Middle East, have convinced themselves that a widespread natural catastrophe of this kind must have taken place at some point in time in order to have left such a powerful folk-memory behind it. Similar myths were also known to the Greeks, the people of the Indian subcontinent, and the Aztecs. It is also worth noting that the Ark itself has powerful symbolic force, since it is the visible representation of divine protection for all living things.

In classical mythology, the legend that gave the most scope for the representation of a multitude of animals in one place was that of Orpheus, the singer and lyre player who charmed not

PABLO CAMPOS Nona's Ark *1996*

333

ROELANDT JACOBSZ SAVERY
Orpheus Charming the Animals *1626*

only the animals, but also gods, humans, plants, and natural forces such as the winds and waves. Animals generally play a preponderant part in representations of this aspect of the story, since their fascination with Orpheus' music was easier to demonstrate in purely visual terms. Another similar mythological scene is the Mistress of the Animals, the title given in Homer to the Greek goddess of the hunt, Artemis.

Pictures of Eden or of the animals entering, or sometimes leaving, the Ark under Noah's direction occur in European art from the late Middle Ages to the Baroque period, with a few stragglers such as the nineteenth-century American painter William Hicks' much-loved Peaceable Kingdom (c. 1840–45). Those created from the mid-nineteenth century on are of particular interest because they not only offer a catalog of the animals and often also the birds known in Europe at that time,

but give as well a good idea which of them a particular artist had actually seen, and which were only copied from pattern books and other visual

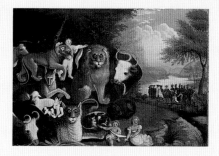

documents. They also serve as a reminder of the comparatively limited number of species that were then available for inspection.

These species at times overlap into the realm of the purely fanciful. It is difficult to make out whether the artists concerned were misled by representations, or

EDWARD HICKS
The Peaceable Kingdom *c. 1840-45*

simply descriptions, of species that they had never seen, or

whether, in their eagerness to portray the whole of creation, they deliberately added creatures drawn from both Christian and pagan myths.

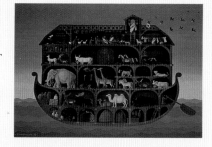

LOVIS CORNITH Noah's Ark *19th Century*

"

THROUGHOUT THE
sensual world
proclaim,

One crowded hour
of glorious life.

"

Thomas Osbert Mordaunt
(1730–1809)

MACKE

Triptych: Large
Zoological Garden
1913

● Macke, who was killed in
World War I (1914–18), was a
close friend and associate of
Franz Marc (1880–1916) in the
Blaue Reiter group. He treats
the animals he has chosen to
paint in much the same lyrical
fashion, though they are shown
in captivity rather than
in the wild.

August Macke (1887–1914)

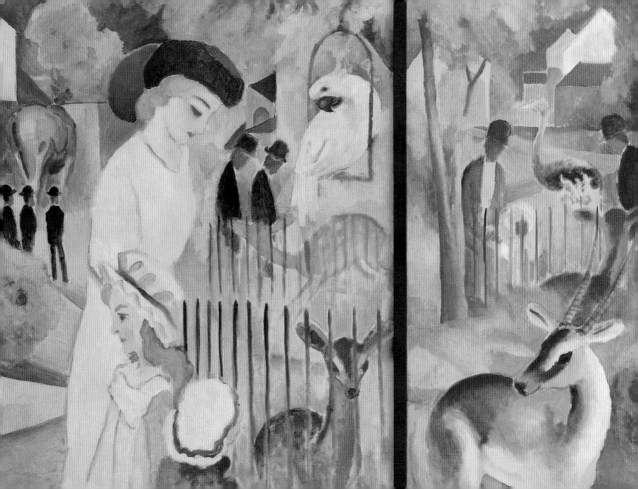

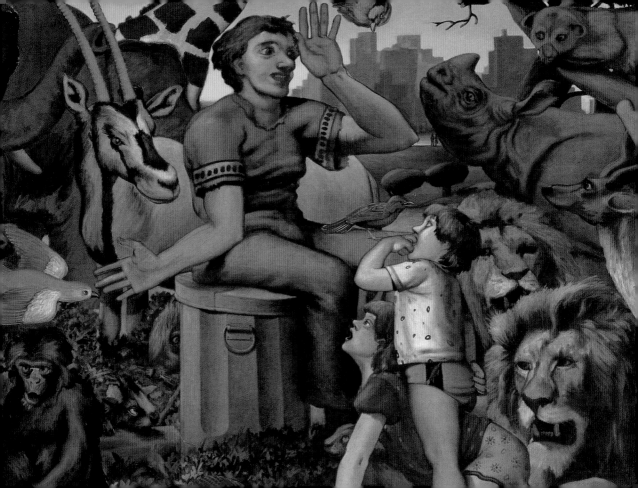

REICE

"Aesop"
(That's Rock 'n' Roll)
1984

● A cheerfully irreverent depiction of the quasi-legendary author of the most celebrated collection of beast fables. Here Aesop is depicted as a kind of Orpheus, surrounded by the animals he wrote about, who listen enchanted to his tales.

Milo Reice (b. 1952)

BOUTTATS

Orpheus and the Animals
17th century

● Orpheus charms the animals with his music, which evokes social harmony even among beings who are by instinct incompatible.

Jacob Bouttats (fl. c.1675)

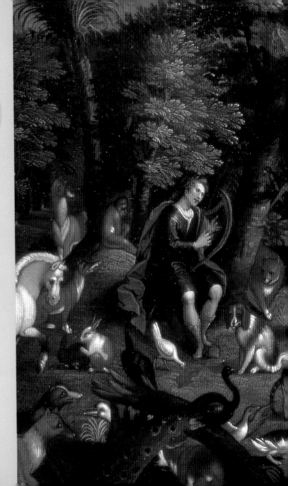

MÜTZEL
Australian Fauna
1907/8

● As late as the beginning
of the twentieth century, the
fauna of Australia was thought
of as peculiarly strange and
exotic. This color lithograph
brings together some of the
species most typical of the
Australian continent, among
them a kangaroo, an emu, and
a duck-billed platypus.

G. Mützel (18th Century)

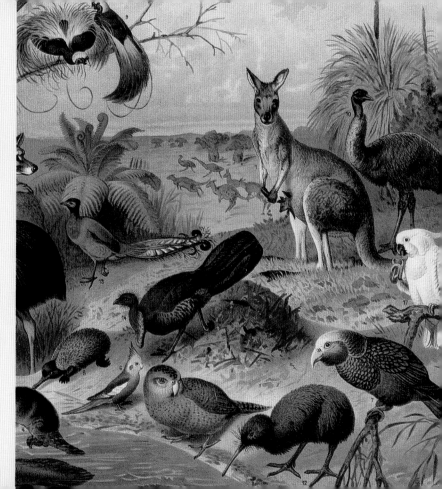

WEENIX

American Menagerie
c. 1695

● Probably from a set of decorative paintings where the Four Continents were symbolized by portraying beasts and bird associated with them. Here one can see a splendid white cockatoo, a toucan, and, in the background to the left, an anxious-looking gopher.

Jan Weenix (1642–1719)

BERTRAM OF MINDEN

The Creation of Animals
1379

● Perhaps the most lyrically beautiful of all medieval representations of the Creation, this panel by a leading practitioner of the International Gothic style gives a good idea of what species were familiar at the time. It is interesting to see that the fish include a pair of sharks and also a pipefish.

Master Bertram of Minden
(c. 1340–1414/15)

❝

IT HAS BEEN SAID *that the highest praise of God is in the atheist's denial of Him, finding creation perfect enough to do without a creator.*

❞

Marcel Proust
(1871–1922)

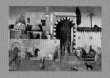

SANCHEZ

A Last Supper 3
1981

● This is one of a series of paintings that appropriates the popular Renaissance theme of *The Last Supper.*

Stephanie Sanchez
(b. 1948)

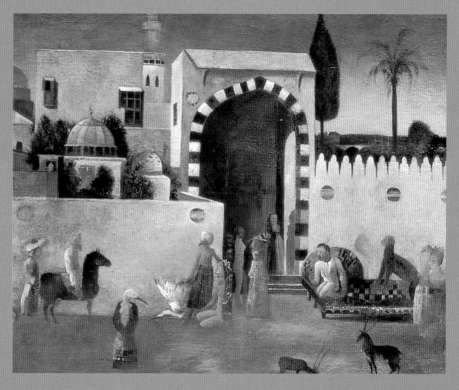

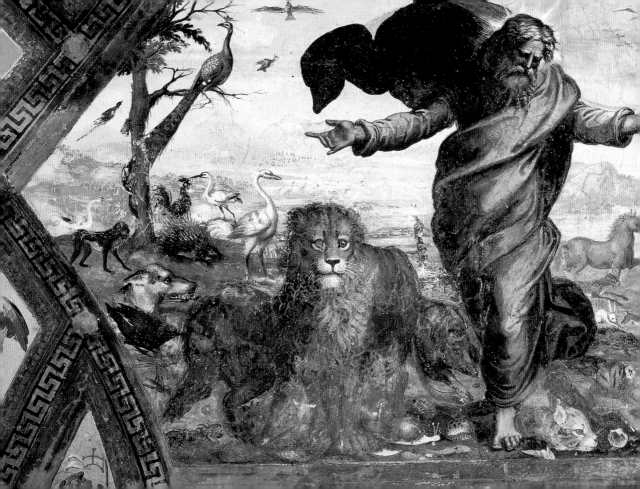

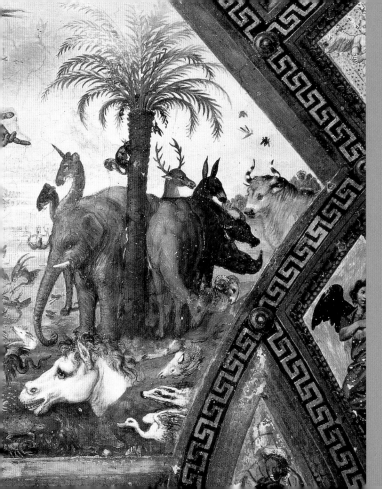

Creation

RAPHAEL

The Creation of the Animals
c. 1515–18

● Raphael's vision of the Creation,
painted in the Vatican loggia, includes a
pair of unicorns, one of which, however,
looks suspiciously like a giraffe with a
horn in the center of its forehead.

Raphael Sanzio (1483–1520)

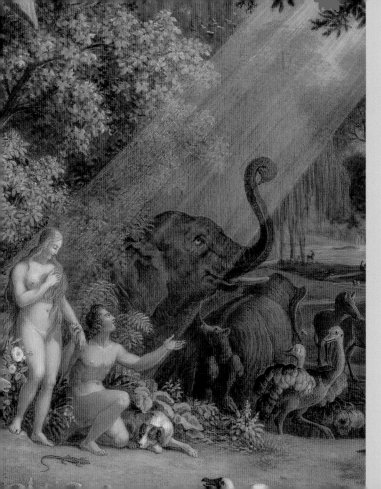

FRENCH

Adam and Eve Surrounded by Animals
c. 1839

● This painted porcelain plaque features some of
the animals and birds considered most interesting
at that time. Plaques of this sort were decorated
over the glaze with enamel colors. They were used
to decorate furniture and were also regarded as
independent works of art.

MERIAN

The Expulsion from Paradise
1625/27

● In this hand-colored engraving, as Adam and Eve
are driven out of the Garden of Eden, the various
animal species continue to co-exist peaceably.
This engraving is a rare example of
hand-coloring contemporary with the print itself.

Matthäus Merian the Elder (1593–1650)

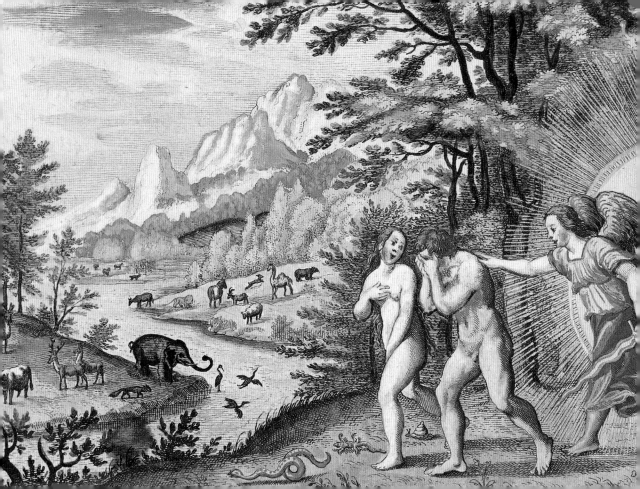

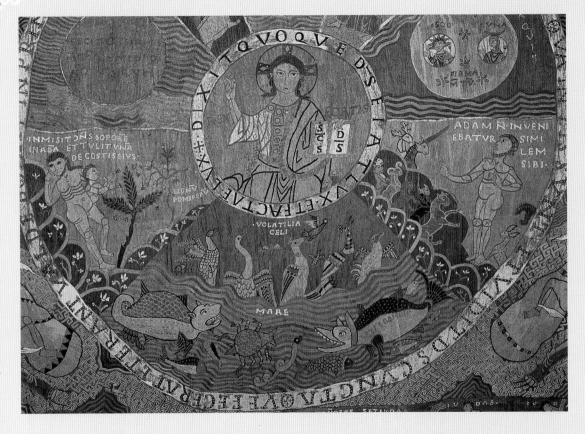

348

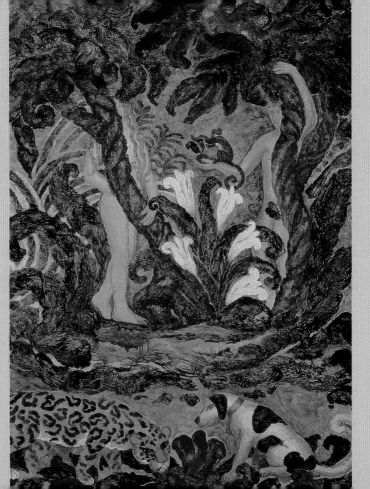

SPANISH

God as Creator, and Adam Naming the Beasts
12th Century

● While God busies Himself with creating the birds and sea creatures—some of the latter extremely fanciful—Adam names the beasts. His total nudity, though appropriate to the story, is unusual in the art of this epoch.

FERNÁNDEZ SAUS

The Garden of Eden
1996

● Fernández Saus returns once more to his signature theme— the leopard, figuring prominently in this contemporary depiction of an age-old theme.

Ramiro Fernández Saus
(20th Century)

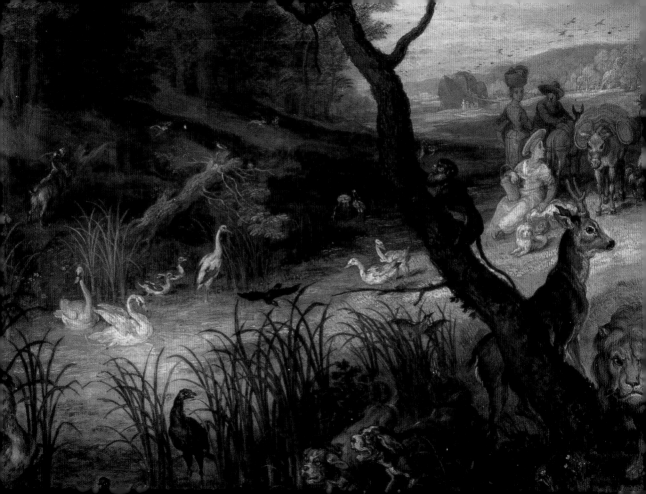

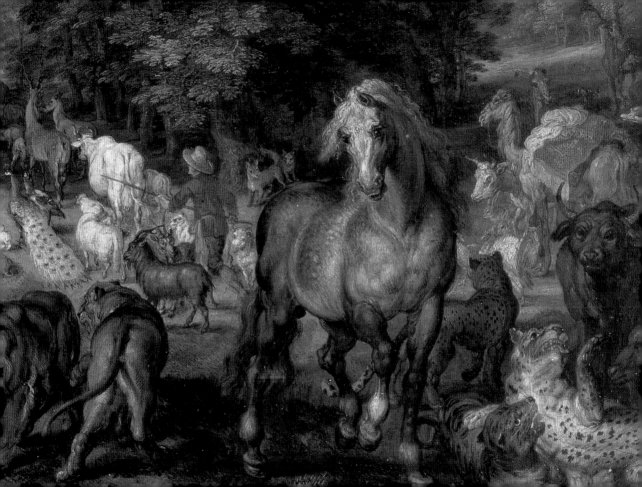

BRUEGHEL

The Animals Entering
the Ark
1613–15

● This is a copy after Jan Brueghel
the Elder (1568–1625). Members of
the Brueghel family often repeated
one another's compositions. A
striking feature is the playfulness
of some of the animals, notably the
pair of leopards seen to the right.
(see previous page).

Jan Brueghel the Younger (1601–78)

And to him on board the ark went one pair,
a male and a female, of all beasts,
clean and unclean, of birds,
and of everything that creeps on the ground,
two by two, as God had commanded.

Genesis (chapter 7:8–9)

SAVERY

The Animals Entering the Ark
17th Century

● The familiar biblical story is here used as
an excuse for a virtuoso display of zoological
information, including both species familiar
and unfamiliar in Europe at this time.

Jacob Savery (1593–1627)

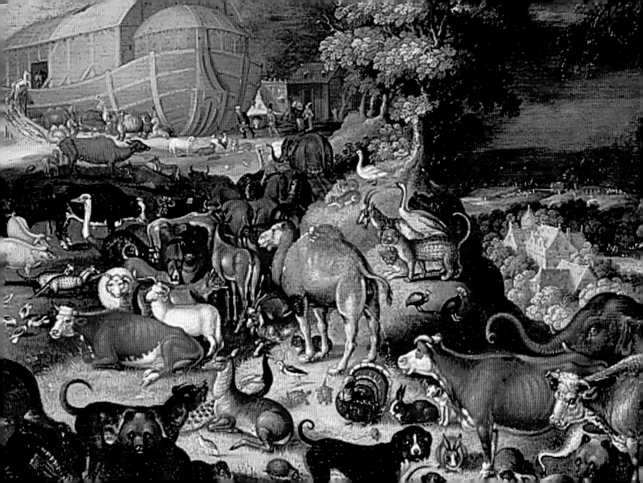

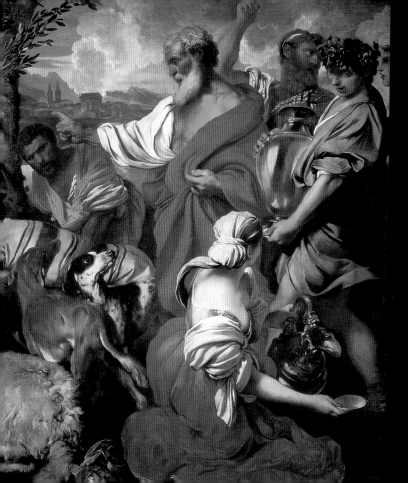

CASTIGLIONE

The Animals Entering the Ark
c. 1650

● The Genoese painter Castiglione
follows the Bassano tradition, but puts
more emphasis on the human beings
involved. Exotic species are pushed into
the background, as if the artist felt less
confident about portraying them.

Giovanni Benedetto Castiglione
(c. 1609–63/65)

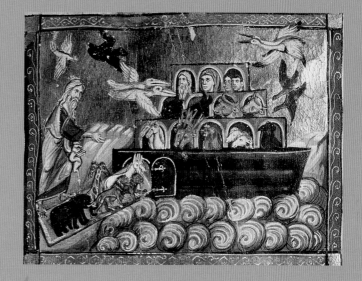

> *God wiped out every living*
> *creature that existed on*
> *earth, man and beast,*
> *creeping thing and bird; they*
> *were all wiped out over the*
> *whole earth and only Noah*
> *and those who were with him*
> *in the ark survived.*

Genesis (chapter 7:23)

FRENCH

The Animals
Entering
the Ark
c. 1260/70

● An orderly and hierarchical arrangement
here, in an illumination made for a Crusader
manuscript. Noah urges the animals forward,
with his family already occupying the top deck
and the more valuable domestic species
accommodated immediately below.

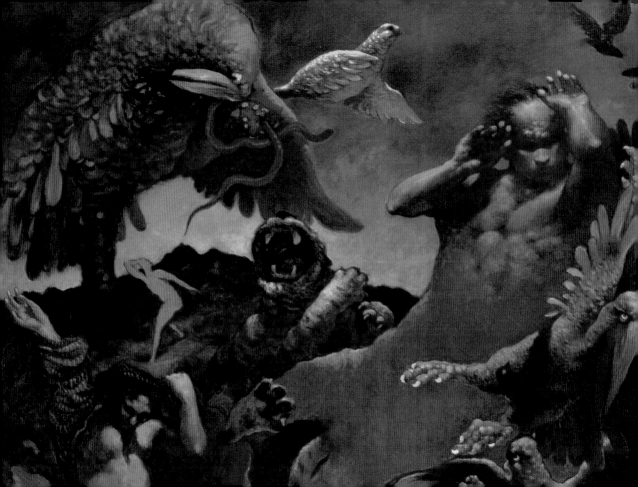

XIA

Wild Distortion
1990

● A wonderfully bizarre modern Chinese variation on the theme of Orpheus among the animals. None of the beasts and birds is quite what the spectator expects it to be. They are all in a state of metamorphosis.

Xia Xiaowan (20th Century)

" IF WE STOP LOVING ANIMALS,
aren't we bound to stop loving humans, too?
"
Alexander Solzhenitsyn (b. 1918)

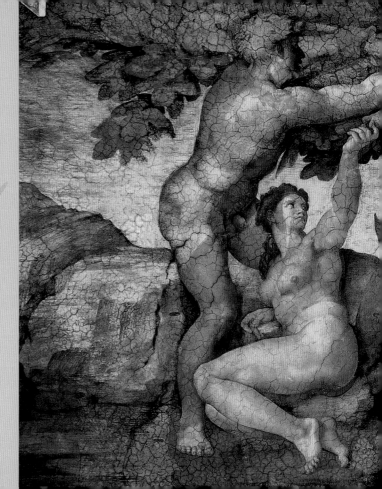

MICHELANGELO

*The Fall and the Expulsion
from Eden*
c. 1509/10

● In this scene from the Sistine Chapel,
Michelangelo offers his version of two of
the central episodes from the Book of
Genesis. It is notable that the landscape is
reduced to a minimum, and that the story
is told entirely in terms of human figures.
Even the serpent, leaning from the tree to
proffer the fatal apple, takes on human
guise—a snake below the waist, but a
nude female above it.

Michelangelo Buonarotti (1475–1564)

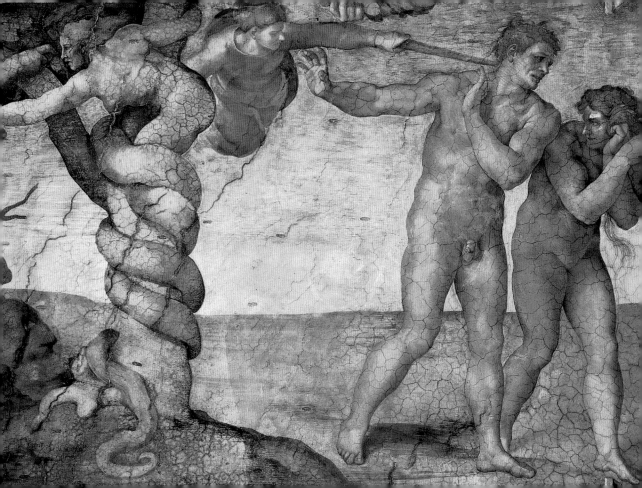

FANTASTIC BEASTS

EGNAZIO DANTI
St. Mark the Evangelist
1580—83

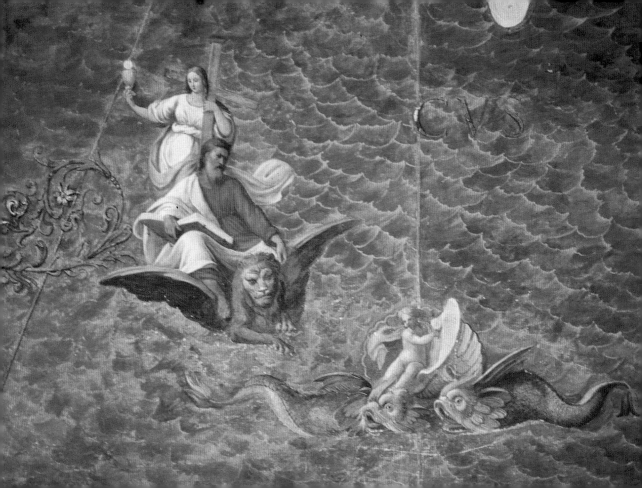

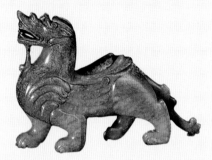

CHINESE Amulet in the Shape of a
Winged Beast 206 B.C.–220 A.D.

T HE LIST OF FANTASTIC BEASTS *is almost endless and includes centaurs, minotaurs, sphinxes, chimeras, basilisks, and of course dragons. In general they are made up of familiar elements— being either part animal, part human, or created from parts of different animals. For example, a chimera has the head of a lion, the body of a goat, and the tail of a dragon, and a basilisk is a mixture of rooster, snake, and toad.*

The fantastic beast is often seen as hostile and evil, but is also used to symbolize benevolence, or has a significance that is mixed. The unicorn, a great favorite in medieval legend and therefore in medieval art, was an emblem of power and purity. Its single horn enabled it to separate pure water from that which was contaminated, and to detect poisons. It could be captured only by a virgin, who

enticed it to sleep in her lap. The sphinx, a creature with a lion's body and human face, was the representative of royal power in ancient Egypt and was therefore often a portrait of the ruling pharaoh. In Greece, however, it was female—a winged lioness with a human head, which asked riddles and devoured those who failed to give the correct answer. Centaurs, also part of Greek mythology, were half horse and half man. Less threatening than the sphinx, they were often depicted as representatives of the "animal" side of human nature, prone to lust and violence. The battle of the centaurs and Lapiths, a favorite subject in Greek art, was

JOHN FRAME
Old Will *1996*

used as an allegory of the triumph of civilization over barbarism. On the other hand, Chiron, the centaur who was tutor to the young Hercules, was a representative of wisdom, strength, and nobility.

RUSSIAN Mermaid *17th Century*

363

One of the most important fantastic creatures that we recognize is the dragon, a beast that makes its appearance in many cultural contexts. It is particularly significant in Chinese art, where the dragon was the symbol of imperial power and a manifestation of the sovereign's omnipotence. The dragon does also play a prominent role in both Greek and Celtic mythology, and continues to fascinate twentieth-century writers of science-fantasy.

Dragons, in the form of wyverns, played quite a prominent role in heraldry, where they were depicted as two-legged creatures with barbed tails. The etymology of the term "wyvern" actually comes from "bittern"—a marsh bird of the heron family.

Other fantastic beasts that played a similar role in heraldry include the griffin or gryphon, a creature with the beak and wings of an eagle and the body of a lion, and the phoenix, the legendary bird that had

CHINESE
Vase *Yuan Dynasty 14th Century*

the power to be reborn from its own ashes, having burned itself to death in a nest of aromatic twigs. Some connect the phoenix as well as the wyvern to the heron family.

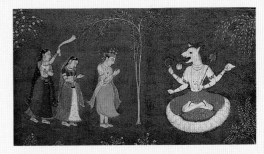

INDIAN Narasimhavatara c. *1650*

Perhaps the most intensely imagined of all these mythical creatures is the unimaginably huge and formidable Leviathan. The Leviathan was often mentioned in the Bible, but originally derived from Phoenician mythology. The name was applied to a monster that was the personification of primeval chaos, the embodiment of hostility to God, slumbering but ready to be roused if the wrong words were said. Mythical animals and monsters are essentially products of what psychology calls the unconscious mind. Leviathan can be thought of as the unconscious mind itself, ready to devour and obliterate the everyday phenomenal world.

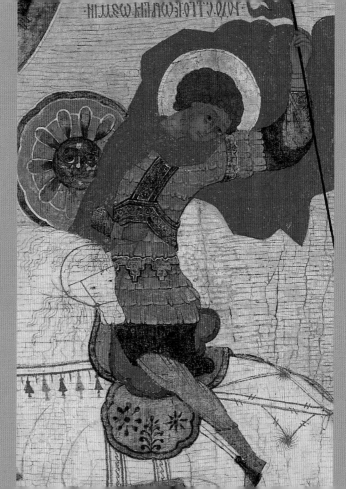

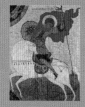

RUSSIAN

*St. George and the
Dragon
15th Century*

● St. George is a popular
subject with both Greek
and Russian icon painters. In
this School of Novgorod icon,
the dragon lies on the ground
in coils, more like a boa
constrictor than the generally
accepted idea of a dragon.
The work is painted in
tempera—pigment bound with
an emulsion made from egg
yolks or whole eggs—on
wood coated with gesso.

66

NEVER
*laugh
at
live
dragons.*

99

J. R. R. Tolkein
(1892–1973)

GERMAN

Kylin

1735/36

Early eighteenth-century European porcelain artists often copied decorative motifs from Chinese and Japanese wares, getting them slightly wrong in the process. The artist of this piece of Meissen porcelain, in the Beast Fables service, intended to render a *kylin,* a composite animal with a fierce appearance but a gentle nature.

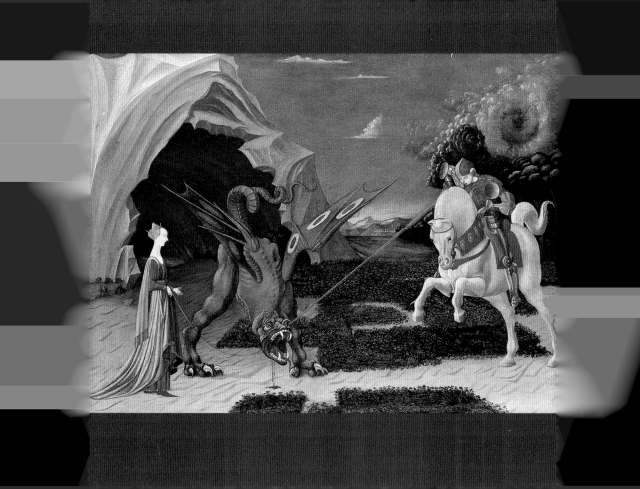

UCCELLO

St. George and the Dragon
14th Century

● A very distinctive version of the traditional dragon, which here is essentially birdlike, with only two legs, and wings in place of forelimbs. The snaky tail suggests a link with the chimera of Greek and Roman legend, but the general configuration is not unlike that of some dinosaurs. Oddly enough, there is no evidence that the legend of the dragon was inspired by any subliminal memory of the dinosaurs, which died out before the appearance on earth of humans.

Paolo Uccello (1397–1475)

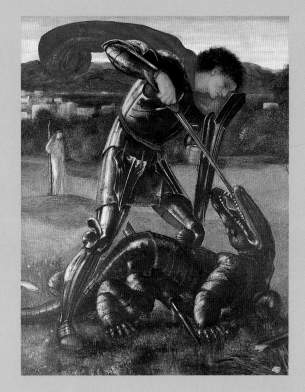

BURNE-JONES

St. George and the Dragon
1868

● The Pre-Raphaelite Burne-Jones pictures his dragon as something very much resembling a large lizard, like the komodo dragon from Indonesia, which grows to 100 feet long and can weigh up to 300 pounds. Already wounded by a lance, the dragon appears to wait rather passively to be finished off with a sword-thrust down the throat.

Sir Edward Burne-Jones (1833–98)

MARIN

Don't Drop Me
1996

● The contemporary
Mexican sculptor Jorge
Marin makes work in
polychromed clay that
looks back to the
creations of the Baroque
artists of the seventeenth
and eighteenth centuries.
Here he offers a female
centaur.

Jorge Marin (b. 1962)

66

CURIOUSER
and curiouser!

99

Lewis Carroll
(1832–98)

MADZO

Among Fantastic
Shadows
1991

● A collage in the Surrealist
tradition, which depicts a
basically horselike beast
with horns and other
protruberances at odd angles,
and with legs evidently too
small and feeble to carry it.

Michael Madzo (b.1950)

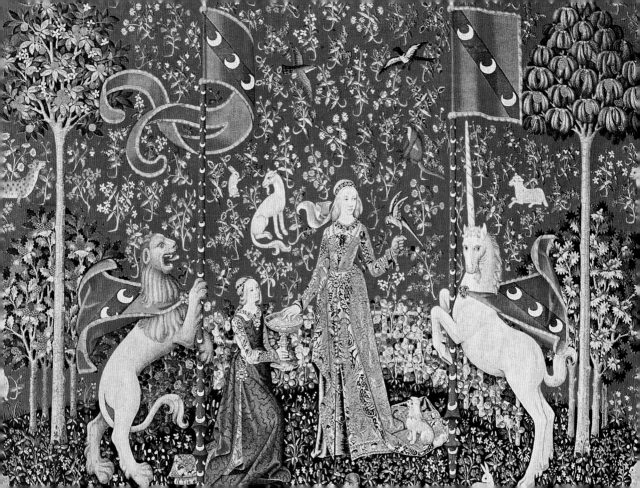

FRANCO-FLEMISH

The Sense of Taste
Late 15th Century

● From the famous series of tapestries showing a lady with a unicorn. The lady prepares to feed a pet parakeet, while a lion and a unicorn hold heraldic banners on either side of her.

FRENCH

The Maiden and the Unicorn
1533

● A margin decoration from the *Book of Hours of Antoine le Bon, Duke of Lorraine*. Even at this comparatively late date, the unicorn retained its popularity as an emblem of purity.

ATTRIBUTED TO JACOPO

Caesar's Horse
1514

● Caesar's mount on this majolica dish has been confused with Alexander's steed Bucephalus, endowed by later legend with a horn in the middle of his forehead. Bucephalus was afraid of his own shadow and therefore could only be ridden toward the sun— that is, toward glory. The design contains other symbolic elements: the rider holds a palm branch, emblematic of victory, on top of which is balanced a globe. Behind him sits a monkey, in mockery of worldly glory.

Attributed to Jacopo di Pietro
(16th Century)

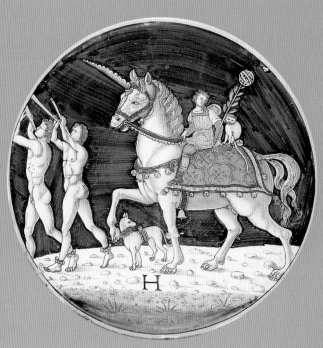

FRENCH

From the Livre des Merveilles
1351

● The *Livre des Merveilles* was a compilation made by the Benedictine monk Jean Le Long d'Ypres from a number of other books of travel, including genuine accounts by the Franciscan friar Odoric of Pordenone (*c.*1286–1361) and the Venetian merchant Marco Polo (1234–1324), plus apocryphal accounts. Similarly here, real animals, such as the elephant, are mingled with legendary ones like the unicorn.

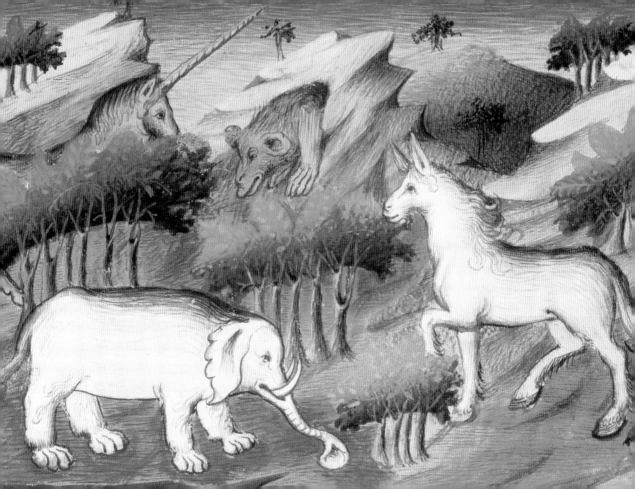

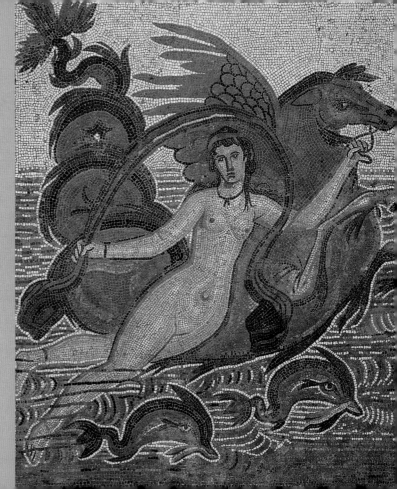

mermaid

ROMAN

*Nereid with a Hippocamp
and Two Dolphins*
3rd Century A.D.

● The idea that waves were like
horses heaving and plunging seems to
have established itself early in the
imagination of the Greek and Roman
world. The result was the invention
of a hybrid creature, part horse, part
sea serpent, and sometimes winged,
as presented in this mosaic.

> 66
> *Since once I sat upon*
> *a promontory*
>
> *And heard a mermaid on*
> *a dolphin's back*
>
> *Uttering such dulcet and*
> *harmonious breath,*
>
> *That the rude sea grew*
> *civil at her song,*
>
> *And certain stars shot*
> *madly from their spheres,*
>
> *To hear the sea-maid's*
> *music.*
> 99

William Shakespeare (1564–1616)

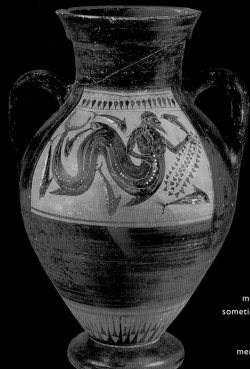

ETRUSCAN
Sea-God with
Dolphins and Ivy
6th Century B.C.

● Sea-monsters could
also be composites of
people and fish. The sea god
on this Etruscan vase is the
precursor of the mermaids and
mermen of later legend, which are
sometimes said to have been suggested
by the sea cow (the manatee).
Columbus believed he had seen
mermaids—but "ugly ones"—on his
first voyage across the Atlantic.

POINT
The Siren
1897

● In Greek legend, the siren was half bird and half woman, and lured sailors to their deaths with her song. In the hands of the Symbolist artist Armand Point, she has become a marine deity who is fully human in form, riding on the back of a horned beast that seems to be half antelope and half sea serpent. With an imperious gesture, she lures the ship in the distance toward the rock that will wreck it.

Armand Point (1861–1932)

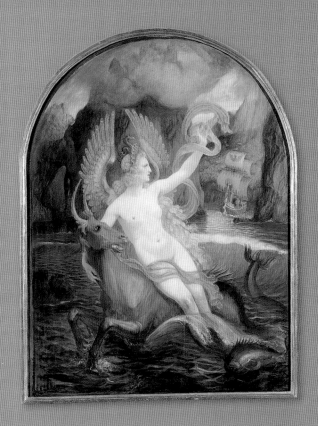

SEGANTINI

*A Mermaid Being
Mobbed by Seagulls
19th Century*

● Mermaids were sometimes
confused with sirens, sea
creatures who were supposed
to sing and lure sailors to
their death by drowning. It has
been supposed that the legend
of the mermaid arose from
encounters with the manatee
or the dugong, both of which
suckle their young above the
water. Segantini seems to
envision the mermaid as
an unnatural creature
who is attacked for her
outlandishness by the gulls,
which fully belong to their
environment.

Giovanni Segantini (1858–99)

ARCIMBOLDO

The Lawyer
1566

● One of Arcimboldo's grotesque composite heads. This image satirizes lawyers by giving this aged jurist a nose made from a fledgling, a mouth and beard that are parts of two fishes, and a trussed chicken for cheek and brow. The picture was looted from Prague during the Swedish occupation of the city at the end of the Thirty Years' War (1618–48).

Giuseppe Arcimboldo
(1527–93)

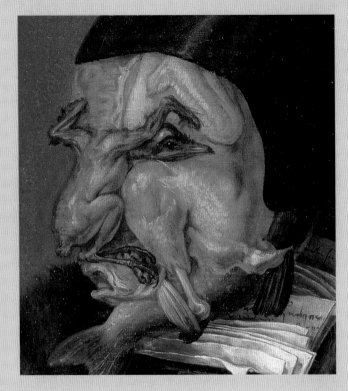

SANCHEZ

A Last Supper 1
1981

● Magical personages are often represented with the heads of birds, and that is the case here. The one fully human participant in this feast seems to flinch away from the blasphemous gesture of blessing made by the central personage.

Stephanie Sanchez
(b. 1948)

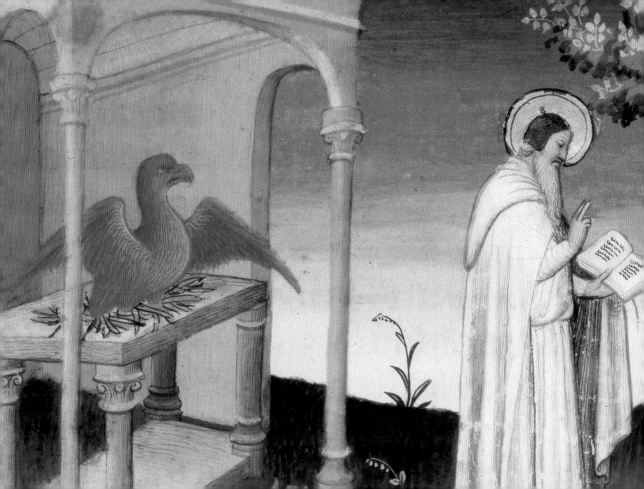

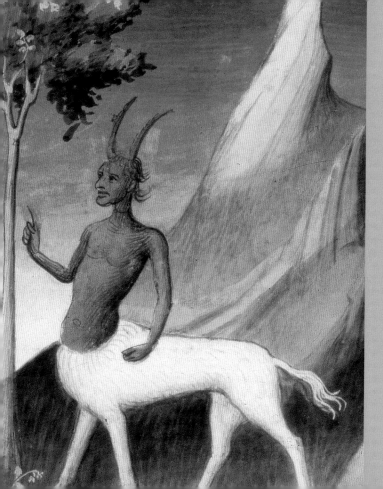

FRENCH

From the Livre des Merveilles
1351

● This illumination from the *Livre des Merveilles*, a compilation of "wonders" made by the Benedictine monk Jean Le Long d'Ypres from a number of books of travel, both genuine and spurious, plus other texts. The scene shown is taken not from a travel book but from *The Golden Legend* by Jacob de Voraigne, a collection of stories about the saints that was extremely popular in the late Middle Ages. According to this source, after a long search the 90-year-old St. Antony Abbot found the 113-year-old St. Paul the Hermit living in the desert being fed on dates and bread by a raven. Their actual meeting is depicted in one of the panels of Grünewald's Isenheim Altarpiece.

● INDEX OF ARTISTS

Full artists' biographies have been included whenever possible. When it has not proved possible to obtain a full biography, all available information has been provided.

GIUSEPPE ARCIMBOLDO
1527–93
Italian painter initially known for depictions of vegetables and fruit. Many of his works show huge heads or human figures made up of fruits, flowers, animals, and landscapes.
(Page 172, 380)

BALTHASAR VAN DER AST
1593/94–1657
Dutch painter specializing in flowers, fruits, and shells. He was the son-in-law of Ambrosius Bosschaert (1573–1621), under whom he trained.
(Page 323)

JOHN JAMES AUDUBON
1785–1851
American naturalist and bird painter. He went to Philadelphia in 1804 to look after his father's estate, but spent his time cataloging every species of bird in the United States. In 1827 he published the first of 87 volumes of *Birds of America*. The National Audubon Society, dedicated to the conservation of birds in the United States, was founded in his honor in 1866.
(Page 293)

H. BAERT
fl. 1842
(Page 214–15)

THOMAS BAINES
1822–75
Self-taught artist who originally painted ornamental coaches. He went to South Africa in 1842 and became known for painting landscapes, seascapes, and portraits in this region.
(Page 280–81)

BALTHUS (BALTHASAR KLOSSOWSKI DE ROLA)
b. 1908
French painter, illustrator, and stage designer. His early works, mainly Parisian scenes, were inspired by the Old Masters and by his friends Pierre Bonnard (1867–1947) and André Derain (1880–1954). After a period of producing erotic paintings and opera stage sets, he returned to an earlier interest in landscapes.
(Page 122–23)

DAVID BATES
b. 1952
(Page 121, 166–67)

MASTER BERTRAM OF MINDEN
c. 1340–1414/15
German painter, illuminator, and woodcarver whose major work was the Grabow altarpiece in Hamburg, a combination of carved figures and painted scenes. His lively, expressive style made him one of the most influential early German artists.
(Page 342)

PANCRASE BESSA
1772–1835
French flower painter who studied under van Spaendouck and Pierre Joseph Redouté. He was flower painter to the Museum of Natural History in Paris and to the Duchesse de Berri, to whom he also gave lessons.
(Page 148)

WILLIAM BLAKE
1757–1827
English printmaker, painter, and poet, whose visual art has become as well known as his poetry. Blake generally presented the two together in what he called *Illuminated Printing*, where poetry and design were integrated in hand-printed books. He believed all art forms were a sign of hope in a materialistic society.
(Page 192–93)

ROSS BLECKNER
b. 1949
American artist who made his mark in the early 1980s with contrasting black-and-white pictures portraying life and death. His more recent work has been influenced by nature. Examples of his work can be seen at the Mary Boone Gallery in New York.
(Page 150–51)

PIETER BOET
1622–74
Flemish painter who studied under Frans Snyders (1579–1657). He painted animals, birds, flowers, and fruits. His style was free and spirited, and he used very natural coloring.
(Page 134–35)

JACOB BOGDÁNY

c. 1660–1724

Hungarian painter who worked in the Netherlands and England. He enjoyed royal commissions for flower paintings in London, but became interested in birds when he had access to the aviary of Admiral George Churchill. He was in great demand among the aristocracy for his paintings of wild and exotic birds, often featuring backgrounds of classical architecture.

(Page 149)

ROSA BONHEUR

1822–99

French painter and sculptor taught by her father, Raymond Bonheur (d. 1849). She was part of a Realist current that emerged in the 1840s and worked from direct observation. She was influenced by her love of animals, particularly horses, and by a trend in natural history at the time. Her father encouraged her independence at a time when this attitude was unusual for women.

(Page 244–45)

ÉMILE-ANTOINE BOURDELLE

1861–1929

French painter and sculptor inspired by ancient Greek art. He left the École des Beaux-Arts after two years in a rebellion against academic training and went on to assist in the studio of Auguste Rodin (1841–1917). He co-designed the Classical façade of the Théâtre des Champs-Élysées and undertook many portraits. After World War I (1914–18), he concentrated on designing public monuments.

(Page 57)

JACOB BOUTTATS

fl. c. 1675

(Page 32, 339)

CONSTANTIN BRANCUSI

1876–1957

Roman sculptor based in Paris from 1904. He is recognized for the simplistic, abstract shapes he created, which came to have a tremendous impact on the world of sculpture and abstract art.

(Page 288)

DOMENICO BRANDI

1683–1736

An Italian painter, Brandi was taught by his uncle, Nicola Rossi, in Naples and then apprenticed to Benedetto Luti in Rome. He was best known for his animal and bird paintings, but he also executed some fine landscapes.

(Page 216–17)

JOHANN BRANDSTETTER

b. 1969

(Page 300–1)

WILLIAM HENRY BROWN

1808–82

(Page 76–77)

JAN BRUEGHEL THE YOUNGER

1601–78

Born into a family of artists from the Netherlands, Brueghel took over the studio after his father's sudden death. He headed a large studio with many assistants, and became Dean of the Antwerp Guild of St Luke in 1630. The same year he was commissioned by the French court to paint an Adam cycle. He worked with Rubens (1577–1640) and Hendrick van Balen (c. 1575–1632).

(Page 330–31, 350–52)

SIR EDWARD BURNE-JONES

1833–98

English painter and decorative artist who was a major force in the second phase of the Pre-Raphaelite movement and a friend and colleague of William Morris (1834–96). Burne-Jones's painted scenes of classical mythology and medieval legend, and his designs for stained glass and tapestry, inspired the Aesthetic movement.

(Page 369)

PABLO CAMPOS

b. 1952

Born in Valparaiso, Chile, this contemporary artist started painting at an early age, participating in his first group exhibition at fourteen. He now lives in California, and continues to show his work in both solo and group exhibitions, including shows at the Lizardi Harp Gallery in Los Angeles.

(Page 333)

VITTORE CARPACCIO
c. 1455/65–1526
Italian painter who was famous for scenes of his native Venice. His best-known work is *The Legend of St. Ursula* (1490–98).
(Page 68)

MANUEL CASTELLANO
1828–80
(Page 88–89)

GIOVANNI BENEDETTO CASTIGLIONE
c. 1609–63/65
Italian painter influenced by Peter Paul Rubens (1577–1640).
(Page 354)

LUIS CHAN
1905–95
(Page 159)

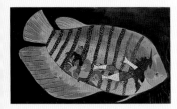

JUDY CHICAGO
b. 1939
American painter, sculptor, and art teacher. Her major achievement was her involvement in *The Dinner Party* (1974) a triangular table set for 39 women, each with an individually designed place setting. This work was regarded as a major statement of feminist art.
(Page 99, 126–27)

FRANCESCO CLEMENTE
b. 1952
Italian painter who has divided his life between Madras, Rome, and New York, leading to an eclectic body of work. He became known in the 1970s for his erotic paintings and was part of a revolt against the formal and impersonal nature of art.
(Page 226)

ADRIAEN DE COORTE
fl. 1683–1707
Dutch painter of mainly still lifes who preferred simple objects in simple compositions to the complicated scenes that were fashionable at the time. His usual subjects were vegetables, fruits, flowers, and shells, often arranged on a stone base with a crack at the front, but early works often feature birds.
(Page 325)

LOVIS CORNITH
1858–1925
German engraver and painter who trained with Adolphe William Bouguereau (1825–1905) in Paris. He is recognized as one of the leading representatives of the German Impressionist school, and is best known for landscapes, portraits, and still lifes, particularly of religious subjects.
(Page 335)

GUSTAVE COURBET
1819–77
French painter and writer known for his images of landscapes, hunt scenes, peasants, and laborers, many of which were politically motivated. He was briefly imprisoned following the Commune of 1871 and thereafter lived in exile in Switzerland. His views against state patronage and the academic system made him influential in the development of Modernism.
(Page 242)

THOMAS CRANE
1808–59
English painter best known for his elegant oil and watercolor portraits of ladies and children. In his early career he worked as a miniaturist and also published sketches of celebrated characters in North Wales. He was a member of the Liverpool Academy and spent many years of his life in Torquay, Devon, due to poor health.
(Page 278)

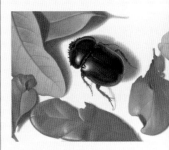

MARY ANN CURRIER
20th Century
Contemporary American artist. Examples of her work can be seen at the Tatistcheff Gallery in New York.
(Page 314–15)

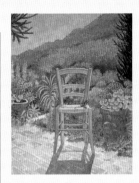

TSUGOUHARU FOUJITA

1886–1968

French painter of Japanese birth who graduated from the Tokyo School of Fine Arts, then moved to Paris. He was associated with the École de Paris, but still developed his own style. He divided his time between Paris, Japan, and the United States, finally taking French nationality and converting to Catholicism in 1955.

(Page 127)

JOHN FRAME

b. 1950

American artist born in Colton, California, and now living in Los Angeles. Examples of his work have been shown at the Kohn Turner Gallery and the Municipal Art Gallery, both in Los Angeles.

(Page 363)

FRANS FRANCKEN THE ELDER

1542–1616

(Page 332)

CHARLES-THÉODORE FRERE

1814–88

French painter who studied under Roqueplan and Léon Cogniet. He made his debut at the Paris Salon in 1834 with landscapes of northern France. He traveled extensively in France, Algeria and other parts of Africa.

(Page 274–76)

RICHARD FRIESE

1864–1935

German artist who was particularly well known for his paintings of animals. He placed special significance on studying animals in their natural habitat, a practice that was somewhat unusual at this time.

(Page 297)

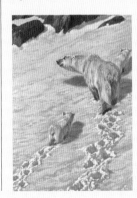

HENRY FUSELI

1741–1825

Swiss painter and writer, born Johann Heinrich Füssli, who changed his name after settling in England in 1779. He established himself as the most original history painter of his time, and his teaching and writing made him popular in art circles. He became Professor of Painting at the Royal Academy in 1799.

(Page 7, 189)

STEVE GALLOWAY

b. 1952

American artist born in Los Angeles, California. His work has been shown in a number of solo and group exhibitions, the latest of which took place at the James Corcoran Gallery in Santa Monica, California.

(Page 54–55, 175)

GALOYER

20th Century

(Page 132)

GIOVANNA GARZONI

1600–70

Italian painter specializing in fruit, vegetables, flowers, and animals, painted with stippled watercolor on parchment. She had many influential patrons, including members of the Medici court and The Duke of Savoy. She was a supporter of the Accadèmia di S Luca, to which she bequeathed her property.

(Page 200–1, 322–23)

PAUL GAUGUIN

1848–1903

French painter, printmaker, and sculptor who gave up a successful career in stockbroking to follow his artistic tendencies. He became leader of the Pont Aven school and a dominant speaker in Parisian art circles. He developed his own style, brought about by a hatred of Western society and inspired by by primitive peoples, and was influential on early twentieth-century avant-garde artists.

(Page 144, 206–7)

VINCENT VAN GOGH

1853–90

Dutch painter who studied in Brussels and painted for a time in The Hague before moving to Paris in 1886. There he studied and developed his work from a dark Realistic style to a more colorful, Expressionistic one. He moved to Arles in 1888 to become a peasant painter, but institutionalized

himself a year later when his mental illness became worse. He shot himself in 1890. Van Gogh sold only one painting during his lifetime, yet in 1987, *Irises* sold for some $80 million.
(Page 62–63)

FRANCISCO DE GOYA
1746–1828
Spanish painter and printmaker whose long working life spanned three generations of Spanish kings and lasted from the period of late Rococo to Romanticism and the beginnings of Impressionism. His work reflects the rapid changes of society around him. His prints were greatly appreciated in Spain and abroad.
(Page 70, 89, 119)

HEINRICH GRÜNEWALD
19th Century
(Page 318–19)

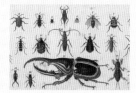

MATTHIAS GRÜNEWALD
c. 1470/80–1528
German painter, architect, and hydraulic engineer, regarded as the greatest painter of the German Renaissance. His work is characterized by an expressive style with dramatic movement and beautiful drapery forms. His religious beliefs led him to paint many images of Christ.
(Page 246–47)

CHARLES HAMILTON SMITH
1776–1859
(Page 261)

M. HANZAN
fl. 1835–62
(Page 98)

EDWARD HICKS
1780–1849
American painter who was raised by a devout Quaker family. He began a career as a coach and sign painter, but gave it up to become a Quaker minister. He continued to paint signs and wagons throughout his life, but also painted religious themes and farm scenes in oils, characterized by flat colors and simple figures.
(Page 44–47, 335)

JULIUS HOEPPNER
1839–93
(Page 313)

WINSLOW HOMER
1836–1910
American painter, illustrator, and etcher, specializing in scenes of outdoor life and the relationship between people and nature. His work, mostly in watercolor, is characterized by bold brushwork and strong composition.
(Page 230–31)

ELIZABETH ELLEN HOUGHTON
19th Century
(Page 278)

DELMAS HOWE
b. 1935
Contemporary New Mexico artist best known for his portrayal of cowboys.
(Page 85)

CH'IEN HSÜAN
c. 1235–1300
Chinese painter of figures, landscapes, horses, birds, and flowers. He is known as a major painter of the early Yüan period, but the first half of his life was spent under the Sung dynasty, and his early works show evidence of the academic style popular in the court at Lin'an.
(Page 224–25)

ARTHUR HUGHES
1832–1915
English painter and illustrator who was associated with the Pre-Raphaelite movement (and in particular with Sir John Everett Millais (1829–96), who was a good friend). Hughes was greatly influenced by their work, but his paintings had an emotional quality all their own; executed with a precise technique, most depicted unhappy relationships or childhood emotions.
(Page 222)

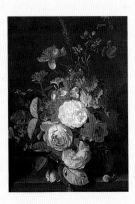

JAN VAN HUYSUM

1682–1749

Painter and draughtsman from a Dutch family of artists, he was best known as the last real Dutch flower painter. Van Huysum was famous for the realism of his subjects and had many royal patrons from all over Europe. He was the first to use a light background and brighter colors in his work.

(Page 200)

SUSANA JACOBSON

20th Century

(Page 10–11)

JACOPO DI PIETRO

16th Century

(Page 374)

KENDAHL JAN JUBB

b. 1957

American artist, born in New Jersey. Examples of her work can be seen in various galleries throughout the United States, including the Lizardi Harp Gallery in Los Angeles and the Emerald City Fine Arts Gallery in Seattle. Her work has also appeared in various magazines and in the children's books *Bold and Bright Black and White* and *Flashy Fantastic Rainforest Frogs* (by Dorothy Hinshaw Patent)

(Page 15, 16–17, 227, 284–85)

FRIDA KAHLO

1907–54

Mexican painter who began to paint while convalescing after a bus accident in 1925 that left her seriously crippled. She made a partial recovery but spent her life in and out of hospital. Her pictures, of which many are self-portraits, deal mainly with her struggle for survival. She was inspired by Mexican popular art, especially its naiveté and fantasy.

(Page 202–3)

RUPRECHT VON KAUFMANN

b. 1974

Contemporary artist born in Munich, Germany, now living in Los Angeles. His work has appeared at a number of recent exhibitions in the United States, including *Contemporary Realism III* at the Old City in Philadelphia.

(Page 41)

JAN VAN KESSEL THE ELDER

(1626–79)

Coming from a Flemish family of artists, Jan van Kessel was registered in the Antwerp Guild of St. Luke as a flower painter, but he also painted animals, birds, fish, and insects. His pictures were often large and complicated scenes filled with minute detail, drawn from scientific texts and from nature.

(Page 174–75, 311)

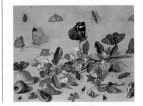

JOHN KIRBY

b. 1949

(Page 65)

GUSTAV KLIMT

1862–1918

Austrian painter and draftsman, and leading exponent of Art Nouveau. His early erotic paintings caused much controversy, but his later work was dominated by landscapes and portraiture. He painted Viennese bourgeois women, often against a background of swirls, disks, or geometric patterns. Klimt played an important role in the formation of the Vienna Secession, a radical group of Austrian artists.

(Page 190–91)

LUDWIG KNAUS

1829–1910

German painter who studied with Carl Ferdinand Sohn in Düsseldorf. He left the Akademie to study rural life after a disagreement with the director about the importance of study from nature. He went to Paris in 1853, where he received a gold medal at the Salon. His success was partly due to the popularity of rural scenes at the time.

(Page 72–73)

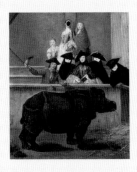

PIETRO LONGHI
1702–85

Italian painter thought to have studied with Giuseppe Maria Crespi (1665–1747), whose influence is evident in some of his early works. Longhi is best known for his satirical scenes of Venetian life, small-scale paintings in clear colors with doll-like figures, but he was celebrated during his life as a great imitator of nature.
(Page 75)

AUGUST MACKE
1887–1914

German painter who was first influenced by Impressionism, then by the work of Carl Hofer (1878–1955) and the Fauves, whom he met on a trip to Paris. Macke tackled traditional themes such as portraits, still lifes, interiors, and landscapes, contributing to exhibitions organized by Wassily Kandinsky (1866–1944) and Franz Marc (1880–1916), with whom he had a close friendship. Macke and Marc later explored Cubist techniques after a trip to Paris.
(Page 336–37)

MICHAEL MADZO
b. 1950

American artist born in St. Paul, Minnesota. His work has appeared at Couturier Gallery in Los Angeles and Galerie Gastaud and Caillard in Paris.
(Page 102–3, 371)

ÉDOUARD MANET
1832–83

French painter and printmaker who influenced and was influenced by the Impressionists but never fully adopted their techniques. He scandalized the traditional Classicists of the day with his controversial subject matter and innovative color and brushwork. Manet was one of many nineteenth-century painters who were greeted with sarcasm for their avant-garde work.
(Page 90–91)

MANSUR
1590–1630

Indian miniature painter of animals, flowers, and birds, held in such great esteem at the courts of the Mongol emperors Akbar and Jahangir that he was granted the title Wonder of the Age. His paintings were bound into albums.
(Page 283)

ANDREA MANTEGNA
1431–1506

Italian painter and printmaker who was inspired by ancient Roman subjects. He was greatly admired for his bold compositions and precise execution, and is the only artist of the period to have painted a large number of self-portraits. He developed his own, advanced printmaking technique.
(Page 279)

FRANZ MARC
1880–1916

German painter who specialized in animal studies, making extensive observations from nature. He was a colleague of August Macke (1887–1914) and Wassily Kandinsky (1866–1944) with whom he shared artistic intentions to renew spirituality in Western culture, which Marc proposed to do by using animals as symbolic figures. In 1912 Marc and Macke travelled to Paris, where they were both greatly inspired by French Cubism.
(Page 48–49, 108–9)

JORGE MARIN
b. 1962

Contemporary Mexican artist born in Uruapan, Michoacán. He has exhibited in Mexico, the United States (San Francisco), and around Europe.
(Page 370)

PHILIPPE DE MARLIER
fl. 1640–77
(Page 315)

ROBERTO MARQUEZ
b. 1959
(Page 19)

MATO (BERNARD MALAQUIS)
b. 1951
(Page 267)

MBUTHA
20th Century
(Page 266–67)

ADOLPH VON MENZEL
1815–1905
German painter, illustrator, and printmaker who was, in his later years, one of the most respected artists in Germany, specializing in depicting events in Prussia's recent history. He was one of Germany's greatest Realists, undertaking portraits, industrial scenes, interiors, and religious festivals.
(Page 257)

MARIA SIBYLLA MERIAN
1647–1717
Daughter of Matthäus Merian the Elder (1593–1650), Maria Sibylla was a painter of animals, plants, and insects, working mainly in the Netherlands and Surinam. Her immensely detailed and accurate works were the result of painting from life as well as from close contact with scientists.
(Page 270–71, 321)

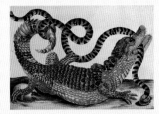

MATTHÄUS MERIAN THE ELDER
1593–1650
Swiss etcher and engraver who took over the family publishing house in Frankfurt after his father-in-law's sudden death. He built the business up into one of the most important publishing houses in Europe, still etching most of the illustrations himself. His subjects included world geography and history.
(Page 346–47)

PAUL FRIEDRICH MEYERHEIM
1842–1915
German watercolorist and lithographer who was taught by his father. He travelled extensively in many parts of Europe, including Belgium, the Netherlands, and France, before returning to his native Berlin.
(Page 74–75)

MICHELANGELO
1475–1564
Italian sculptor, painter, architect, and poet who dominated the High Renaissance and is still considered to be one of the greatest artists of all time. He was an apprentice for Domenico

Ghirlandaio (1449–94), although in later years it appears that he attempted to hide this fact. His most active years were between 1501 and 1505 in Florence, where his work included the famous *David* (1501–4). His most important work is considered to be the ceiling of the Sistine Chapel, which he began in 1508 on his return to Rome and completed in 1512.
(Page 358–59)

MELISSA MILLER
b. 1951
Contemporary American artist based in Texas.
(Page 240–41)

CLAUDE MONET
1840–1926
French painter who associated with Pierre-Auguste Renoir (1841–1919), Camille Pissarro (1830–1903) and Alfred Sisley (1839–99), exhibiting with them at the first Impressionist exhibition in 1874. It was one of Monet's works (*Impression, Sunrise*) that gave the movement its name. He traveled in France, England, the Netherlands, and Venice, capturing nuances of light, color, and atmosphere in landscapes. He also worked on a series of paintings showing the same scene under different conditions, such as haystacks and the façade of Rouen cathedral. He spent his last years creating a garden at Giverny, which featured in many of his works.
(Page 60)

JEAN-BAPTISTE MONNOYER
1636–99
French painter who began his career collaborating with Charles Lebrun (1619–90) on the decoration of royal châteaux around France. He later became known for his still-life paintings of flowers and fruits, which developed the genre into elegant large-scale pieces. In 1690 he visited England, where he was involved in decorating houses and palaces.
(Page 146)

H. MORGAL
fl. c. 1900
(Page 304–5)

FREDERICK MORGAN
19th Century
(Page 211)

J. LE MOYNE DE MORGUES
c. 1530–88
(Page 3)

REV. F. O. MORRIS
19th Century
(Page 327)

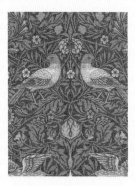

WILLIAM MORRIS
1834–96
English designer, writer, and propagandist for the arts who believed art should be for the people and by the people. In 1861, he founded the firm of Morris, Marshall, Faulkner & Co., producing stained glass, furniture, wallpaper, fabrics, and in designs that revolutionized the art of house decoration and furniture. Morris was both designer and entrepreneur,

involved in all aspects of the business himself, but his greatest talent was as a pattern maker. His designs arose from his love and observation of nature.
(Page 140–41)

RICHARD MÜLLER
1874–1930
(Page 272–75)

ED MUSANTE
b. 1942
American artist born in Honolulu, Hawaii. His work has featured in many solo and group exhibitions in galleries across the United States, including the Schmidt Bingham Gallery in New York and the Campbell-Thiebaud Gallery in San Francisco, California.
(Page 143, 236, 255)

G. MÜTZEL
18th Century
(Page 340)

ANTONIO DA NEGROPONTE
15th Century
(Page 133)

EDWIN NOBLE
20th Century
(Page 296–97)

CH'I PAI-SHIH
1863–1957
(Page 176)

ROBIN PALANKER
b. 1950
American artist born in Buffalo, New York. Exhibitions of his work have been shown most recently at the Patricia Shea Gallery in Santa Monica, California, and the Riverside Art Museum in Riverside, California. His work has also featured in several publications, including *Silence All Around Marked* (by Douglas Messerli) and *Lee Sr Falls to the Floor* (by Leland Hickman).
(Page 9, 58–59, 130)

FRANK PATON
1856–1909
(Page 98)

KIRK PEDERSEN
b. 1959
American artist born in Broken Bow, Nebraska, now based in Los Angeles. As a Contemporary Realist, he uses his chosen city of Los Angeles as the influence for his large acrylic canvases. Examples of his work can be seen at the Watts Tower Art Center in Los Angeles.
(Page 168–69)

HENG PENG
b. 1971
Born in Taipei, Taiwan, Heng Peng moved to California for his schooling and stayed on. The artist's roots are very important to him, and he imbues his contemporary paintings and sculptures with a profound respect for his ancestry. He celebrates each Chinese New Year by adding to his ongoing series of animal paintings, including *Year of the Cock* and *Year of the Rat*.
(Page 64–65)

PABLO PICASSO
1881–1973
Spanish artist who worked in France, dominating twentieth-century European art. Most of his work was in painting, but he was skilled in many other media and had an impact on many disciplines. With Georges Braque (1882–1963), Picasso was responsible for the development of Cubism. He was also a talented writer, starting many artistic debates around the world.
(Page 92–93, 124–25)

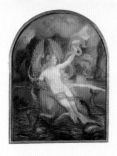

ARMAND POINT

1861–1932

French painter and designer who spent his early life in Algiers painting local subjects. After a visit to Italy, he modeled his work on the Florentine Renaissance, painting magicians and figures from Greek mythology. He also painted landscapes, flowers, and animals in stylized scenes. His studio produced jewelry, furniture, wallpaper and ceramics.

(Page 8, 378)

KIM POOR

20th Century

Brazilian artist now living in London. The myths and fables of the Amazon region of Brazil formed the basis of one of her most recent exhibitions, *Legends of the Amazon*. She uses the medium of glass powder on steel.

(Page 22–23, 147)

PAULUS POTTER

1625–54

Dutch painter and etcher and one of the greatest seventeenth-century animal painters, depicting farm animals in landscapes. Later in his life, he enjoyed more sophisticated patronage at The Hague, and his paintings showed elegant scenes of aristocratic couples visiting the countryside.

(Page 42)

CHARLES B. RALEIGH

1831–1925

(Page 290–91)

RAPHAEL

1483–1520

Italian painter and architect working during the High Renaissance at the same time as Leonardo da Vinci (1452–1519), Michelangelo (1475–1564), and also Titian (c. 1487/90–1576). He completed many altarpieces, decorated part of the Vatican palace, and produced some of the finest portraits and devotional paintings. He is widely acknowledged as one of the greatest European artists.

(Page 344–45)

ODILON REDON

1840–1916

French artist who first specialized in black-and-white charcoal drawings, with a dreamlike, melancholy quality. He was highly respected only among Parisian intellectual circles. In 1900 he turned to painting, specializing in flowers and portraits in intense colors. He is considered to have inspired Surrealism.

(Page 204–5)

MILO REICE

b. 1952

American artist born in New York. He specializes in painting works of allegory and symbolism, exploring the complexity of philosophical, moral, or ethical themes that usually revolve around superbly noble and heroic characters gathered from literature. Examples of his work can be seen at the Dannheiser Foundation and the Jewish Museum, both in New York and the Lannan Foundation in Los Angeles, California.

(Page 338–39)

GUIDO RENI

1575–1642

Italian painter who worked in Bologna and then Rome, and was popular during the seventeenth and eighteenth centuries. He was a pupil at the Carracci Academy in Bologna, and became known for his religious depictions. His most renowned work is the *Hours Preceded by Aurora* (1613).

(Page 182)

FRANK ROMERO

b. 1941

American artist born in Los Angeles. The most recent exhibitions of his work have taken place at the Alitash Kebede Gallery in Los Angeles and the Sylvia White Gallery in Santa Monica, California.

(Page 186, 220)

A. J. RÖSEL VON ROSENHOF

18th Century

(Page 308, 310)

NAGASAWA ROSETSU

1754–99

Japanese painter specializing in meticulous images of birds, flowers, figures, and animals. He was a lay practitioner of Zen and spent some

years decorating the walls of Zen temples. His style became freer and in later years his work was quite eccentric for its time: bold compositions and fluid brushwork. At the age of 45 he was reputedly poisoned by a rival.
(Page 31)

HENRI ROUSSEAU ("LE DOUANIER")
1844–1910
French painter who had no artistic training and spent most of his life as a customs official, hence his nickname. He finally retired to take up painting full time, producing highly colored, dreamlike pictures of exotic subjects that have been described as

Naive Art. He was considered a joke among critics.
(Page 20–21, 26–27, 112–13)

PETER PAUL RUBENS
1577–1640
Flemish painter and diplomat. Rubens was employed as an ambassador by the rulers of the southern Netherlands and became a painter to the European courts, depicting scenes glorifying his patrons. He turned his wide knowledge of Classical art and literature into magnificent altarpieces, historical and mythological scenes, landscapes, portraits, and works in many other disciplines.
(Page 218, 256)

DAVID RYCKAERT III
1612–61
Flemish painter who was taught by his father and became a master at the Antwerp Guild of St Luke. His early works, under the influence of David Teniers (1582–1649) and Adriaen Brouwer (1605/6–38), usually show the interiors of ale houses with peasants drinking and making merry. His later works feature more dignified people, often enjoying musical activities.
(Page 198–99)

STEPHANIE SANCHEZ
b. 1948
American artist born in New York. Her work appears in public collections at the Madison Art Center, Wisconsin and the Oakland Museum in California.
(Page 136–37, 156, 343, 381)

LOUIS SARGENT
20th Century
(Page 287, 294–95)

RAJA SARUPSINGH
19th Century
(Page 97)

JACOB SAVERY
1593–1627)
(Page 352–53)

ROELANDT JACOBSZ SAVERY
1576–1639)
(Page 334)

OTTO MARSEUS VAN SCHRIEK
c. 1619–78
Dutch still-life painter who worked in Rome for patrons such as Ferdinando II de'Medici and the Grand Duke of Tuscany. He is known for his accurate

portrayals of insects, reptiles, and amphibians, and pictures of sand dunes with a variety of different plants. He was also greatly interested in depicting animal behavior.
(Page 195, 309, 324)

ALBERT SEBA
18th Century
(Page 203)

GIOVANNI SEGANTINI
1858–99
Italian painter and draftsman from a very poor background who was supported and encouraged by his patron, Vittore Grubicy, to paint landscapes from nature. He was very successful in the Netherlands and Germany.
(Page 379)

LUIS SERRANO
b. 1955
American artist born in Guayaquil, Ecuador, and now based in Los Angeles. His work has featured in group exhibitions such as *The Drawing Group: An Emerging School of Los Angeles?* at the Laband Gallery, Loyola Marymount University, Los Angeles.
(Page 138, 223)

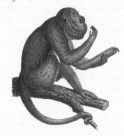

DIEGO RODRÍGUEZ DE SILVA VELÁZQUEZ
1599–1660

Spanish painter best known for portraits, and considered to be one of the most outstanding Spanish artists of this period. In 1623 he was appointed Court Painter to Philip IV in Madrid.
(Page 96)

VENEGAS
20th Century
(Page 235)

CARLE VERNET
1758–1836

French painter and lithographer who made his reputation with witty satires and then moved on to depicting battle scenes of Napoleon's Italian campaign.
(Page 250–51)

J. WALTER
16th Century
(Page 132)

ANDY WARHOL
1928–87

American painter, printmaker, sculptor, and filmmaker. He worked as a commercial artist before becoming a pioneer of Pop Art, drawn to shocking images of tabloid newspapers, money, and products of a consumer society. He also devoted many years to experimental filmmaking while continuing to paint throughout his life.
(Page 124)

JAN WEENIX
1642–1719

Dutch painter and son of Jan-Baptist Weenix (1621–63), from whom he received his training. His early works were Italianate landscapes like his father's, but he later went on to specialize in still lifes of dead game birds, flowers, and statuary, often set in parkland with palatial houses in the background.
(Page 341)

JAN-BAPTIST WEENIX
1621–63

Dutch painter and etcher who specialized in depicting Dutch Italianate landscapes and harbor views. His fantasy landscapes often included real or fanciful architectural ruins, sculptures, and picturesque figures. He consciously combined past and present. Weenix also spent time in Rome in the service of Pope Innocent X.
(Page 114)

MARGO WEINSTEIN
20th Century
(Page 194, 271)

JOSIAH WOOD WHYMPER
1813–1903

Self-taught English wood engraver who attained the highest excellence. He earned a reputation as a teacher and among his pupils were C. Keene, Fred Walker, and J. W. North. He also painted in watercolor and was a member of the Royal Institute of Painters in Water-Color.
(Page 290)

WILLIAM T. WILEY
b. 1937
(Page 28, 241)

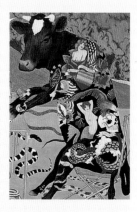

MARIAN WINSRYG
b. 1941

American artist based in Los Angeles, California. Her work can be seen in many collections, including the Los Angeles County Museum of Art, Los Angeles Art Association, and the Louisville Visual Art Association.
(Page 40, 229, 263)

XIA XIAOWAN
20th Century
(Page 356–57)

E. YARROW JONES

20th Century

(Page 302)

HAL YASKULKA

b. 1964

American artist born in Brooklyn,
New York. Her work has been featured
most recently in an exhibition at the
Lizardi Harp Gallery in Los Angeles.

(Page 228–29)

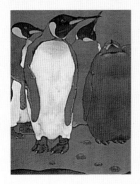

SHIBATA JUNZO ZESHIN

1807–91

(Page 311)

PETER ZOKOSKY

b. 1957

American artist born in Long Beach,
California. His work has featured in
numerous exhibitions, most recently
at the Koplin Gallery, Santa Monica,
California.

*(Page 14, 24, 25, 36–37, 120–21,
154–55, 277)*

FRANCISCO DE ZURBARÁN

1598–1664

Spanish religious painter who spent
most of his life in Seville, where he
was celebrated for his scenes of
monastic life. He also tackled a few
still life studies and portraits. Among
his patrons were churches and
monasteries, but he also gained the
title Painter to the King.

(Page 42–43)

● PICTURE CREDITS

Oxford University Museum of Natural History 183/ Palatina Gallery, Florence 201, 322 / Palazzo Pitti, Florence 182L, 324 / A. F. Pears Ltd, London 211 / Phillips, The International Fine Art Auctioneers 309 / Royal Academy of Art, London 12 / Royal Geographical Society, London 280/281 / Rafael Valls Gallery, London 325 / Vatican Museums & Galleries, Rome 360/361 / Victoria & Albert Museum, London 3, 97R, 234L, 270, 283, 293, 321 / Yale Center for British Art, Paul Mellon Collection 282;

CATHARINE CLARK GALLERY, San Francisco / Travis Somerville p 320 / Margo Weinstein 194, 271;

LUIS CHAN p 159L;

JUDY CHICAGO/DONALD WOODMAN pp 99, 126;

COUTURIER GALLERY, Los Angeles / Jorge Marin p 370 / Michael Mazdo 102/103, 371;

MARY EVANS PICTURE LIBRARY pp 286, 287R, 288L, 289, 294, 296, 298, 302, 303;

NOHRA HAIME GALLERY, New York / Milo Reice p 338 / Francisco Toledo 159R;

LIZARDI/HARP GALLERY, Los Angeles / Pablo Campos p 333R / James Doolin 118 / John Frame 363R / Steve Galloway 54/55, 175 / Kendahl Jan Jubb 15R, 16/17, 227, 285 / Rupert von Kaufmann 41L / Tom Knechtel 100, 181 / Leonard Koscianski 6, 233, 252 / Randall Lavender 40R, 71, 150, 210L, 213 / Ed Musante 143, 236, 255 / Robin Palanker 58/59, 130R / Heng Peng 64 / Kirk Pederson 168/169 / Frank Romero 186, 220 / Stephanie Sanchez 136, 156R, 343, 381 / Luis Serrano 138, 223 / Pia Stern 95, 170 / Marian Winsryg 40L, 229, 263L / Hal Yaskulka 228 / Peter Zokosky 14, 24, 25, 37, 120, 155, 277;

KIM POOR pp 22/23, 147;

VISUAL ARTS LIBRARY pp 11, 18, 19, 26/27, 28, 30, 31, 38R, 40R, 42, 56, 57, 62/63, 65, 67, 71R, 75, 85, 96, 98R, 107, 114, 115, 116/117, 121, 124, 125, 127, 132L, 132R, 134, 144, 146, 148, 149, 166, 174, 208R, 212, 218, 219, 221, 222, 236, 240, 241, 243, 246, 248/249, 251, 254, 266, 267, 273, 274/275, 276, 288R, 291, 314, 315, 335R, 341, 346, 349, 366 / Birmingham City Museum & Art Gallery 140/141 / Bodleian Library, Oxford 49, 250, 307 / Chicago Art Institute 80, 176, 264 / National Palace Museum, China 187, 224/225, 362 / Los Angeles County Museum 101 / Louvre Museum 163, 204, 238/239 / MOMA, New York 247 / Musee De L'Orangerie 112/113 / Musee D'Orsay 60, 82/83, 242 / New Orleans Musem of Art 244/245 / Philadelphia Museum of Art 84, 230 / Prado, Madrid 119 / San Diego Museum of Art 43 / Stockholm National Museum 142 / Washington Gallery of Art 44/45, 46/47, 77;

XIA XIAOWAN pp 356/357;

WERNER FORMAN ARCHIVE/Alaska Gallery of Eskimo Art pp 295 / Smithsonian Institute, Washington 287L.

© DACS 1998 122/23, 124, 127, 202/3, 219, 259 © Succession Picasso/DACS 1998 92, 125.

● ACKNOWLEDGEMENTS

For quotations from the following: Hotel du Lac by Anita Brookner © 1994 by Anita Brookner, reproduced by kind permission of the author and Jonathan Cape Ltd; Mad Dogs and Englishmen by Noel Coward © The Noel Coward Estate – Copyright Agent: Alan Brodie Representation Ltd, 211 Piccadilly, London, W1V 9LD; Cautionary Verses by Hilaire Belloc, reprinted by permission of The Peters Fraser and Dunlop Group Limited on behalf of The Estate of Hilaire Belloc, published by Gerald Duckworth & Co Ltd, All rights reserved; Dolpins by Stephen Spender, reproduced by kind permission of Faber and Faber Limited; Alec Issigonis in Notes & Queries in The Guardian, January 14 1991 © The Guardian; Parliamentary copyright material from Hansard, reproduced with permission of the Controller of Her Majesty's Stationery Office on behalf of Parliament; The Complete Poems of D. H. Lawrence, reproduced by kind permission of Laurence Pollinger Limited and the Estate of Frieda Lawrence Ravagli; "To A Butterfly" by James Merrill in Everyman Book of Animal Poetry, published by Random House Inc; Cancer Ward by Alexander Solzhenitsyn (Bodley Head), published by Random House UK Limited.

Every effort has been made to trace all copyright holders and obtain permissions. The editor and publishers sincerely apologise for any inadvertent errors or omissions and will be happy to correct them in future editions.